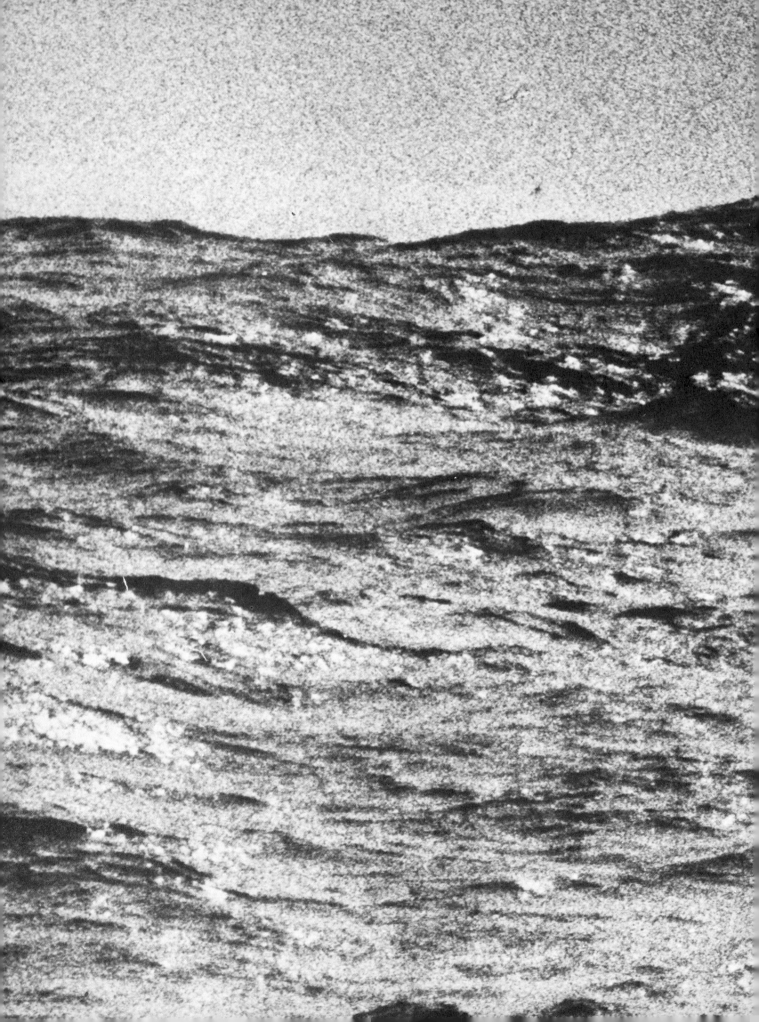

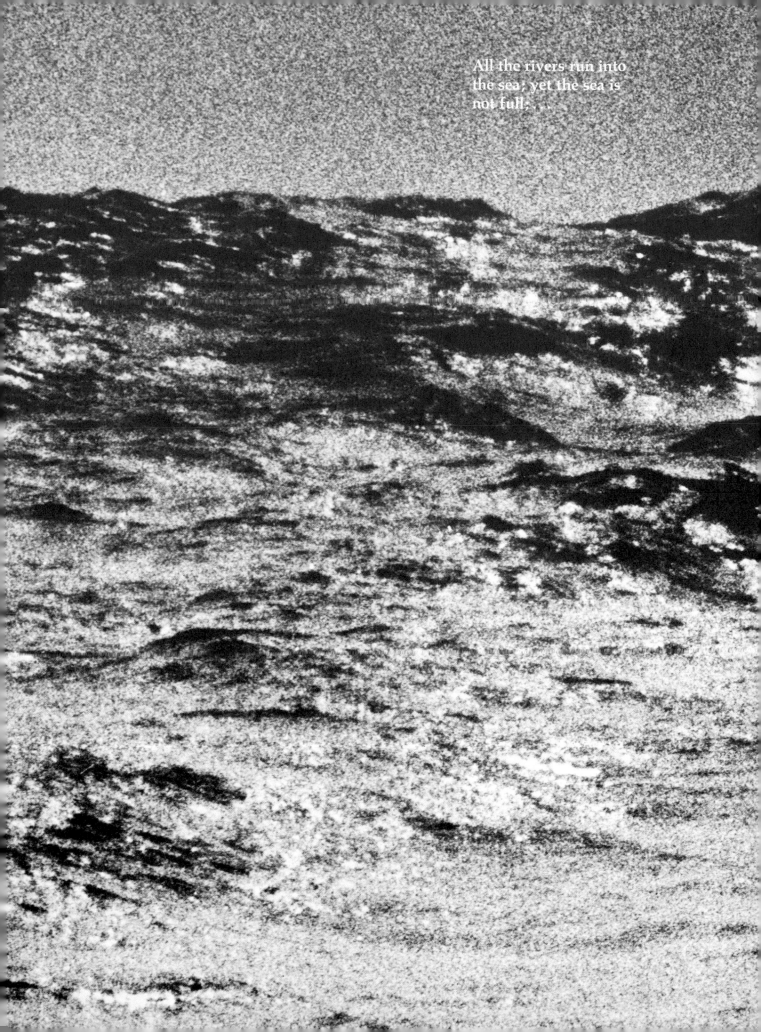

All the rivers run into
the sea; yet the sea is
not full; . . .

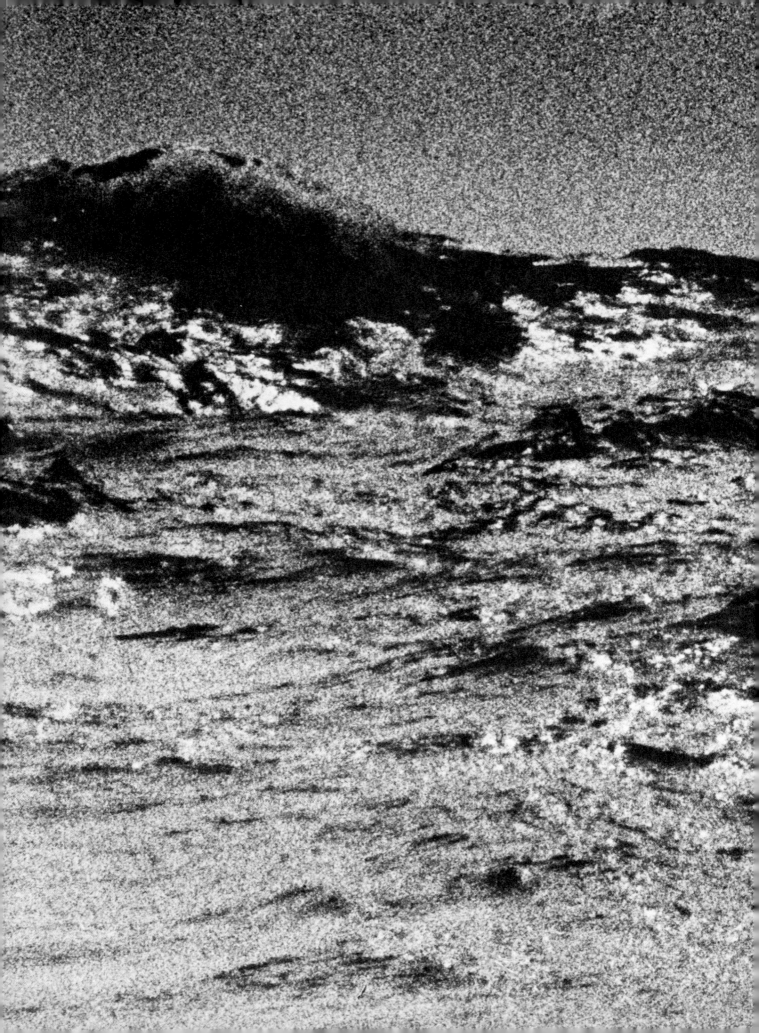

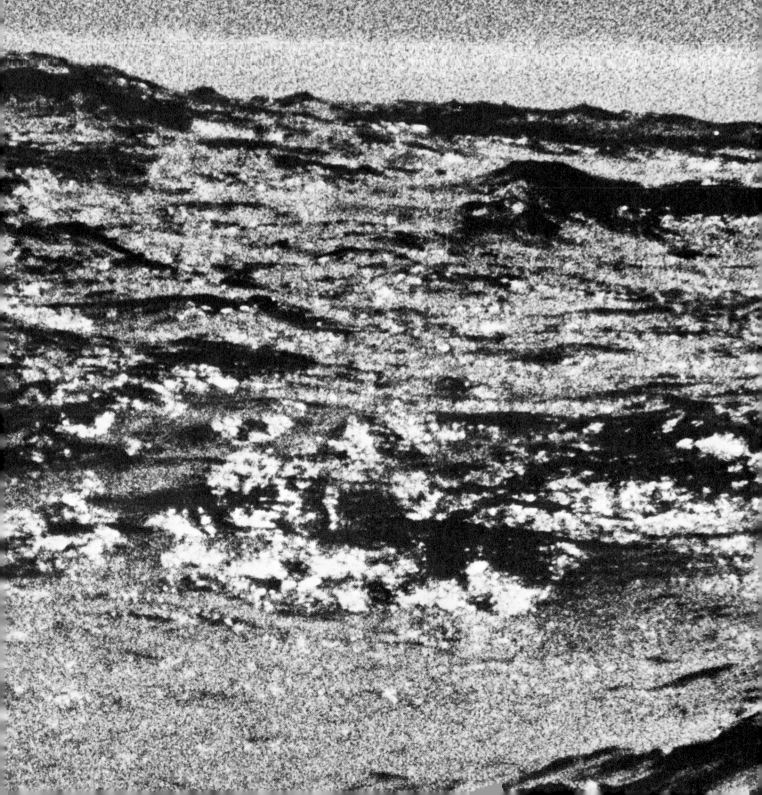

unto the place from whence
the rivers come, thither
they return again.
The Bible
Ecclesiastes 1:7

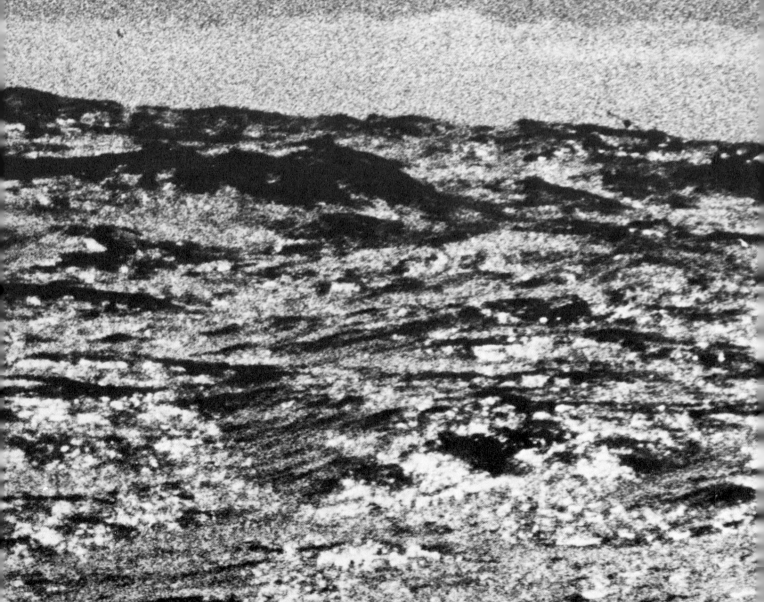

The Illustrated Eternal Sea

Photographs by Gene Anthony
Edited by Howard Chapnick

GROSSET & DUNLAP
A FILMWAYS COMPANY
Publishers · New York

Designed by Robert S. Nemser, Nemser and Howard, Inc.

Thanks are due the following copyright owners and publishers for permission to reprint certain passages and poems in this anthology:

WILLIAM BLACKWOOD & SONS LTD.—for extract from "Perils for Trial" by James Harper, published in *Blackwood's Magazine* and reproduced with the permission of William Blackwood & Sons Ltd, Edinburgh, Scotland.

DOUBLEDAY & COMPANY, INC.—for Homer's *The Odyssey*, translated by Robert Fitzgerald, copyright © 1961 by Robert Fitzgerald; and for Rudyard Kipling's "Harp Song of the Dane Woman." Reprinted by permission of Doubleday & Company, Inc.

NORMAN HAPGOOD—for Elizabeth Hapgood's translation of Victor Hugo's *The Toilers of the Sea*.

HARPER & ROW, PUBLISHERS, INC.—for Robert Manry's *Tinkerbelle*, copyright © 1966 by Harper and Row, Inc.

GEORGE G. HARRAP & COMPANY LTD.—for Antrea Karkavitsas' *Sea* and Pierre Loti's *Iceland Fisherman*, both selected from H. M. Tomlinson's *Great Sea Stories From All Nations*.

HARVARD UNIVERSITY PRESS—for Francis P. Magoun Jr.'s translation of *The Old Kalevala*, reprinted by permission of the publishers from *The Old Kalevala and Certain Antecedents*, compiled by Elias Lonnrot, Francis P. Magoun Jr., translator, Cambridge, Mass: Harvard University Press, © 1969 by the President and Fellows of Harvard College.

HOLT, RINEHART AND WINSTON—for *The Outermost House* by Henry Beston. Copyright 1928, 1949, © 1956 by Henry Beston. Reprinted by permission of Holt, Rinehart and Winston, Publishers.

MRS. CHARLES W. KENNEDY—for Charles W. Kennedy's "The Seafarer."

LITTLE, BROWN AND COMPANY—for Henryk Sienkiewicz's *The Lighthouse Keeper of Aspinwall*, translated by Jeremiah Curtin.

MACMILLAN PUBLISHING CO., INC.—for Marianne Moore's "A Grave" from *Collected Poems* by Marianne Moore, copyright 1935 by Marianne Moore, renewed 1936 by Marianne Moore and T. S. Eliot. Reprinted by permission of Macmillan Publishing Co., Inc.

McCLELLAND AND STEWART—for "The Old Figurehead Carver" by H. A. Cody, reprinted by permission of the Canadian publishers, McClelland and Stewart Ltd., Toronto.

NEW DIRECTIONS PUBLISHING CORPORATION—for Henry Miller's "Big Sur and the Oranges of Hieronymus Bosch. Copyright © 1957 by New Directions Publishing Corporation. Reprinted by permission of New Directions Publishing Corporation.

THE NEW YORK TIMES—for Marguerite Janurin Adams' "They Who Possess The Sea," copyright © 1943 by The New York Times Company. Reprinted by permission of The New York Times.

A D PETERS & CO.—for Hilaire Belloc's *The Silence of the Sea*, reprinted by permission of A D Peters Co. Ltd.

RAND McNALLY & COMPANY—for Thor Heyerdahl's *Kon-Tiki*. Copyright © 1950 by Thor Heyerdahl. Published in the United States by Rand McNally & Co.

RANDOM HOUSE, INC.—for Anne Morrow Lindbergh's *Gift from the Sea*. Copyright © 1955 by Anne Morrow Lindbergh. Reprinted by permission of Pantheon Books, a Division of Random House, Inc.

MRS. MARTHA RUTAN—for David Morton's "Old Ships."

CHARLES SCRIBNER'S SONS—for Ernest Hemingway's *The Old Man and the Sea*, reprinted by permission of Charles Scribner's Sons from *The Old Man and the Sea* by Ernest Hemingway. Copyright © 1952 by Ernest Hemingway.

THE VIKING PRESS, INC.—for D. H. Lawrence's "Whales Weep Not," from *The Complete Poems of D. H. Lawrence*, edited by Vivian de Sola Pinto & F. Warren Roberts, Copyright © 1964, 1971 by Angelo Ravagli & C. M. Weekley, Executors of the Estate of Freida Lawrence Ravagli. All rights reserved. Reprinted by permission of The Viking Press.

YALE UNIVERSITY PRESS—for Eugene O'Neill's *Long Day's Journey into Night*.

All photographs in this volume by Gene Anthony except for the following:

Kosti Ruohomaa pp. 176, 177, 178, 179

Flip Schulke pp. 28-29, 30-31

Stern Magazine pp. 168-169

To Mother and Dad
H. C.

To Anna, Joshua, Maggy and Jill
G. A.

To Robert Nemser, whose editorial and graphic contributions
were more than those of the traditional designer.

To Andrew J. Levin, whose knowledge of sea literature was
invaluable in the selection of the sea passages.

To Nelsena Burt, whose delicate hands have touched every photostat
and positioned every text segment in this volume.

To G and W Photo Service and Lorenzo Alexander, whose prints were
faithful to the beauty and mood of the original negatives.

Howard Chapnick

Many people have contributed to the making of my photographs
used in *The Illustrated Eternal Sea.* My thanks to
Admiral P. Allen of the Chilean Navy; the crew of the "Lientur;"
Able Seaman Gene Segretti of the Seamans Union of the Pacific;
fish restaurateur Lou Sabella; Chief Conlon and his crew at the
San Francisco Coast Guard Headquarters; the San Francisco
Bar Pilots Association; Paul Glenovich and his crew aboard the
"Yankee Boy;" Tom Martin and his son, Rob; Captain Bruce Martins
of Sausalito; Bill and Ellis; Victor di Suvero; and many others.

Gene Anthony

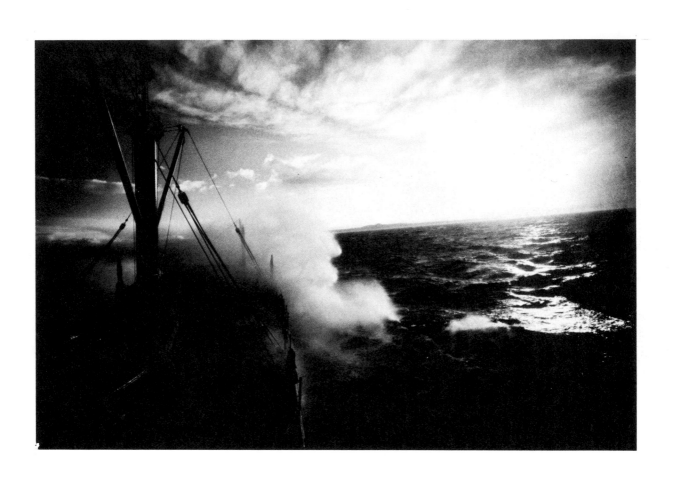

"For all at last returns to the sea—the beginning and the end."
—*Rachel Louise Carson*

The saga of the restless changing sea is a rich treasure of man's heritage. The sea is alternately turbulent and tranquil, cruel and gentle. It exposes weakness and cowardice and magnifies strength and bravery to heroic proportions. It challenges a Cousteau to explore the secrets of the deep, a Heyerdahl to clarify the mysteries that surround man's early migrations and a Chichester to embark on a lonely transatlantic conquest. It is the ultimate romantic dream, the infinite freedom.

The classic giants of sea literature, Coleridge and Conrad, Melville and Masefield, have sketched a canvas of literary passages which urge visual translation. Other writers from Homer to Henry Miller and Eugene O'Neill have created treasures which add to the repository of sea literature.

The importance of the sea does not reside alone in its value to our spiritual senses and its surcease from daily travail. In this International Hydroponic Decade (1970-1980) the nations of the world are challenging concepts of the sea as untouchable, uncontrollable and unharnessable. Contemporary literature has begun to deal with the psychological, social, ecological and environmental impact of these challenges.

Gene Anthony is a man of the sea. His journey to Cape Horn, his immersion, figuratively and literally, in the literature and life of the sea prepared him for the task of expressing visually his deep emotional involvement with the sea. His photographs can stand alone as true art. Together with the words that have survived the centuries, they make a seascape of infinite beauty.

Howard Chapnick

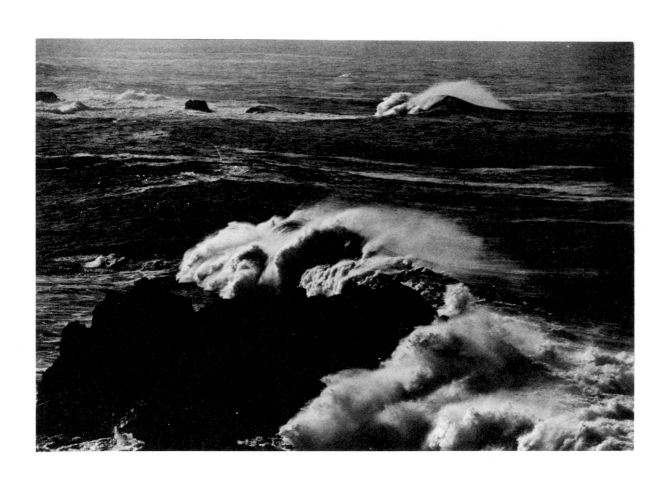

As the photography for *The Illustrated Eternal Sea* neared completion, Howard Chapnick advised me of the need for a photograph or photographs to illustrate a passage from Richard Henry Dana's *Two Years Before the Mast* on death at sea. The request came at an ironic moment. My brother, David, had just been reported missing, lost in a small boat off the coast of California. No trace of the boat had been found despite an intensive four-day Coast Guard search. My brother was not a seaman. For some reason he challenged the ocean in a small, badly equipped boat and was lost. Perhaps his death underscores the ignorance of man about the sea, romanticizing it but underestimating its mysteries and cruelties.

Gene Anthony

CONTENTS

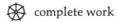 complete work

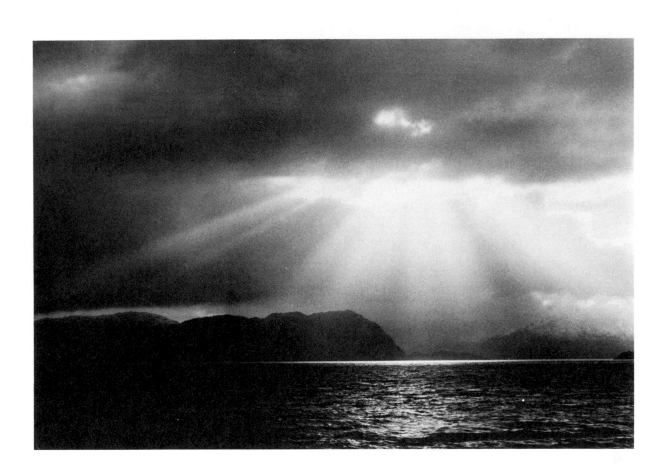

Wherein differ the sea and the land, that a miracle upon one is not a miracle upon the other? Preternatural terrors rested upon the Hebrews, when under the feet of Korah and his company the live ground opened and swallowed them up for ever; yet not a modern sun ever sets, but in precisely the same manner the live sea swallows up ships and crews.

But not only is the sea such a foe to man who is an alien to it, but it is also a fiend to its own offspring; worse than the Persian host who murdered his own guests; sparing not the creatures which itself hath spawned. Like a savage tigress that tossing in the jungle overlays her own cubs, so the sea dashes even the mightiest whales against the rocks, and leaves them there side by side with the split wrecks of ships. No mercy, no power but its own controls it. Panting and snorting like a mad battle steed that has lost its rider, the masterless ocean overruns the globe.

Consider the subtleness of the sea; how its most dreaded creatures glide under water, unapparent for the most part, and treacherously hidden beneath the loveliest tints of azure. Consider also the devilish brilliance and beauty of many of its most remorseless tribes, as the dainty embellished shape of many species of shark. Consider, once more, the universal cannibalism of the sea; all whose creatures prey upon each other, carrying on eternal war since the world began.

Consider all this; and then turn to this green, gentle, and most docile earth; consider them both, the sea and the land; and do you not find a strange analogy to something in yourself? For as this appalling ocean surrounds the verdant land, so in the soul of man there lies one insular Tahiti, full of peace and joy, but encompassed by all the horrors of the half known life. God keep thee! Push not off from that isle, thou canst never return!

—*Herman Melville*

In other, olden times there were only phantoms. In the beginning, that is. If there ever was a beginning.

It was always a wild, rocky coast, desolate and forbidding to the man of the pavements, eloquent and enchanting to the Taliessins. The homesteader never failed to unearth fresh sorrows.

There were always birds: the pirates and scavengers of the blue as well as the migratory variety. (At intervals the condor passed, huge as an ocean liner.) Gay in plumage, their beaks were hard and cruel. They strung out across the horizon like arrows tied to an invisible string. In close they seemed content to dart, dip, swoop, careen. Some followed the cliffs and breakers, others sought the canyons, the gold-crested hills, the marble-topped peaks.

There were also the creeping, crawling creatures, some sluggish as the sloth, others full of venom, but all absurdly handsome. Men feared them more than the invisible ones who chattered like monkeys at fall of night.

To advance, whether on foot or on horseback, was to tangle with spikes, thorns, creepers, with all that pricks, clings, stabs and poisons.

Who lived here first? Troglodytes perhaps. The Indian came late. Very late.

Though young, geologically speaking, the land has a hoary look. From the ocean depths there issued strange formations, contours unique and seductive. As if the Titans of the deep had labored for aeons to shape and mold the earth. Even millennia ago the great land birds were startled by the abrupt aspect of these risen shapes.

—Henry Miller

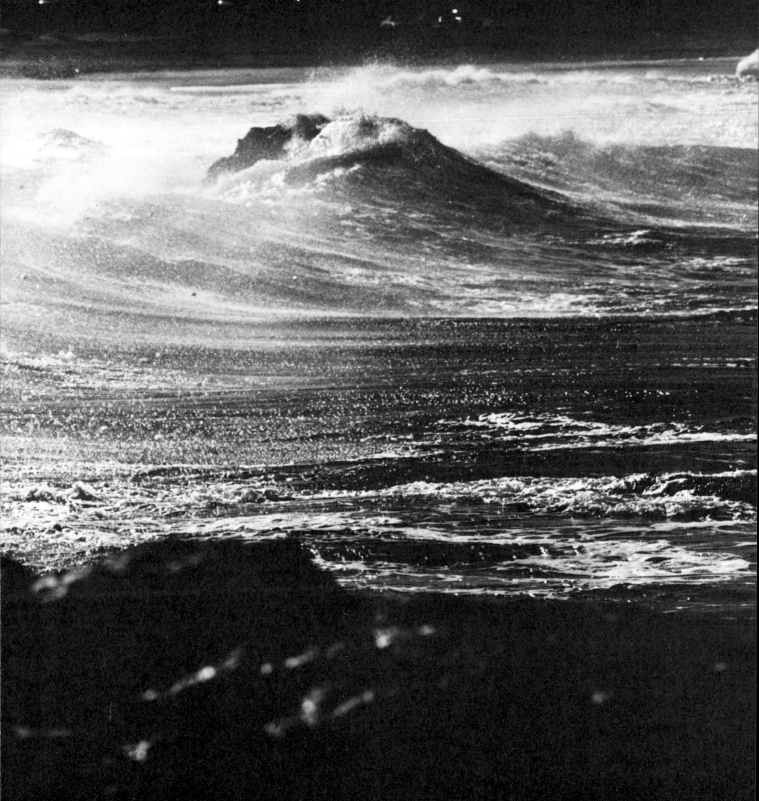

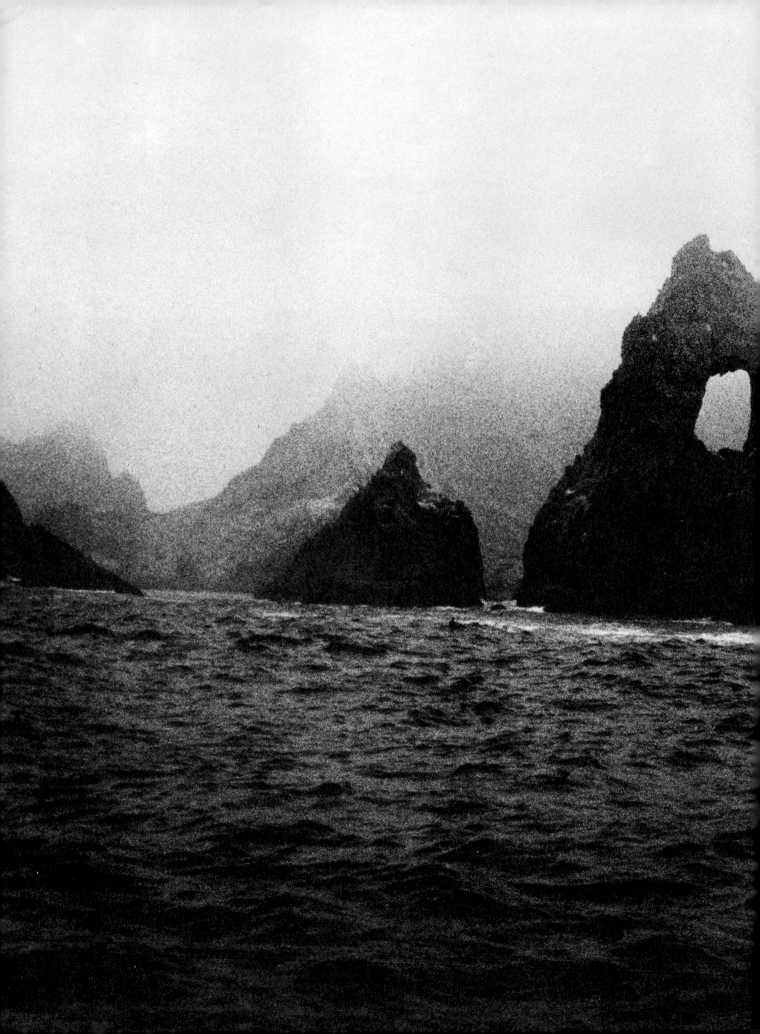

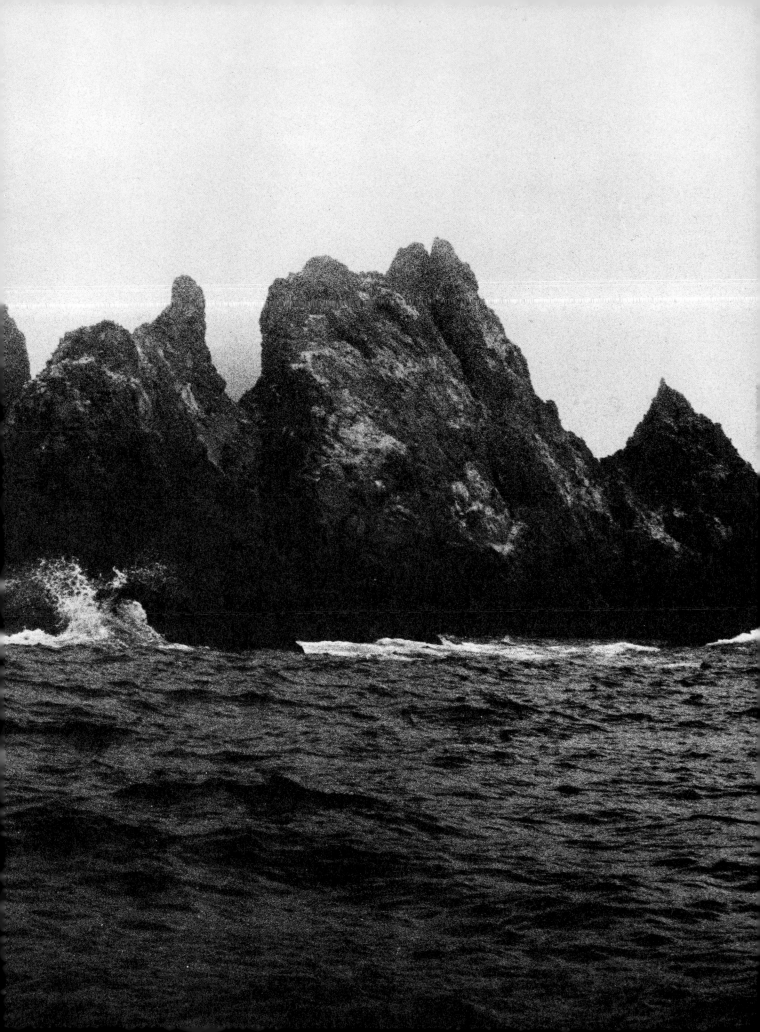

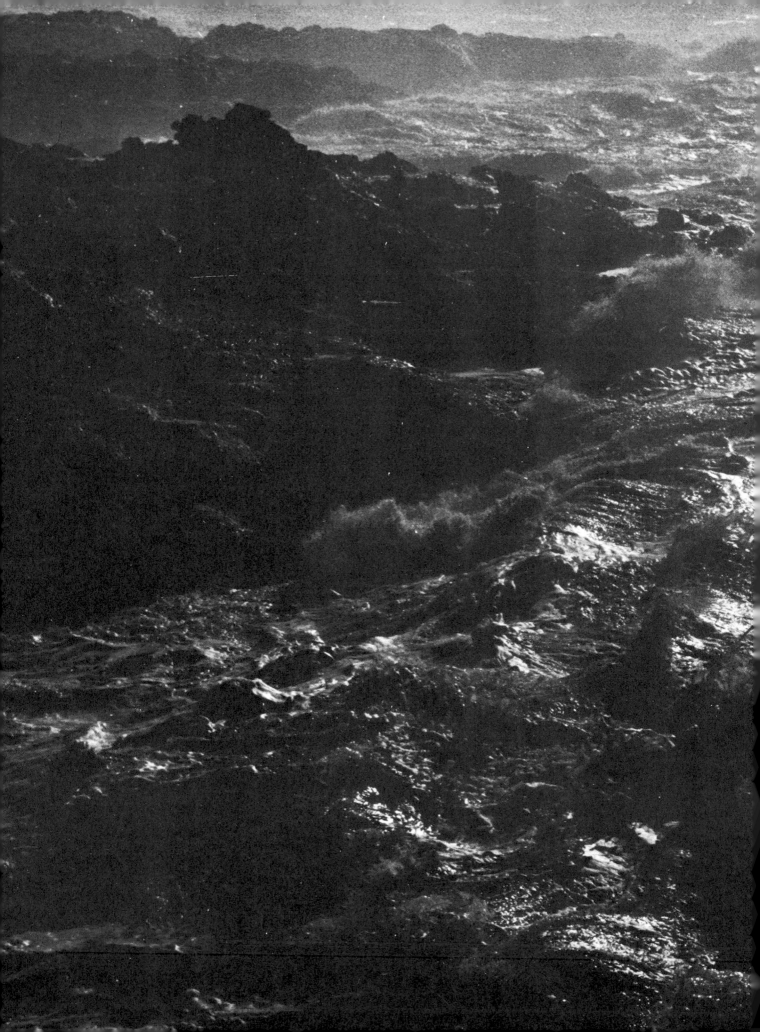

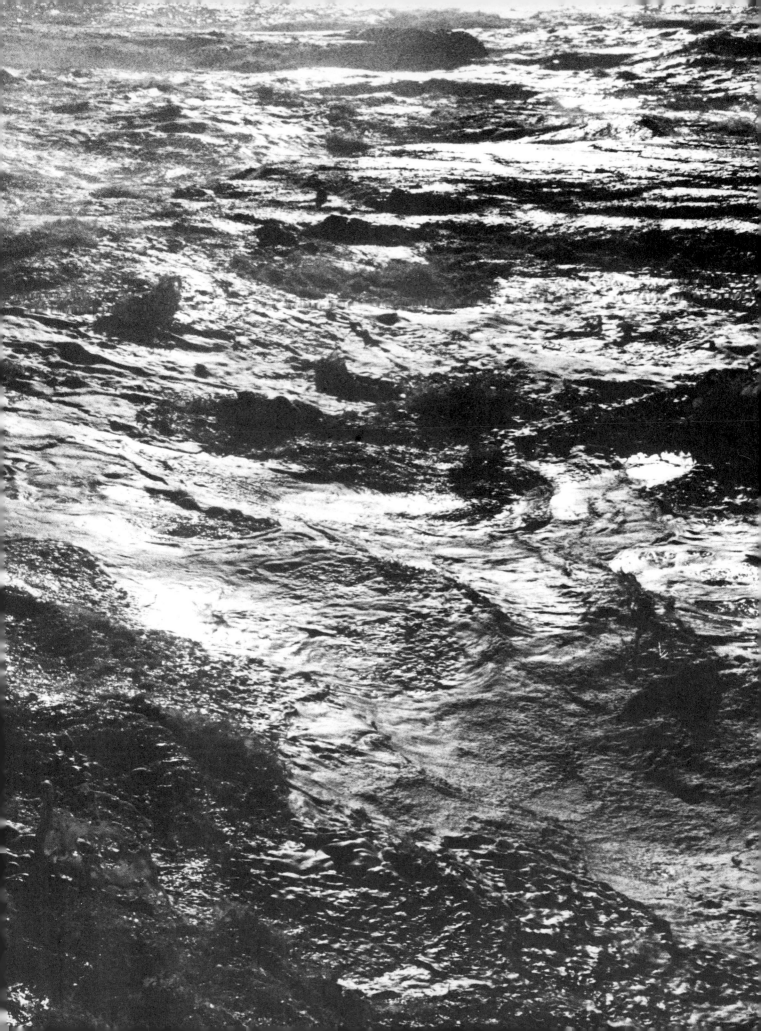

Steadfast old Väinämöinen then went on
 and on for six years,
drifted for seven summers, splashed along
 for eight years
on the clear surface of the sea, on the open
 expanse of the deep,
before him the flowing water, behind him
 the blue heavens.
Then the man looks at the sea, makes an
 estimate of the billows;
where he lifted up his head, there he
 magically evoked islands;
where he swings his hand, there he
 arranged a headland;
where his foot touched, there he hollowed
 out deep spots for fish;
where land faces land, there he magically
 created seining places;
where he stopped on the surface, there he
 creates skerries,
produced reefs on which ships are sunk,
 merchants lose their lives.

An eagle came from the land of Finnmark,
a bird from Lapland settled down; it flies
 about, it moves about,
it flew east, flew west, it flew finally to the
 southwest,
approaching the north, seeking a place for
 its nest,
appraising land to settle on. Then old
 Väinämöinen
raised his knee out of the sea in the form of
 a grassy hummock,
in the form of last year's turf. The eagle
 from Finnmark

then got a place for its nest; it discovered
 the hummock in the sea,
a blue spot on the billows; it flies about,
 moves about,
settles down on top of the knee. It rustles
 out a nest in the grass,
scratches one out of the withered grass.
 Thus it laid six eggs,
six golden eggs, a seventh of iron.
It rustles around, it broods, warms the top
 of the knee.
Then old Väinämöinen felt his knee burning
his limb heating up. Suddenly he twitched
 his knees,
made his limbs tremble; the eggs rolled into
 the water,
cracked to pieces on the reefs of the sea; the
 eggs broke to bits,
the eagle rose up in the air.

Then old Väinämöinen
spoke these words: "Let the lower half of
 the egg
be Mother Earth beneath! Let the upper
 half of the egg
be the heavens above; Whatever in the egg
 is white
let that shine as the sun, whatever in the egg
 may be yellow
let that gleam palely as the moon! Let the
 other fragments of the egg
be the stars in the sky!"

—Author Unknown

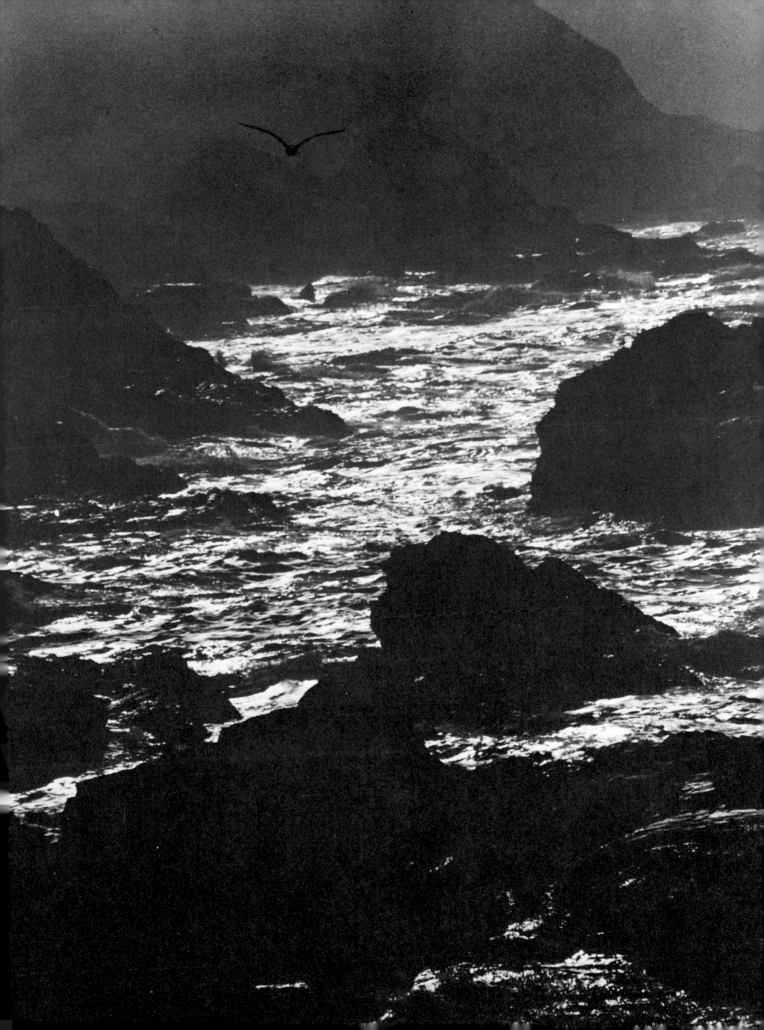

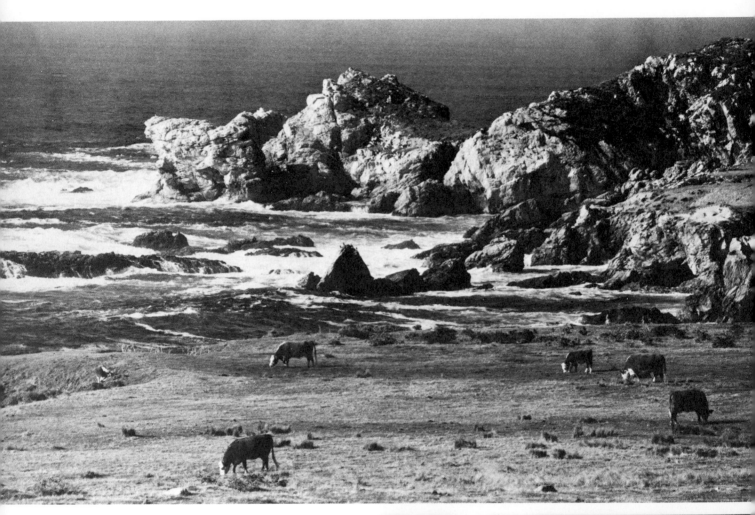

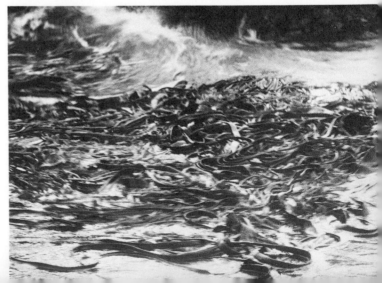

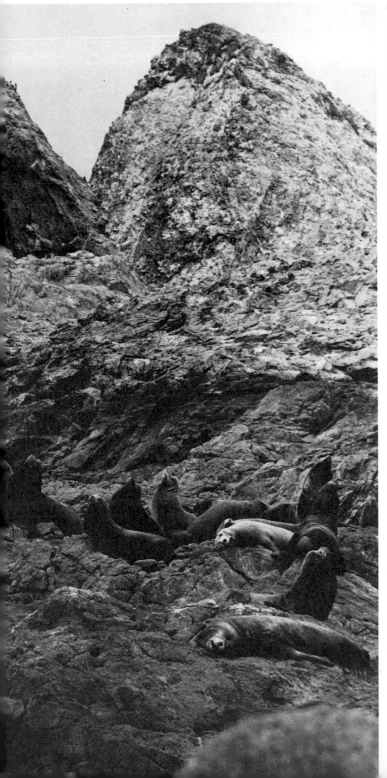

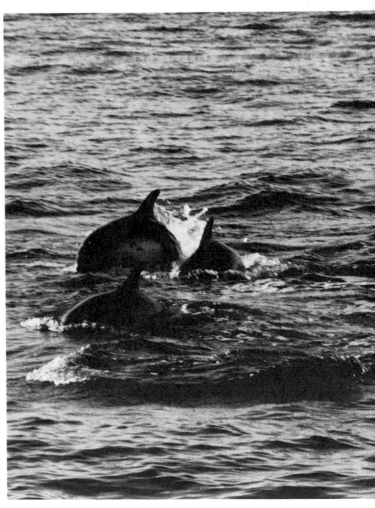

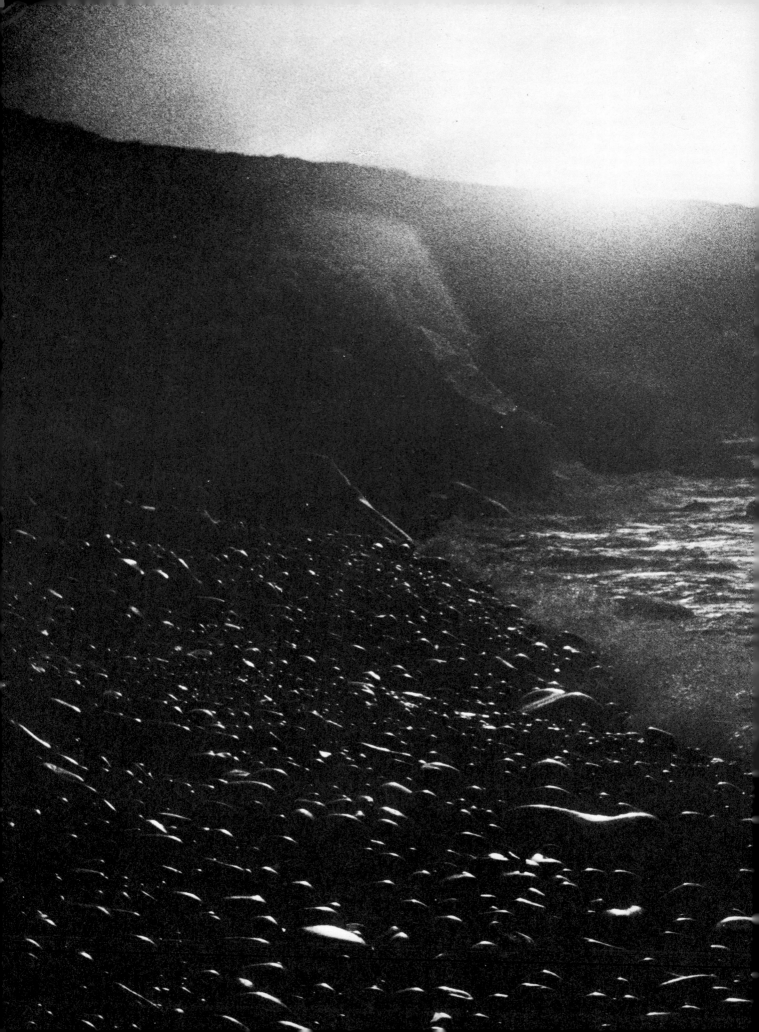

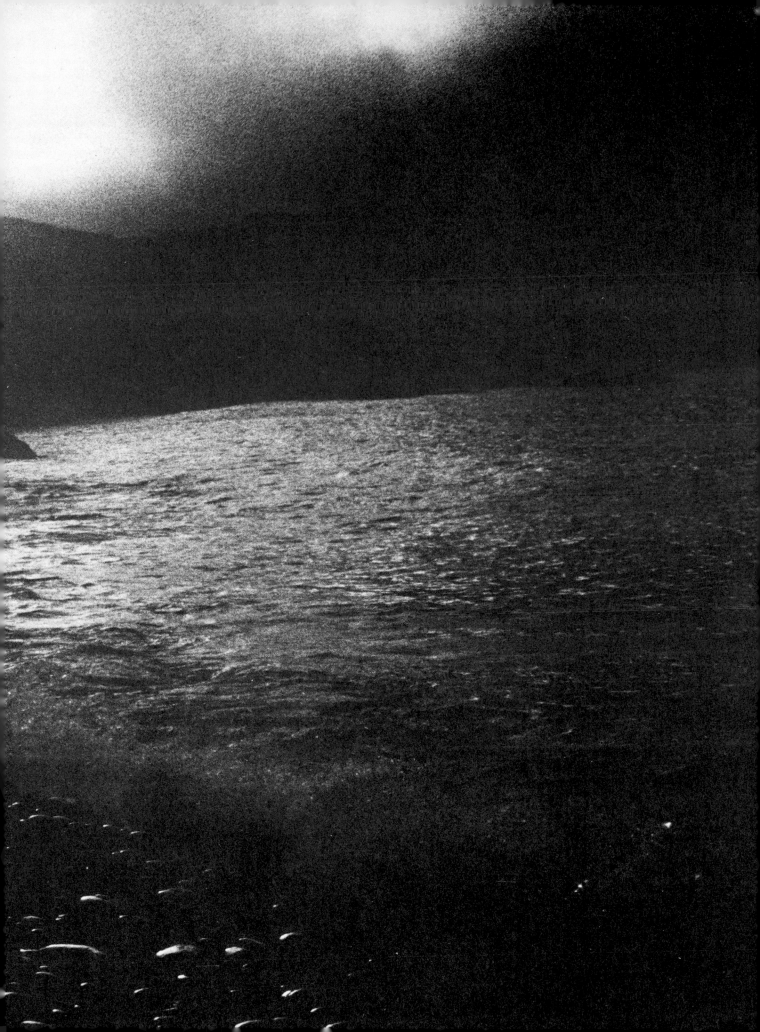

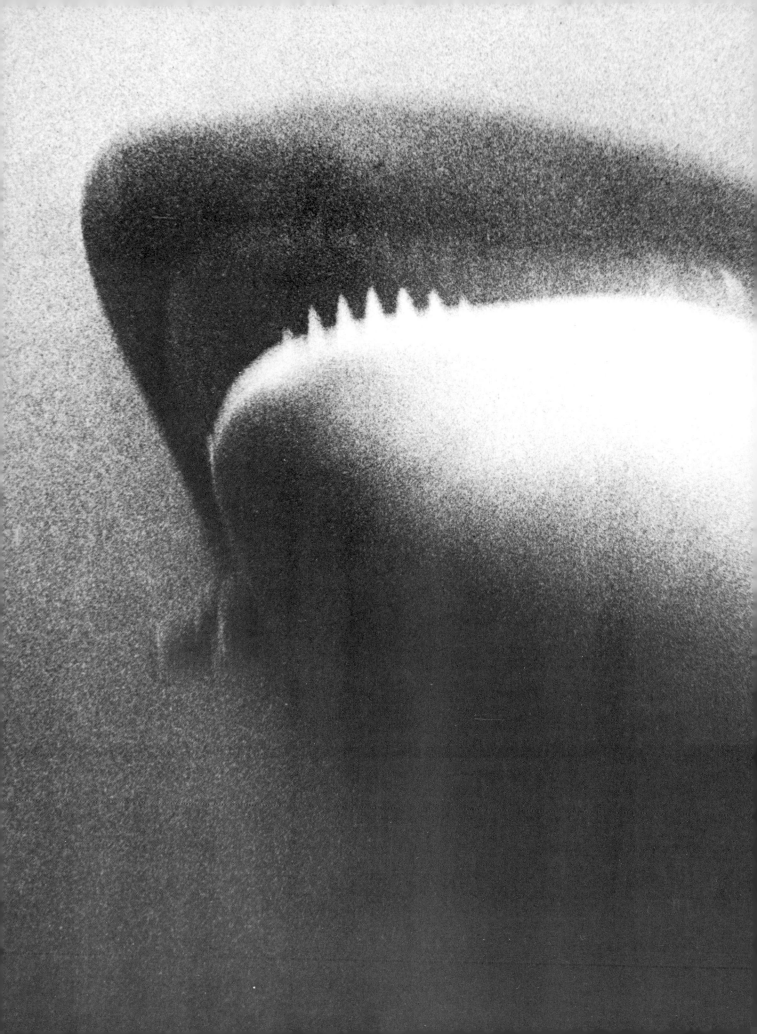

And God created the great whales, and each
Soul living, each that crept, which
 plenteously
The waters generated by their kinds,
And every bird of wing after his kind;
And saw that it was good, and bless'd them,
 saying,
Be fruitful, multiply, and in the seas,
And lakes, and running streams, the waters
 fill;
And let the fowl be multiply'd on the earth.
Forthwith the sounds and seas, each creek
 and bay,
With fry innumerable swarm, and shoals
Of fish, that with their fins and shining
 scales
Glide under the green wave, in sculls that oft
Bank the mid sea: part single, or with mate,
Graze the sea weed their pasture, and
 through groves
Of coral stray, or sporting with quick glance
Show to the sun their wav'd coats dropt
 with gold;
Or in their pearly shells at ease attend
Moist nutriment, or under rocks their food
In jointed armor watch: on smooth the seal
And bended dolphins play; part huge of
 bulk,
Wallowing unwieldy, enormous in their gait,
Tempest the ocean; there Leviathan,
Hugest of living creatures, on the deep
Stretch'd like a promontory sleeps, or swims
And seems a moving land, and at his gills
Draws in, and at his trunk spouts out a sea.

—*John Milton*

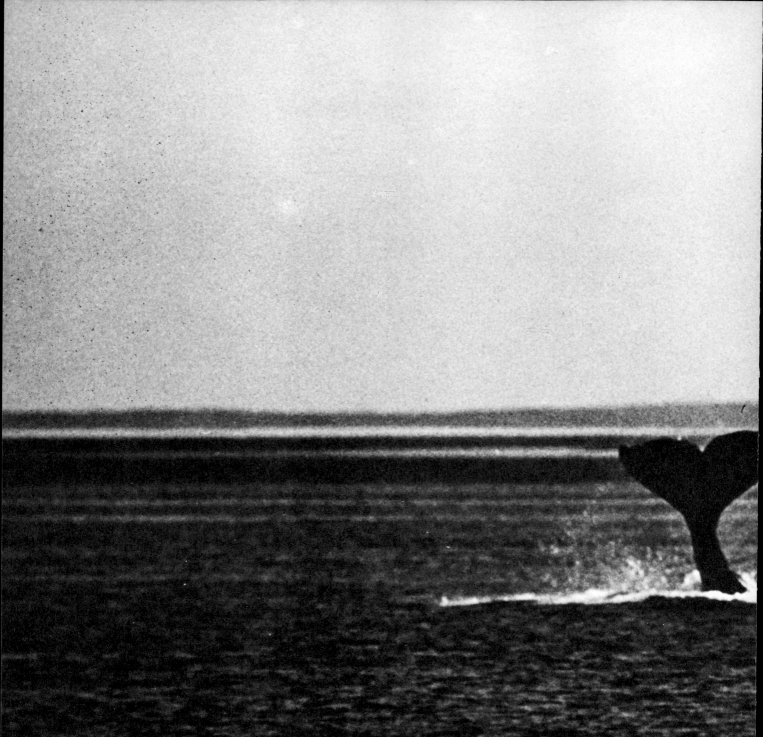

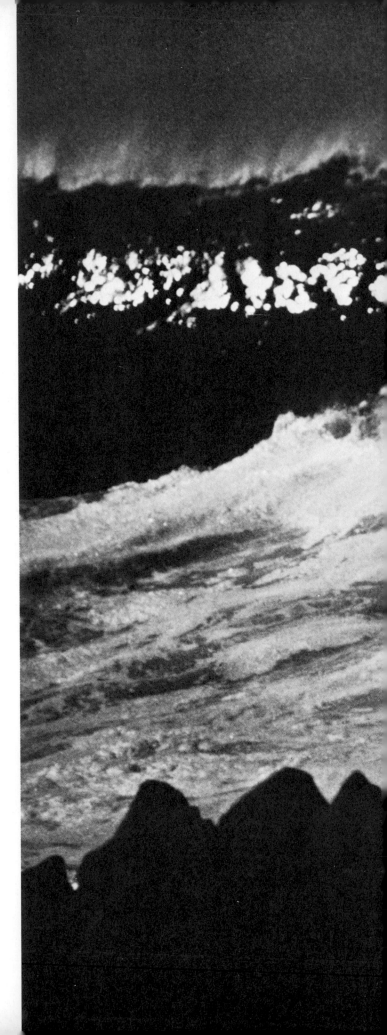

Their first sunrise in this unfamiliar element
was a hopeful one. It was a morning of high-
lights and lively patterns. Water burst
from the bows of the dancing boats and
fanned away in complicated designs of
bright lace-work. The pale gold sun climbed
the sky behind a grille of dark cloud-bands.
The steady north-east trade was sweeping
the sea into long, low ridges which
undulated gently athwart the wind; and the
little waves were bright as molten lead along
their crests. But an even greater brightness
lay upon the horizon, vertically under the
sun: there the sea was a great blinding
splash of platinum.

—*James Harper*

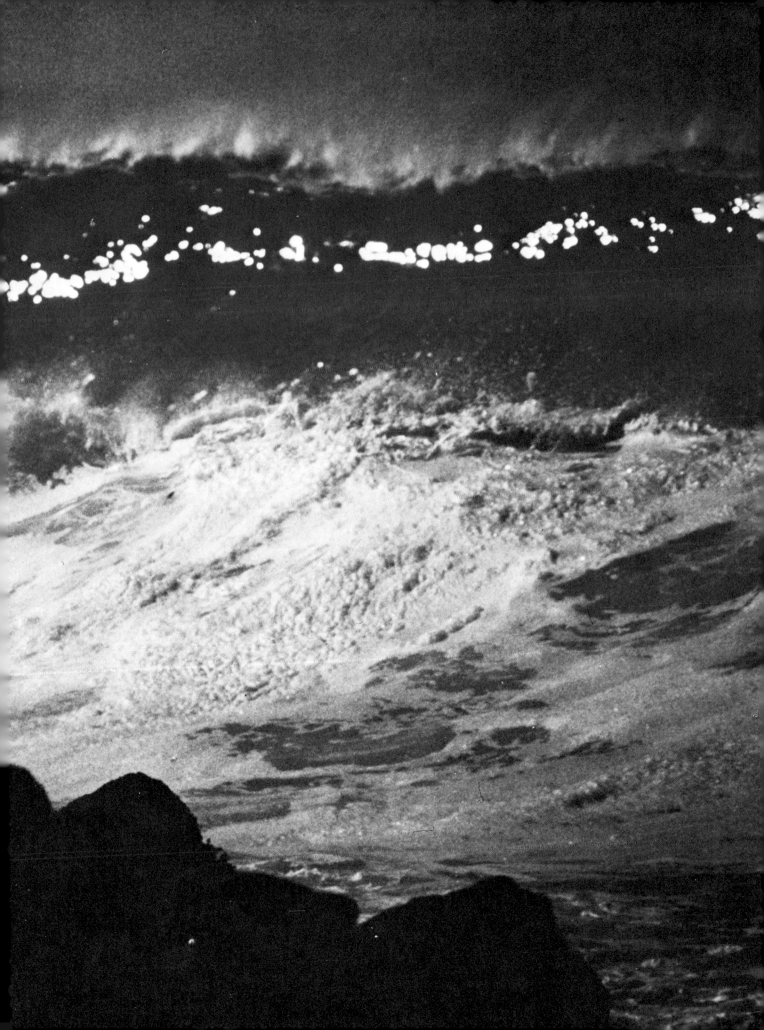

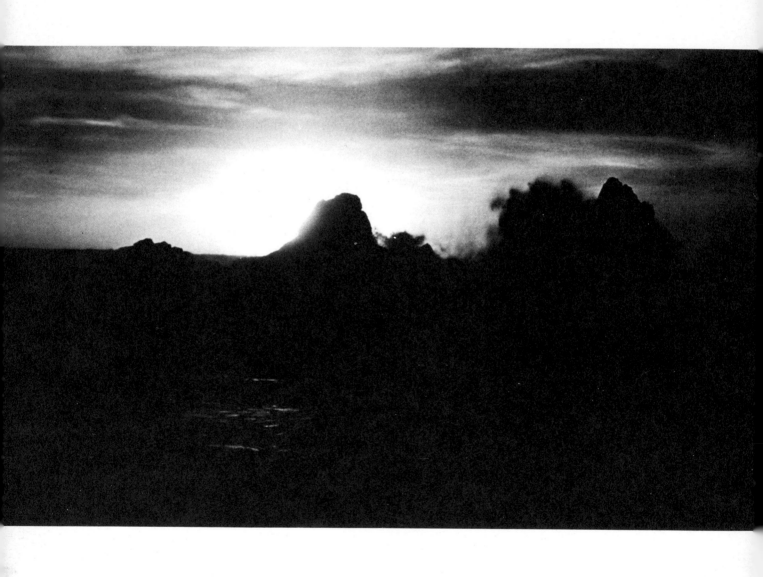

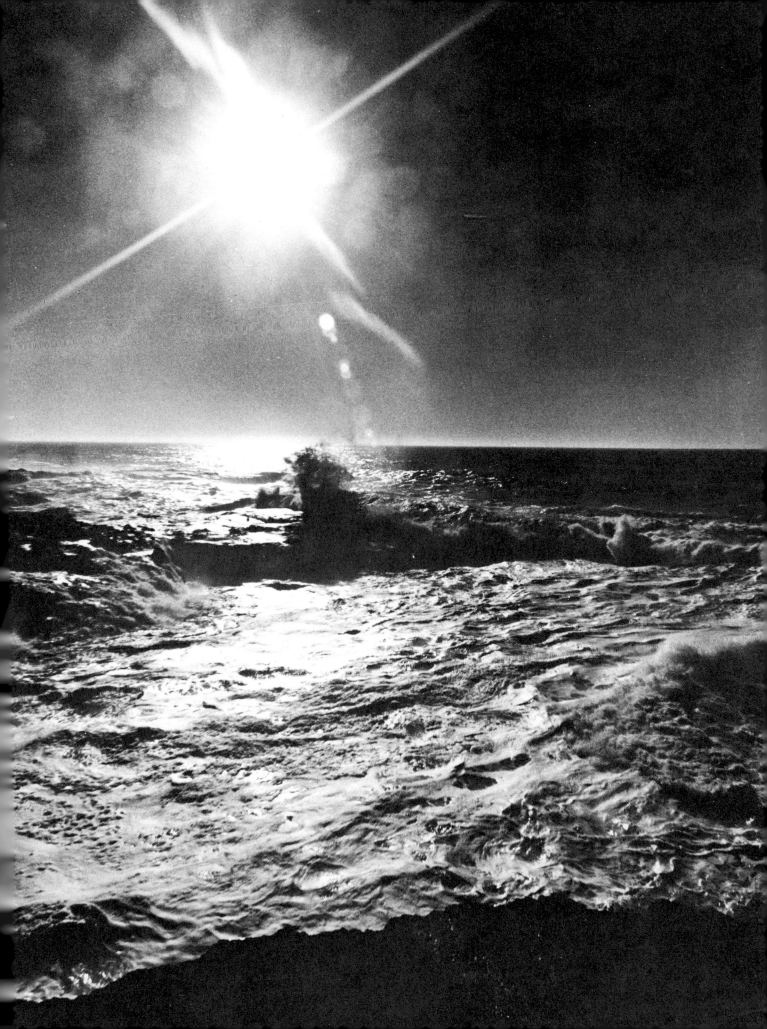

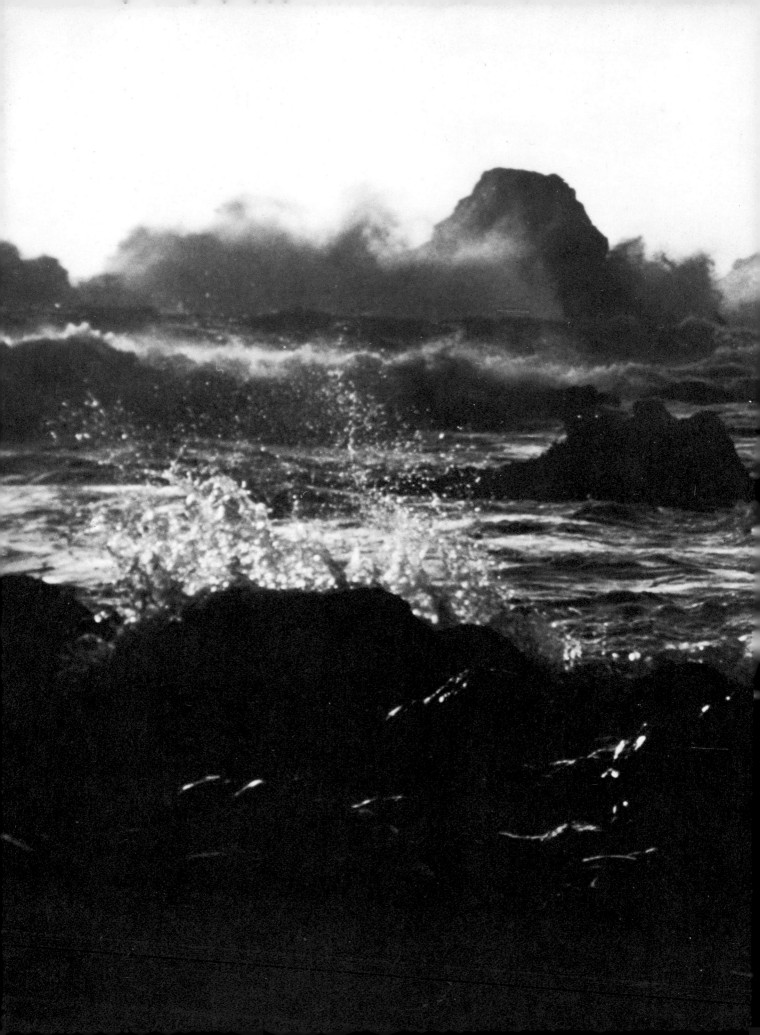

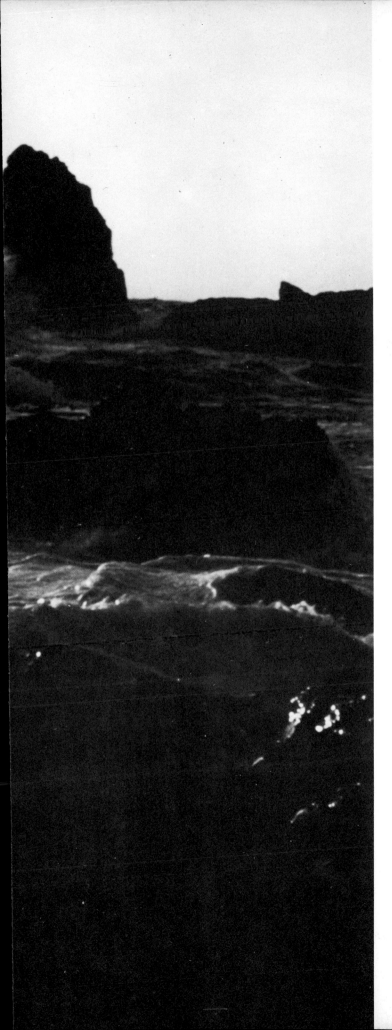

Whoever follows this coast passes through
a series of mirages. At every turn the rock
tries to deceive you. Where do these illusions
originate? In the granite. Nothing stranger.
Enormous stone toads dwell there, come out
of the water, no doubt, to breathe; giant
nuns hurry to and fro, leaning over the
horizon; the petrified folds of their veils
have the form of the waving wind; kings
with Plutonic crowns meditate on large
thrones, which have not been spared by the
breakers; some creatures buried in the rocks
extend their arms aloft, the fingers of the
open hands visible. All this is the shapeless
shore. Approach. There is nothing more.
The stone is worn away. Here is a fortress, a
defaced temple, a chaos of ruins and demol-
ished walls, all the ruins of a deserted city.
Neither city, nor temple, nor fortress exists;
it is only the sea-cliff.

 —Victor Hugo

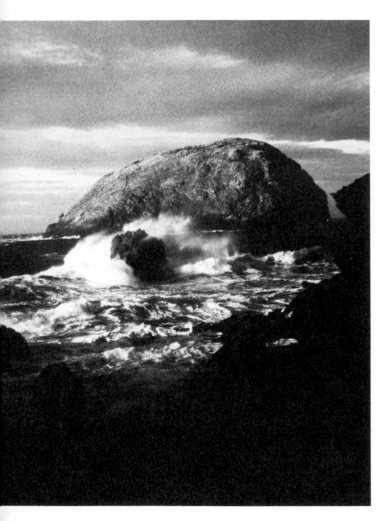

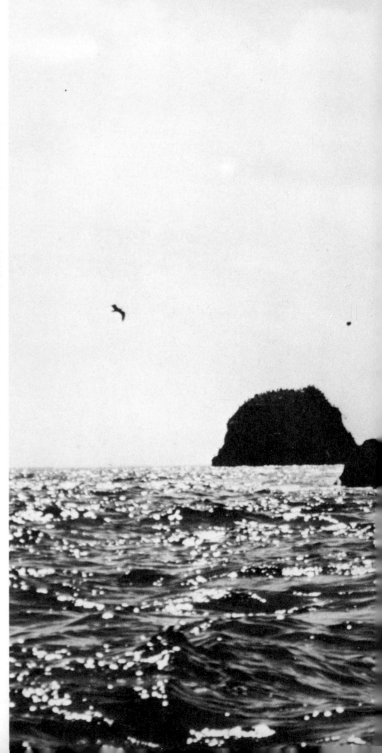

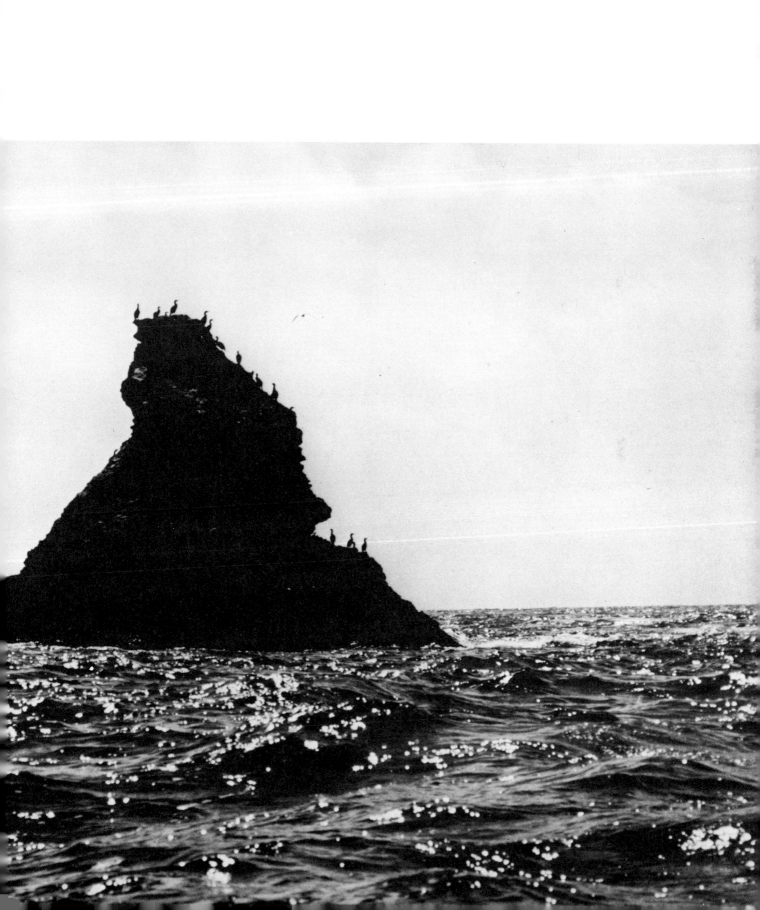

The beach is not the place to work; to read, write or think. I should have remembered that from other years. Too warm, too damp, too soft for any real mental discipline or sharp flights of spirit. One never learns. Hopefully, one carries down the faded straw bag, lumpy with books, clean paper, long over-due unanswered letters, freshly sharpened pencils, lists, and good intentions. The books remain unread, the pencils break their points, and the pads rest smooth and unblemished as the cloudless sky. No reading, no writing, no thoughts even—at least, not at first.

At first, the tired body takes over completely. As on shipboard, one descends into a deck-chair apathy. One is forced against one's mind, against all tidy resolutions, back into the primeval rhythms of the seashore. Rollers on the beach, wind in the pines, the slow flapping of herons across sand dunes, drown out the hectic rhythms of city and suburb, time tables and schedules. One falls under their spell, relaxes, stretches out prone. One becomes, in fact, like the element on which one lies, flattened by the sea; bare, open, empty as the beach, erased by today's tides of all yesterday's scribblings.

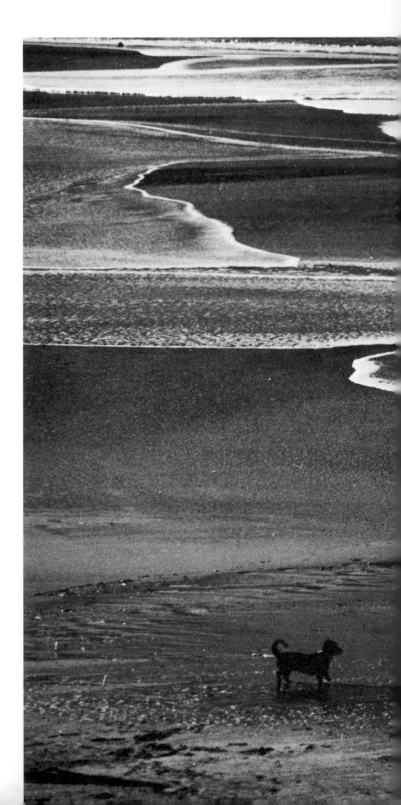

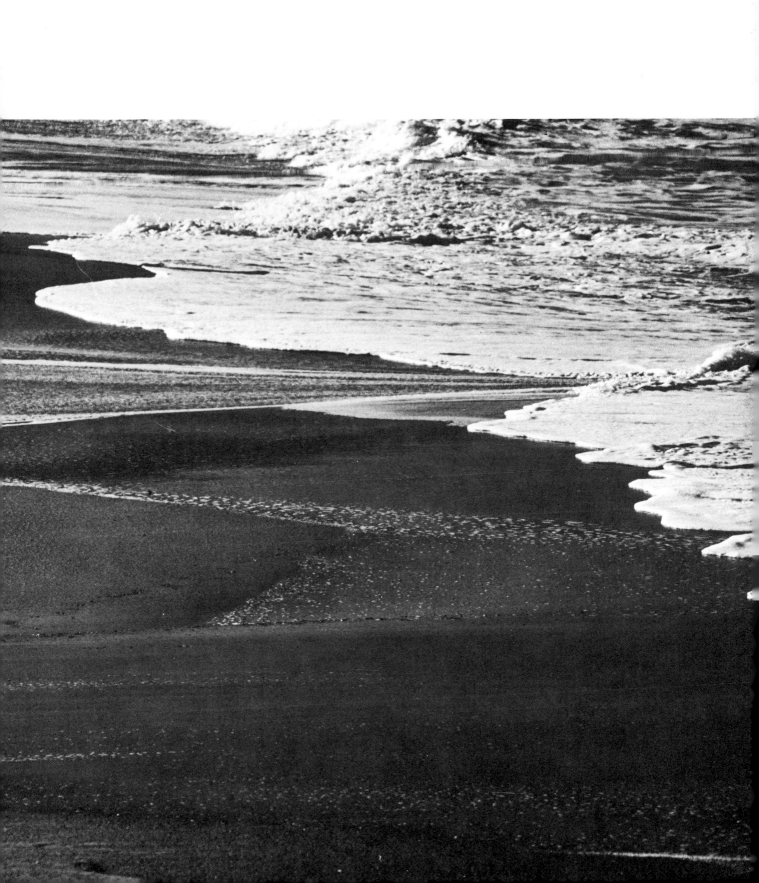

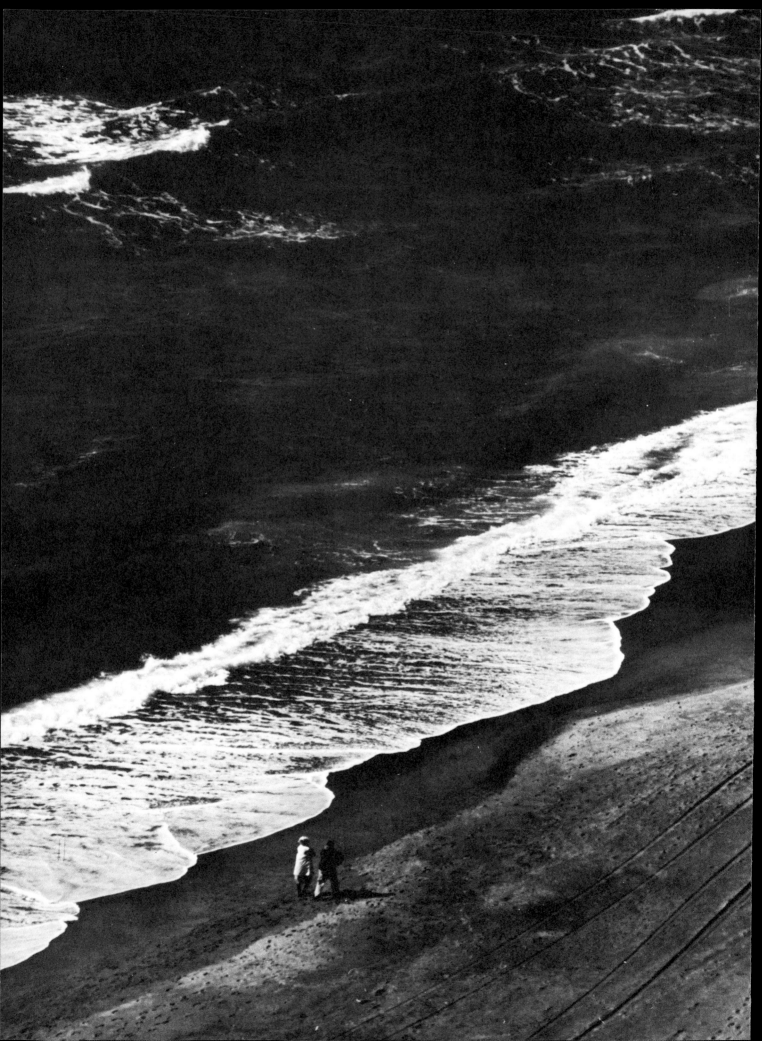

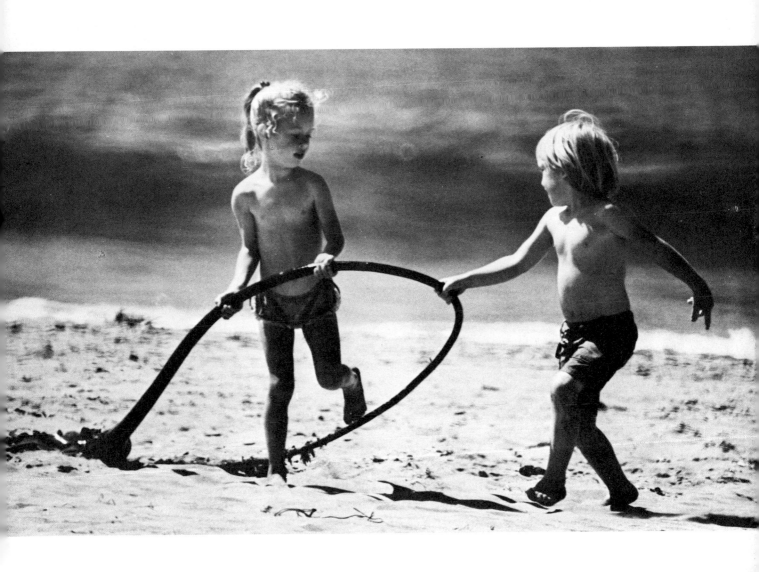

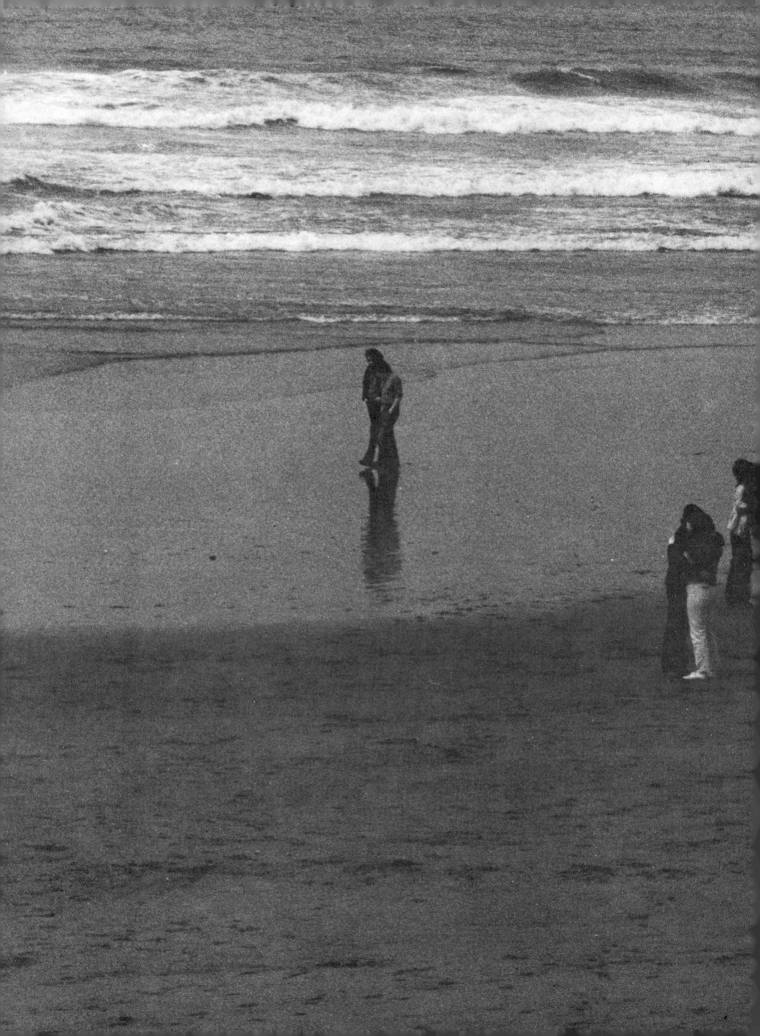

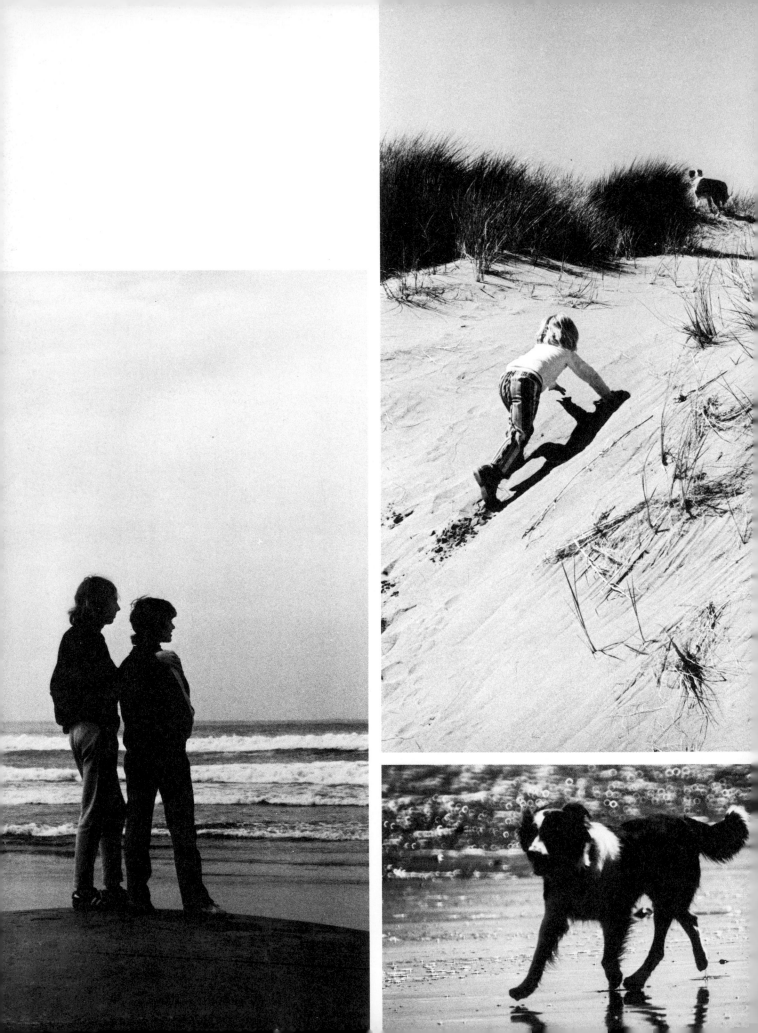

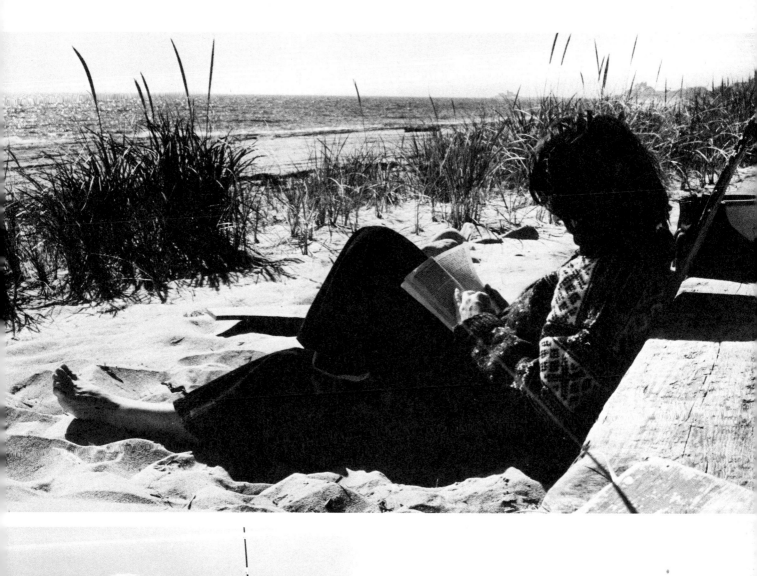

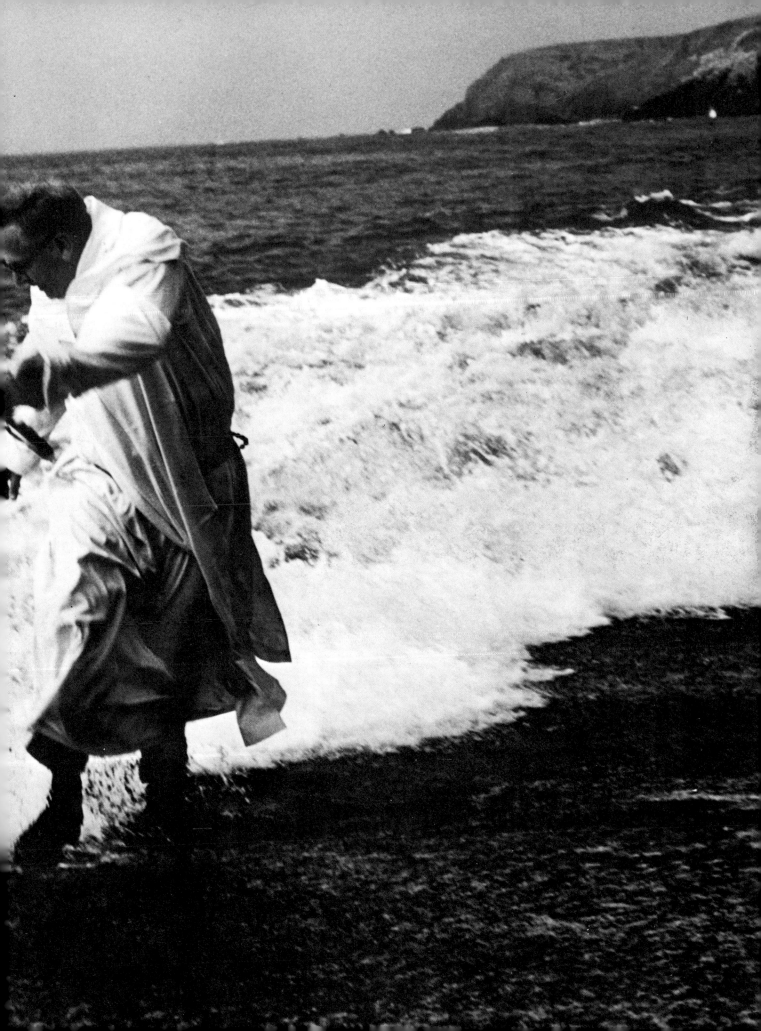

And then, some morning in the second week, the mind wakes, comes to life again. Not in a city sense—no—but beach-wise. It begins to drift, to play, to turn over in gentle careless rolls like those lazy waves on the beach. One never knows what chance treasures these easy unconscious rollers may toss up, on the smooth white sand of the conscious mind; what perfectly rounded stone, what rare shell from the ocean floor. Perhaps a channelled whelk, a moon shell, or even an argonaut.

But it must not be sought for or—heaven forbid!—dug for. No, no dredging of the sea-bottom here. That would defeat one's purpose. The sea does not reward those who are too anxious, too greedy, or too impatient. To dig for treasures shows not only impatience and greed, but lack of faith. Patience, patience, patience, is what the sea teaches. Patience and faith. One should lie empty, open, choiceless as a beach—waiting for a gift from the sea.

—*Anne Morrow Lindbergh*

On that particular evening we sat, as so often before, down on the beach in the moonlight, with the sea in front of us. Wide awake and filled with the romance that surrounded us, we let no impression escape us. We filled our nostrils with an aroma of rank jungle and salt sea and heard the wind's rustle in leaves and palm tops. At regular intervals all other noises were drowned by the great breakers that rolled straight in from the sea and rushed in foaming over the land till they were broken up into circles of froth among the shore boulders. There was a roaring and rustling and rumbling among millions of glistening stones, till all grew quiet again when the sea water had withdrawn to gather strength for a new attack on the invincible coast.

—*Thor Heyerdahl*

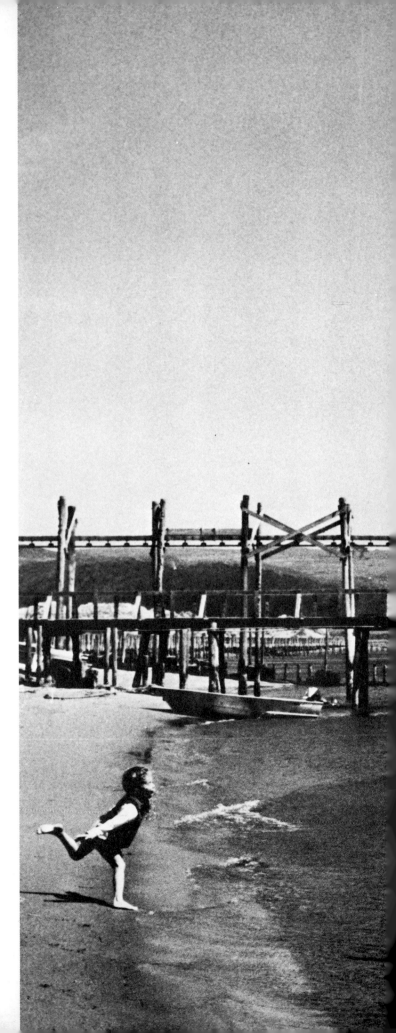

Above the fresh ruffles of the surf
Bright striped urchins flay each other with
 sand.
They have contrived a conquest for shell
 shucks,
And their fingers crumble fragments of
 baked weed
Gaily digging and scattering.

And in answer to their treble interjections
The sun beats lightning on the waves,
The waves fold thunder on the sand;
And could they hear me I would tell them:

O brilliant kids, frisk with your dog,
Fondle your shells and sticks, bleached
By time and the elements; but there is a line
You must not cross nor ever trust beyond it
Spry cordage of your bodies to caresses
Too lichen-faithful from too wide a breast.
The bottom of the sea is cruel.

—*Hart Crane*

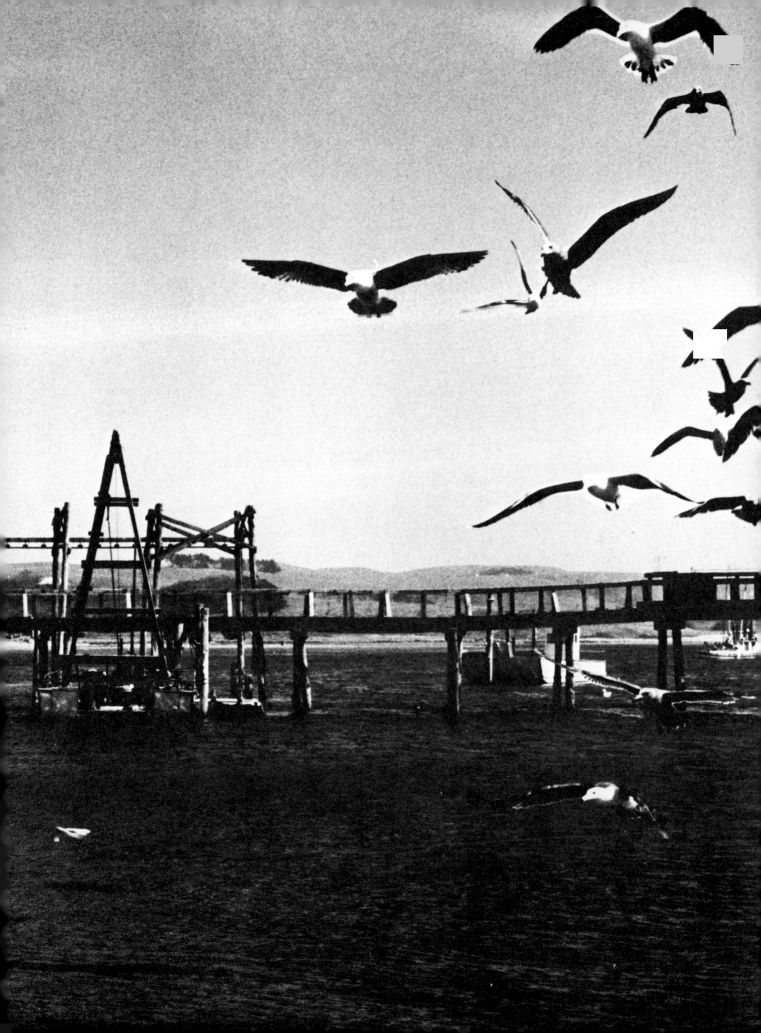

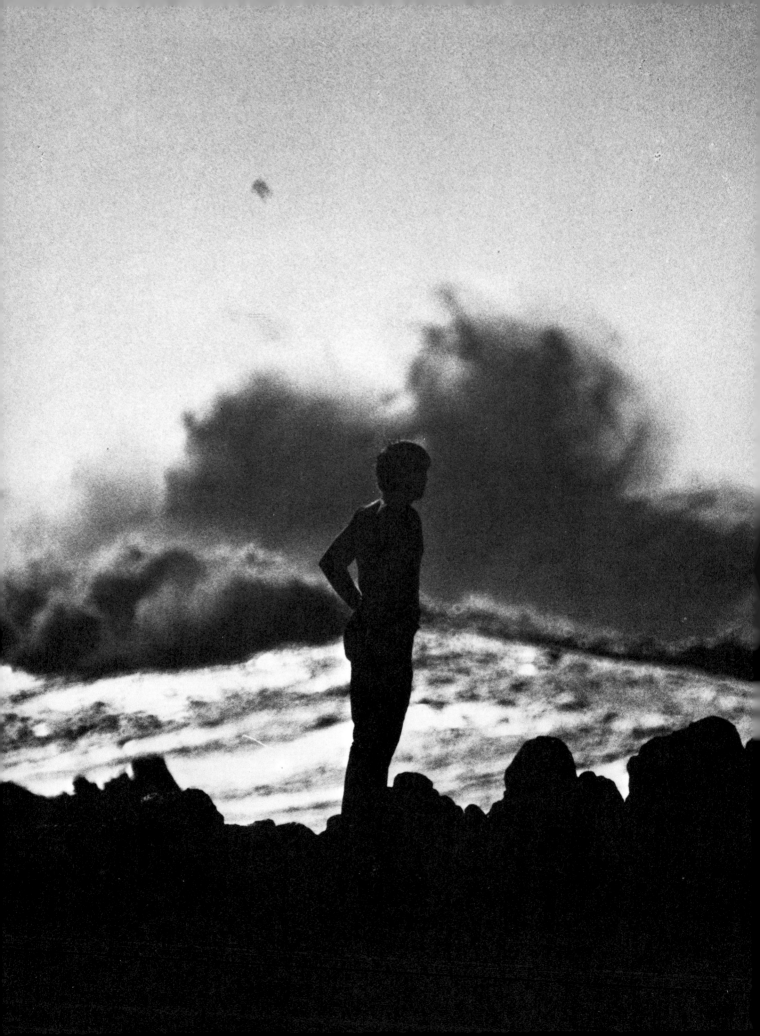

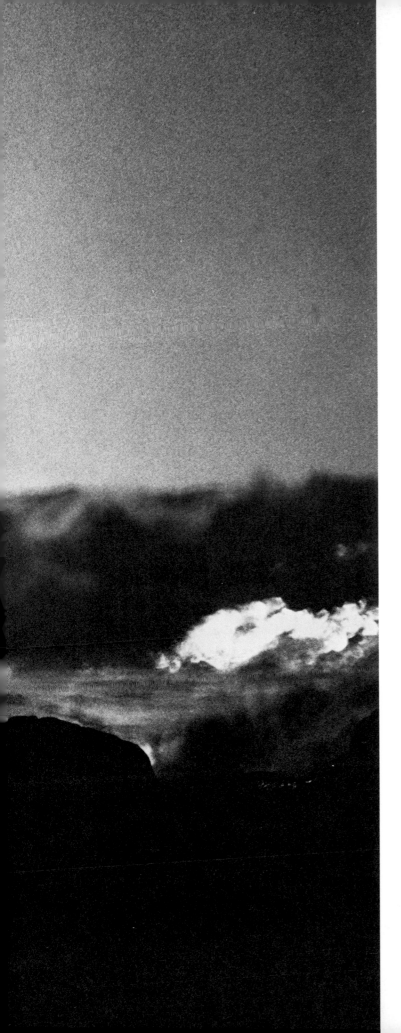

Man looking into the sea,
taking the view from those who have as
 much right to it as you have to it yourself,
It is human nature to stand in the middle of
 a thing,
but you cannot stand in the middle of this;
the sea has nothing to give but a well
 excavated grave.
The firs stand in a procession, each with an
 emerald turkey-foot at the top,
reserved as their contours, saying nothing;
repression, however, is not the most obvious
 characteristic of the sea;
the sea is a collector, quick to return a
 rapacious look.
There are others besides you who have worn
 that look
whose expression is no longer a protest; the
 fish no longer investigate them
for their bones have not lasted:
men lower nets, unconscious of the fact that
 they are desecrating a grave,
and row quickly away—the blades of the
 oars
moving together like the feet of water-
 spiders as if there were no such thing as
 death.
The wrinkles progress among themselves in
 a phalanx—beautiful under networks of
 foam,
and fade breathlessly while the sea rustles
 in and out of the seaweed;
the birds swim through the air at top speed,
 emitting catcalls as heretofore—
the tortoise-shell scourges about the feet of
 the cliffs, in motion beneath them;
and the ocean, under the pulsation of
 lighthouses and noise of bell buoys,
advances as usual, looking as if it were not
 that ocean in which dropped things are
 bound to sink—
in which if they turn and twist, it is neither
 with volition nor consciousness.

—Marianne Moore

57

We see the tides of the water; we do not see the tides of the air. The atmosphere, like the ocean, has its own ebb and flow, even more gigantic, and rising, like a vast tumour, toward the moon. . . .

The wind deals harshly with the sea. Its assault is great enough to disturb that vast rhythm we call the tide. The tormented waters rebel. Long clouds, electric bladders, puff up, and in their bosoms you can recognize, by a misshapen swelling, the thunder held prisoner like a dead animal in a boa's stomach. The foam streams in a thousand undulations over the flanks of the sandbank like the linen robe over the hips of Venus Anadyomene. The barometer sinks, then rises, then drops; there is the same dark play in the storm. You hear the sob of creation. The sea is the great weeper. She is filled with complaint; the ocean laments for all that suffers.

—*Victor Hugo*

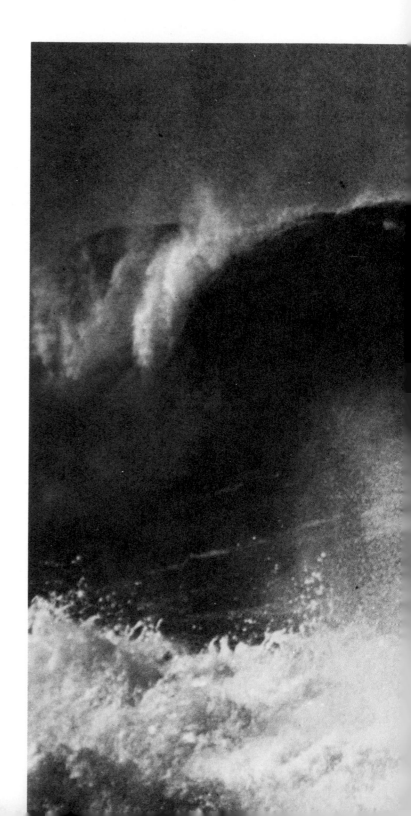

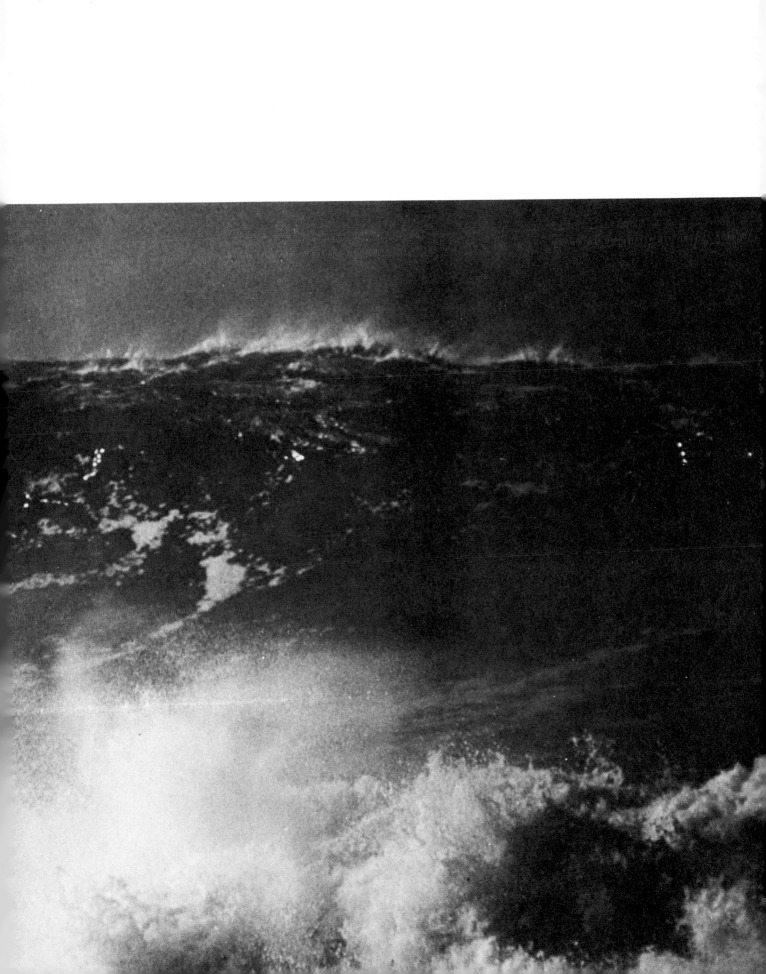

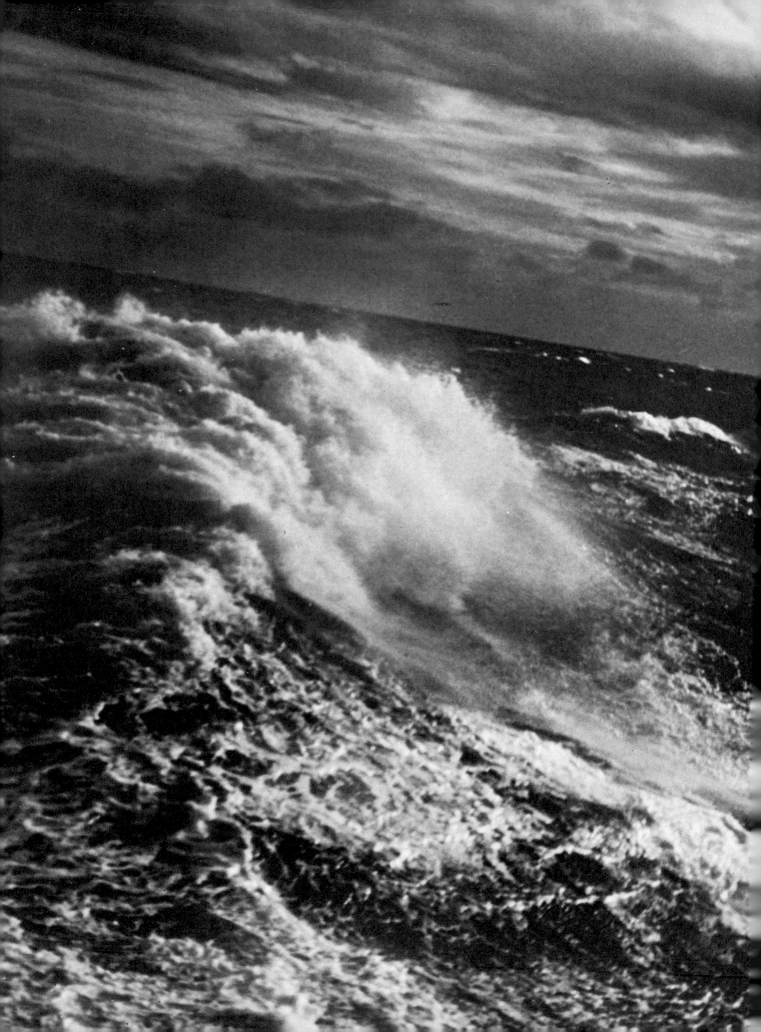

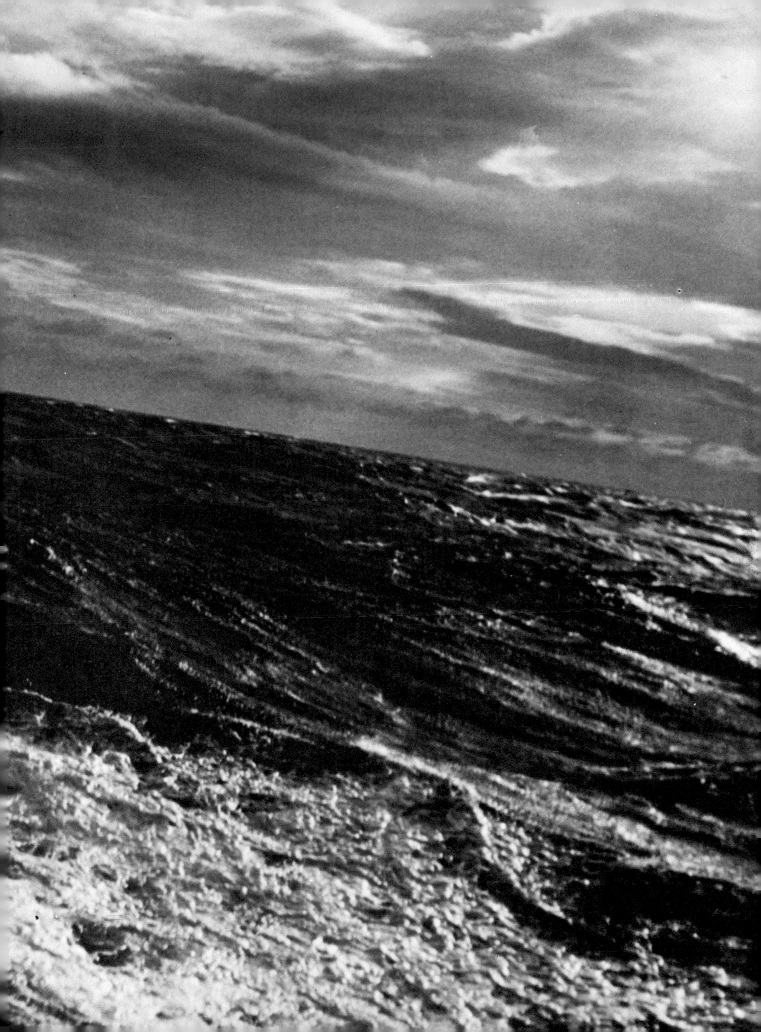

The sea was white as far as the eye could reach; ten leagues of soapsuds filled the horizon. Doors of fire opened. Some clouds seemed burned by other clouds, and resembled smoke above the pile of red clouds which appeared like burning coals. Floating configurations came in contact and amalgamated, changing each other's shapes. An incommensurable flood of water streamed down. The rattle of musketry firing by squads was heard in the firmament. In the middle of the canopy of gloom there was a sort of huge overturned basket whence fell, pell-mell, the waterspout, hail clouds, purple fire, phosphoric gleams, darkness, light, flashes of lightning,—so formidable are these inclinations of the abyss.

—*Victor Hugo*

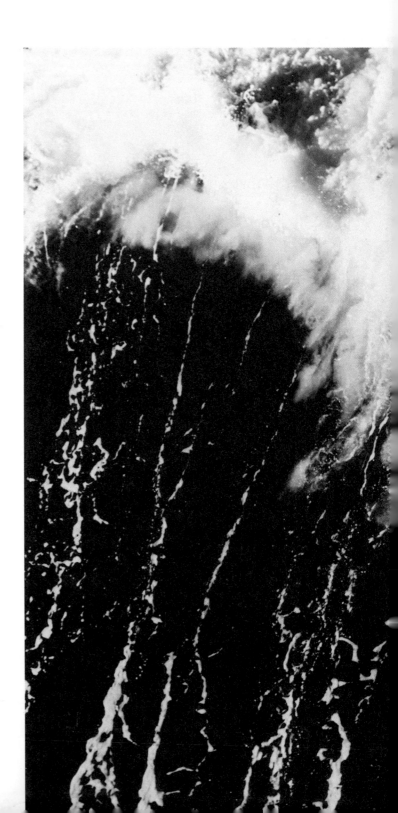

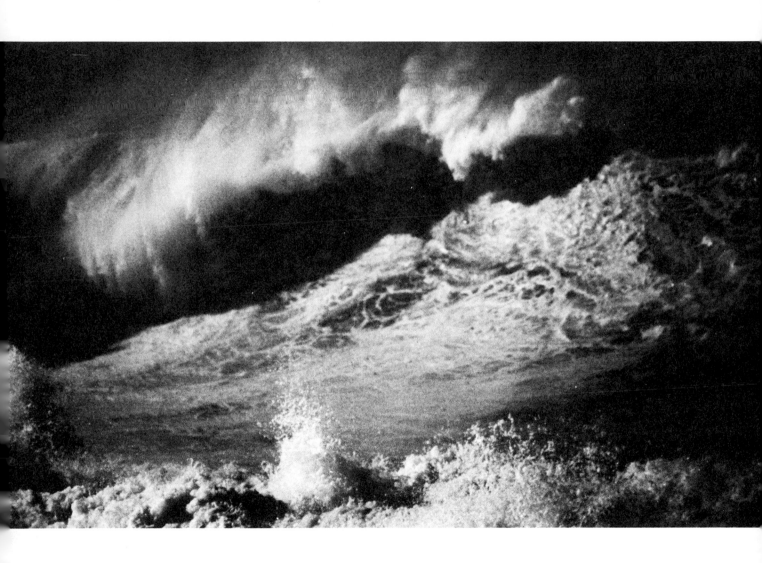

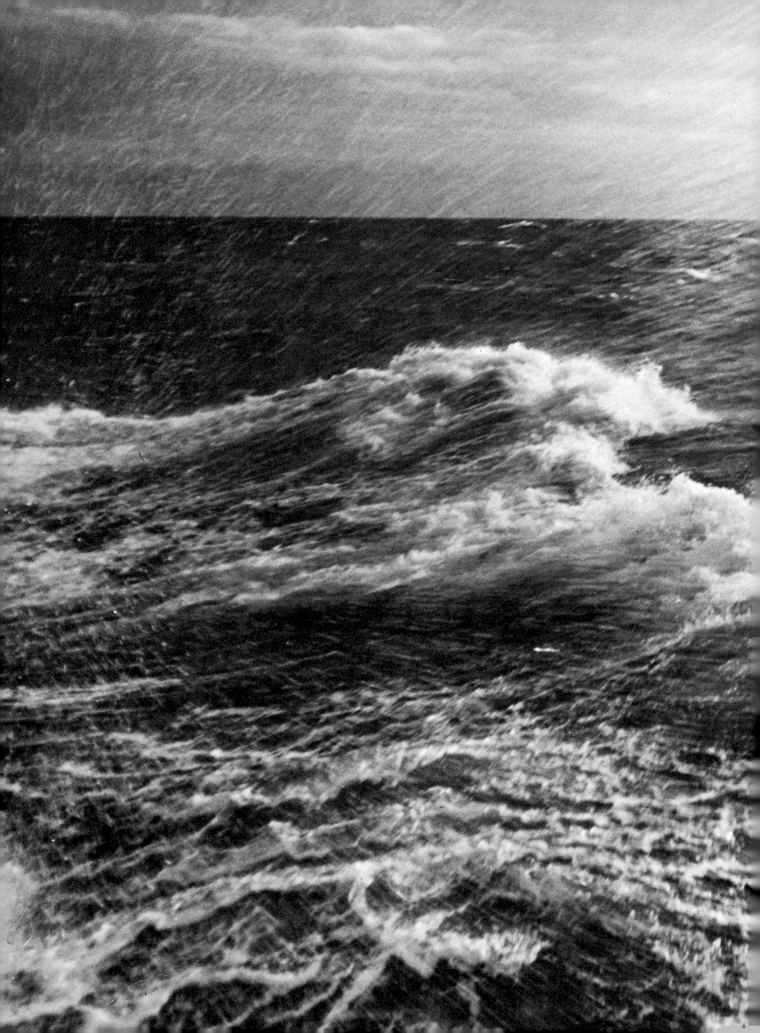

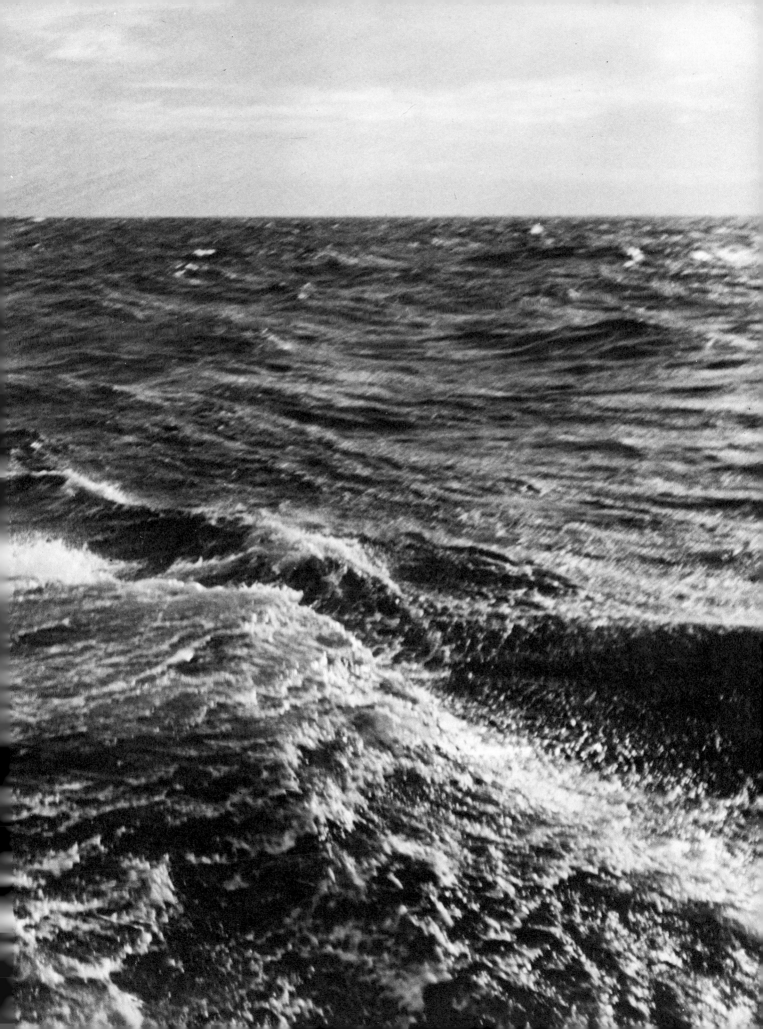

The flakes of foam flying from all directions resembled wool. The vast and angry water overflowed the rocks, mounted above them, entered into them, penetrated the network of interior fissures, and emerged again from the granitic masses by narrow orifices, a sort of inexhaustible mouths, which sent forth peaceful little fountains amid this deluge. Here and there, threads of silver fell gracefully into the sea from these mouths.

—*Victor Hugo*

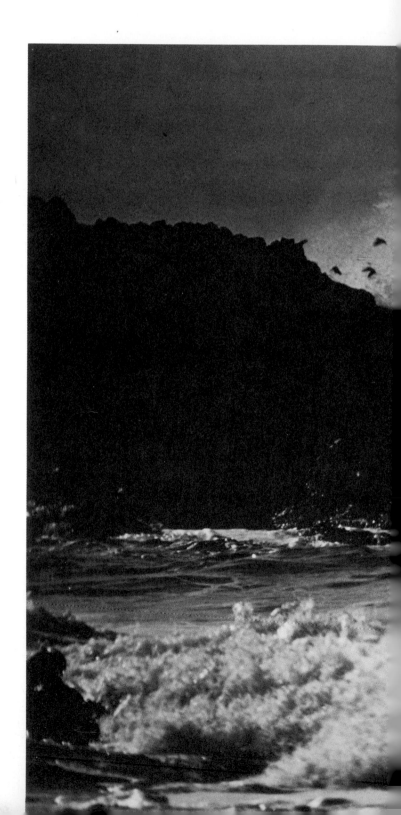

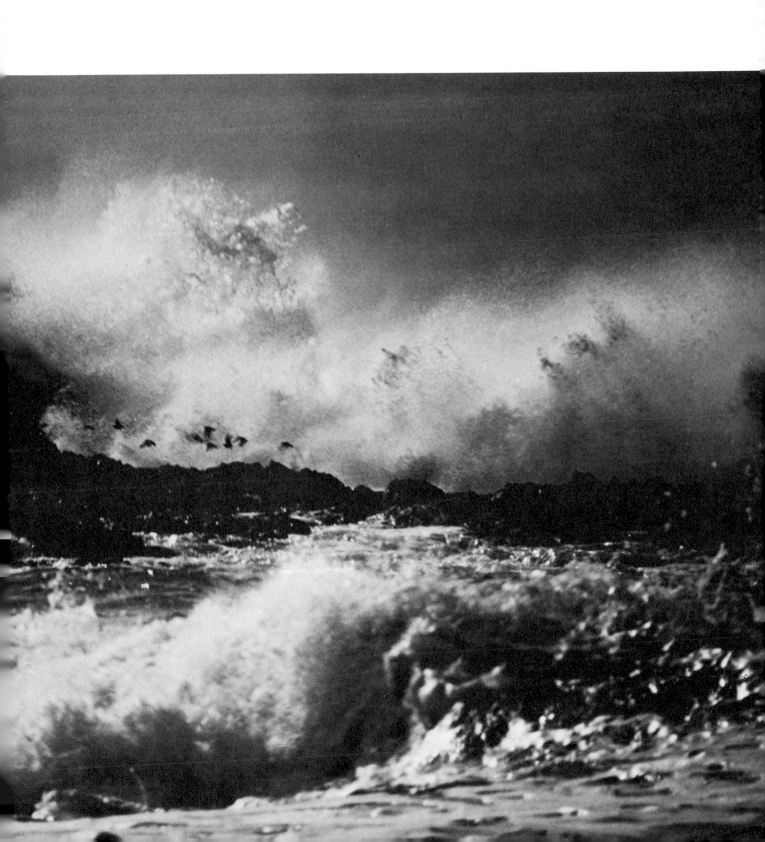

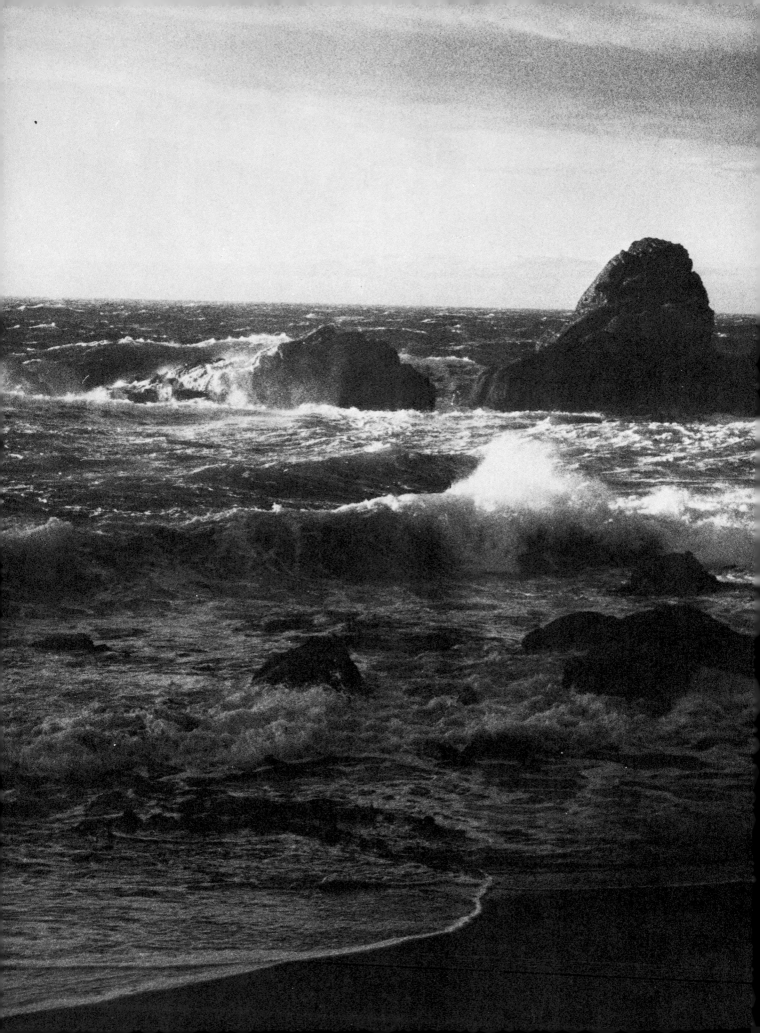

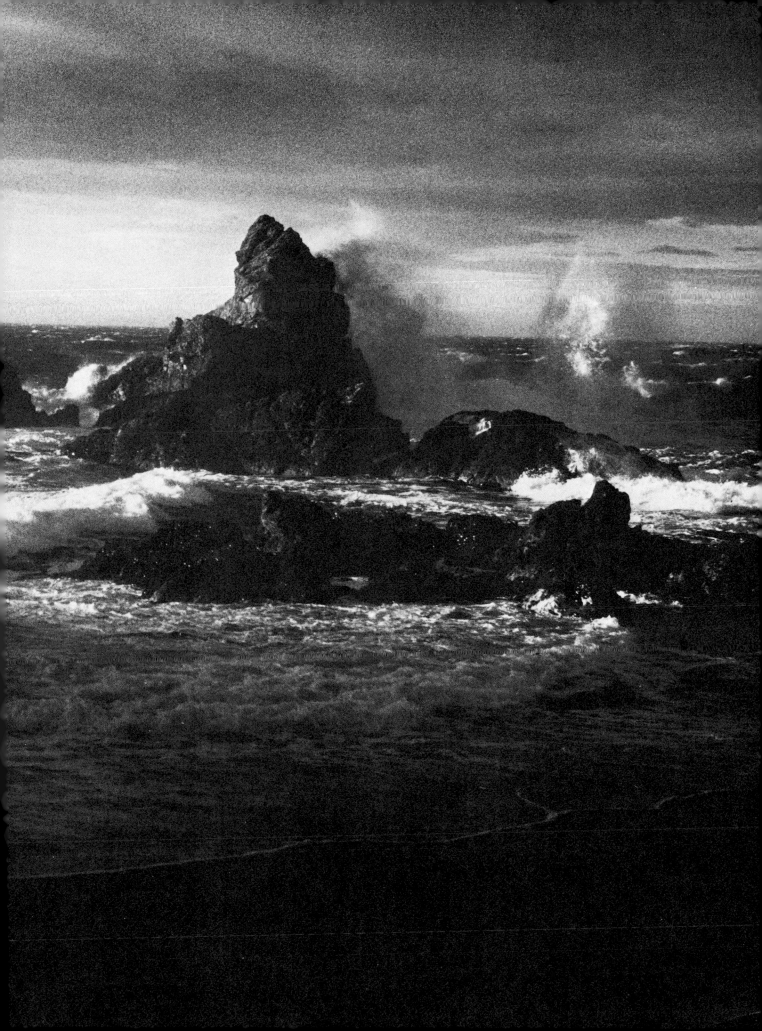

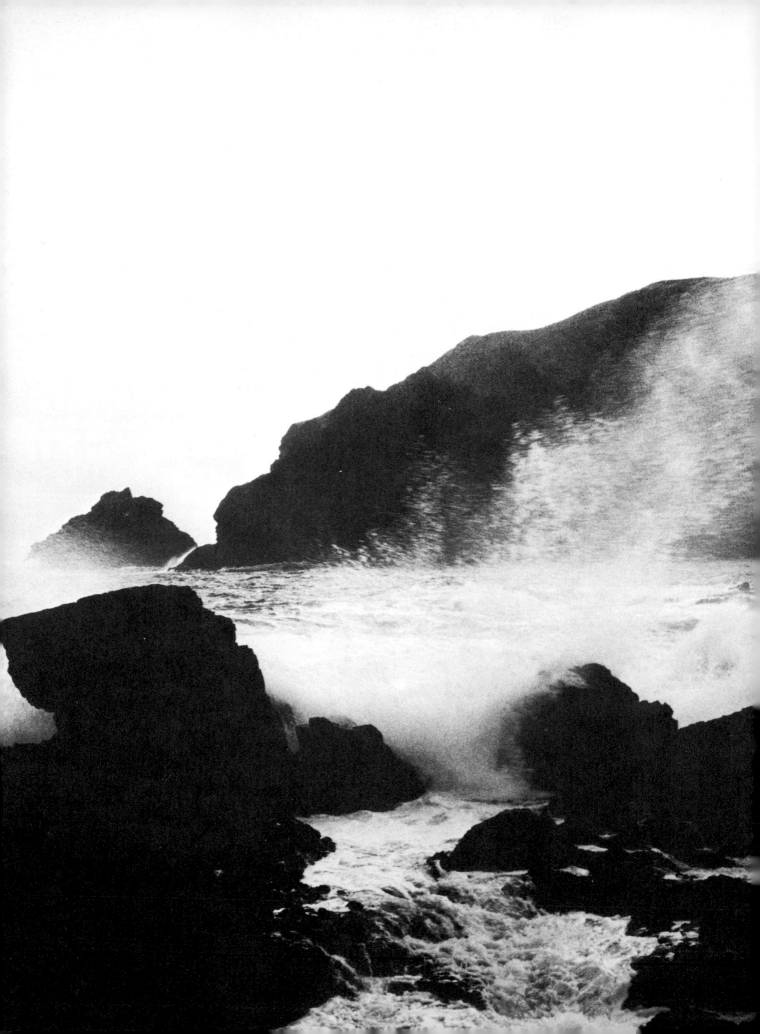

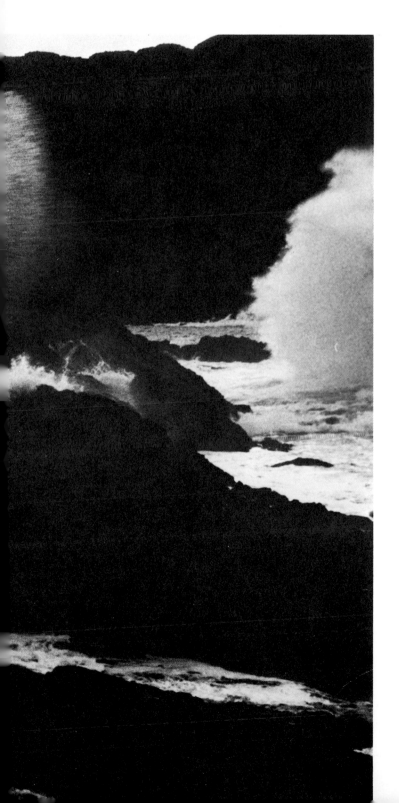

The indefinite and fleeting spirals of the wind whistled as they convulsed the sea; the waves became disks beneath these eddies, and were flung against the rocks like gigantic quoits hurled by invisible athletes. The enormous foam streamed over all the rocks. Torrents above, foam below. Then the roars redoubled. No uproar of men or beasts can give an idea of the mingled din of these displacements of the sea.

—*Victor Hugo*

A seat in this boat was not unlike a seat
upon a bucking broncho, and, by the same
token, a broncho is not much smaller. The
craft pranced and reared, and plunged like
an animal. As each wave came, and she rose
for it, she seemed like a horse making at a
fence outrageously high. The manner of her
scramble over these walls of water is a
mystic thing, and, moreover, at the top of
them were ordinarily these problems in
white water, the foam racing down from the
summit of each wave, requiring a new leap,
and a leap from the air. Then, after scorn-
fully bumping a crest, she would slide, and
race, and splash down a long incline and
arrive bobbing and nodding in front of the
next menace.

—*Stephen Crane*

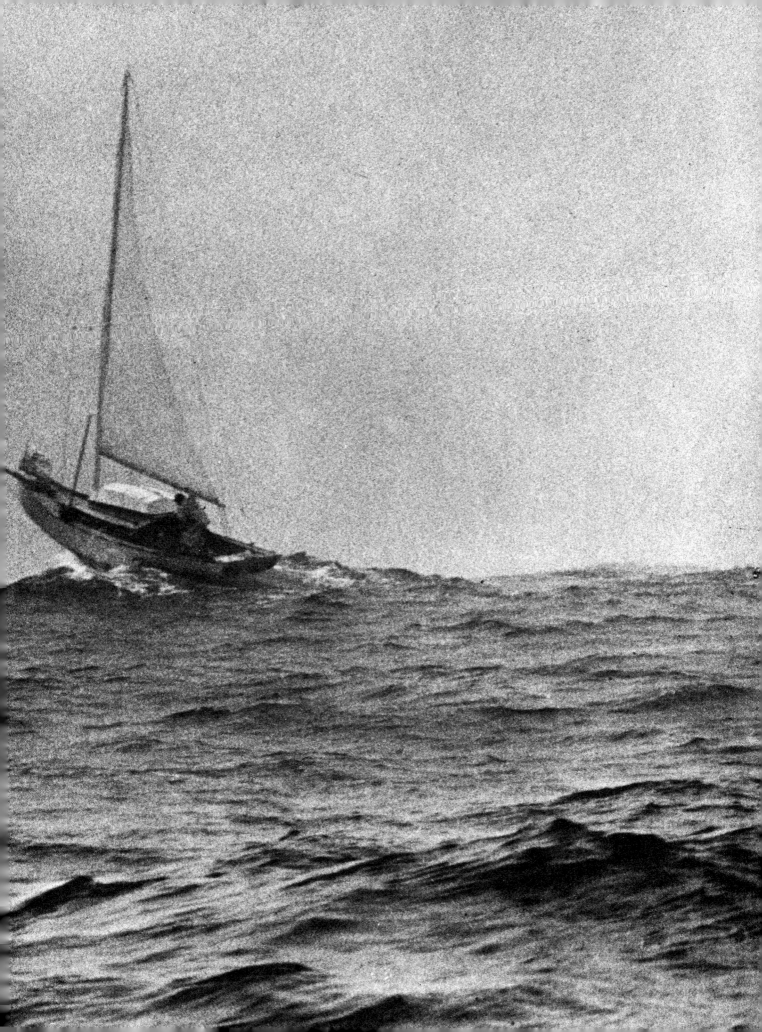

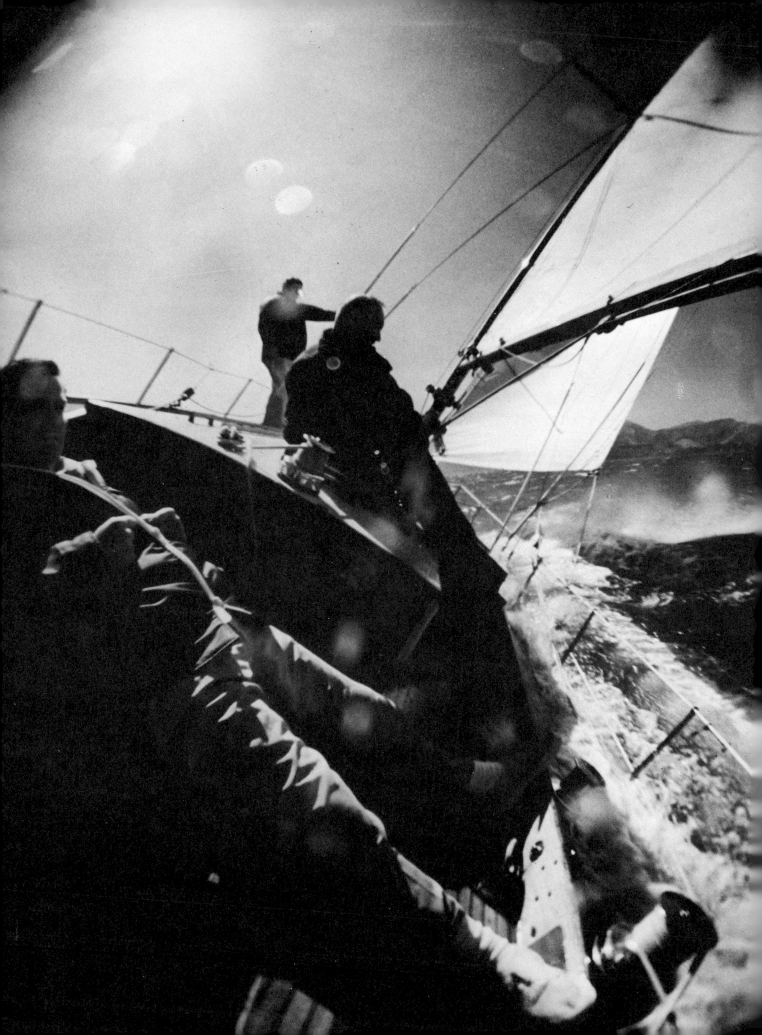

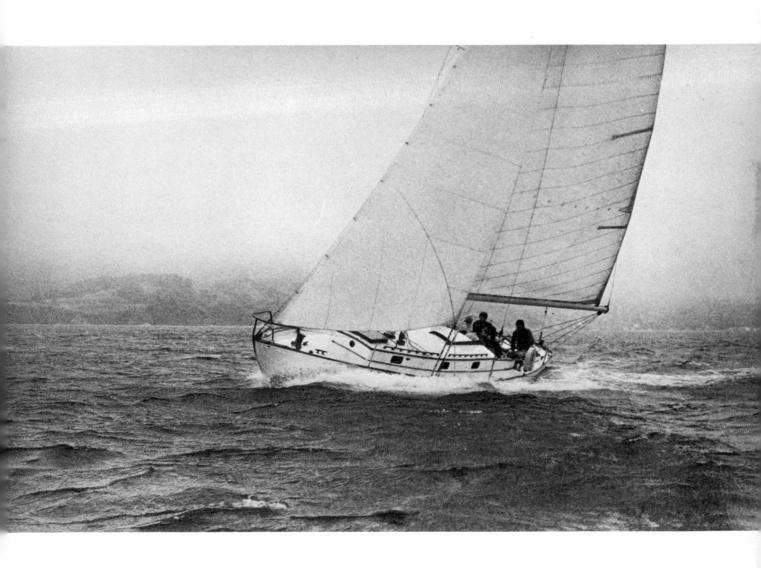

The ship, a fragment detached from the earth, went on lonely and swift like a small planet.

—*Joseph Conrad*

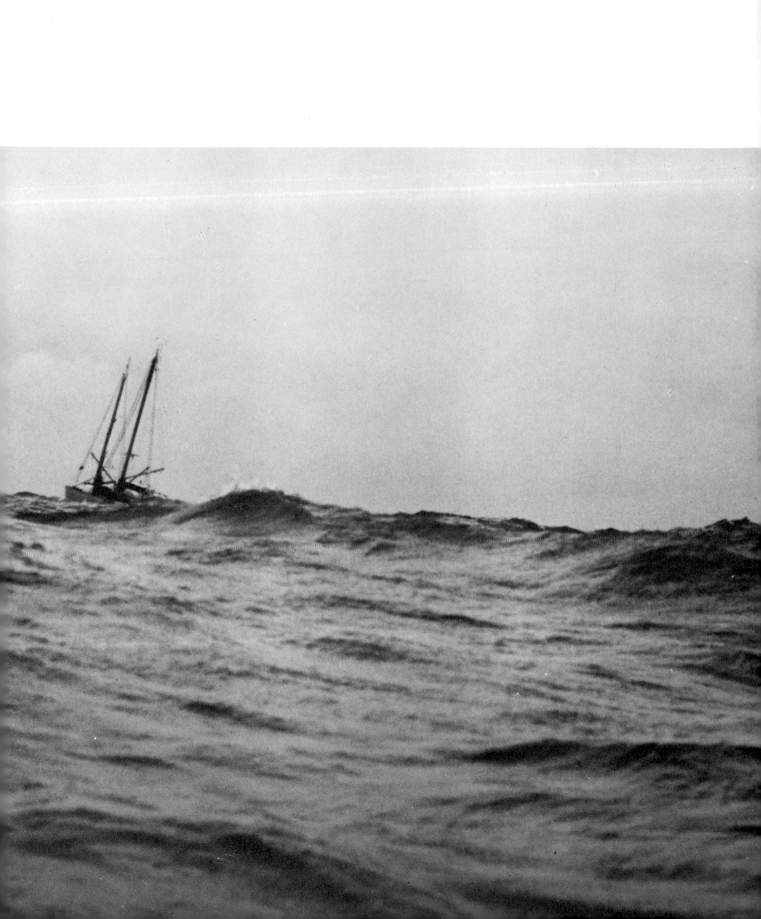

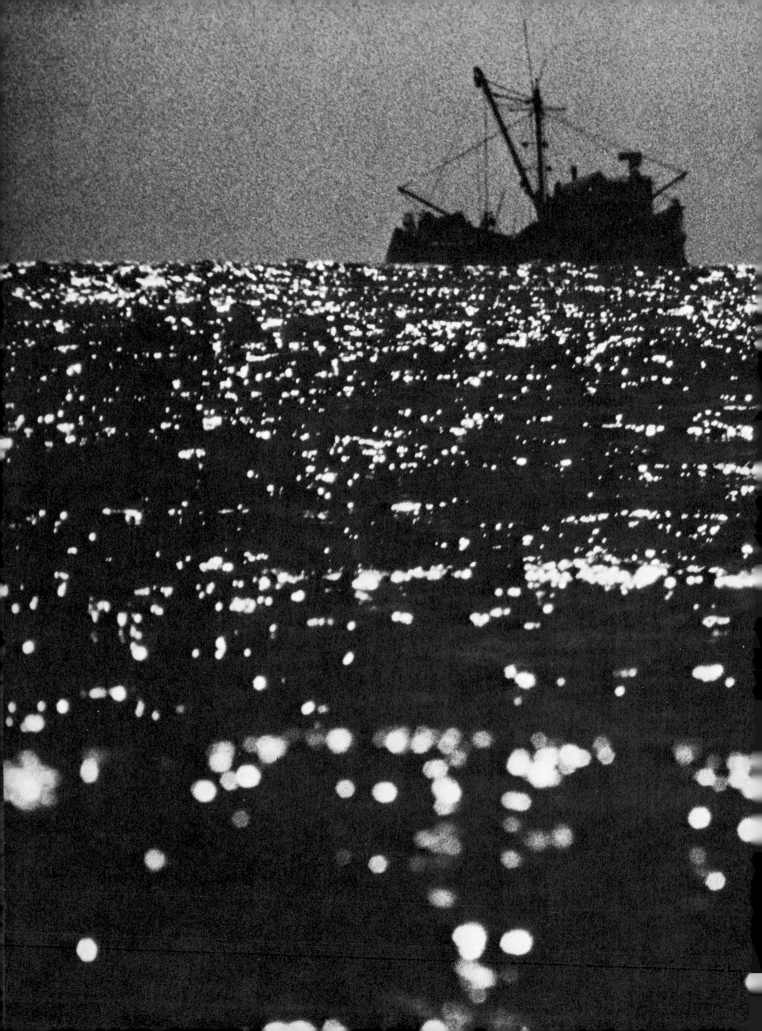

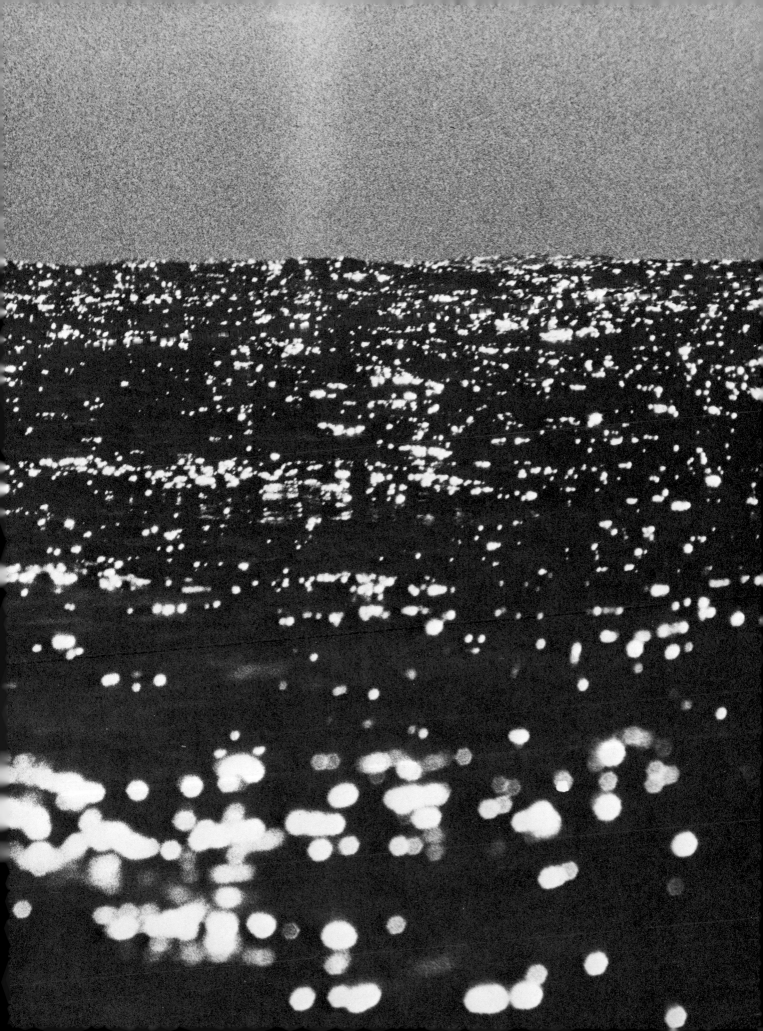

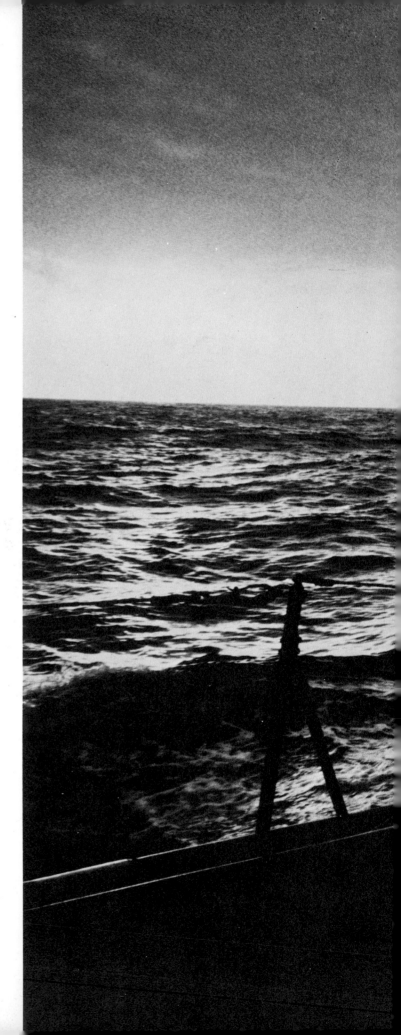

I must go down to the seas again, to the
 lonely sea and the sky,
And all I ask is a tall ship and a star to steer
 her by;
And the wheel's kick and the wind's song
 and the white sails shaking,
And a gray mist on the sea's face, and a gray
 dawn breaking.

I must go down to the seas again, for the
 call of the running tide
Is a wild call and a clear call that may not be
 denied;
And all I ask is a windy day with the white
 clouds flying,
And the flung spray and the blown spume,
 and the seagulls crying.

I must go down to the seas again, to the
 vagrant gypsy life,
To the gull's way and the whale's way where
 the wind's like a whetted knife;
And all I ask is a merry yarn from a laughing
 fellow-rover,
And quiet sleep and a sweet dream when the
 long trick's over.

 —John Masefield

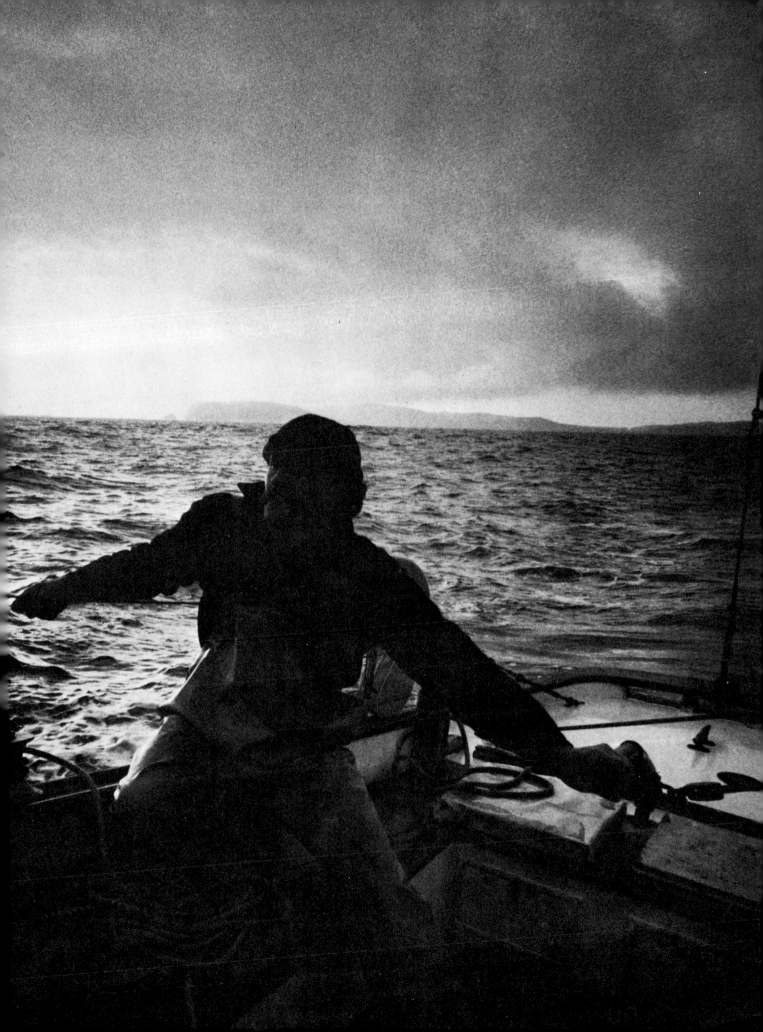

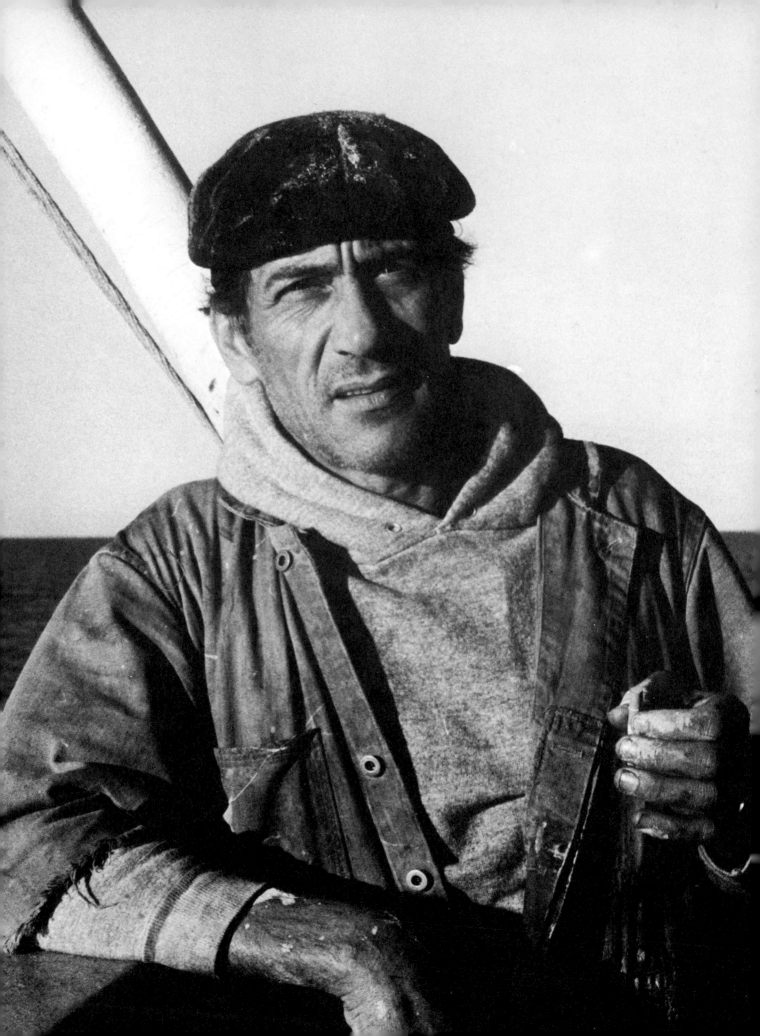

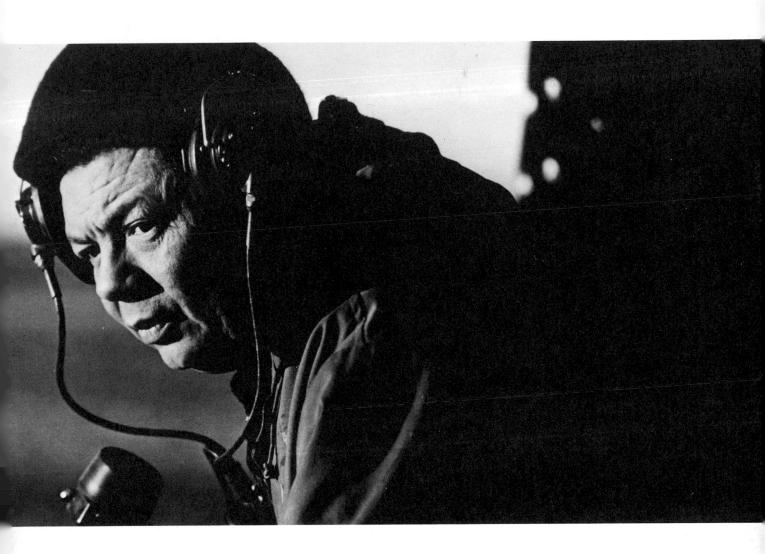

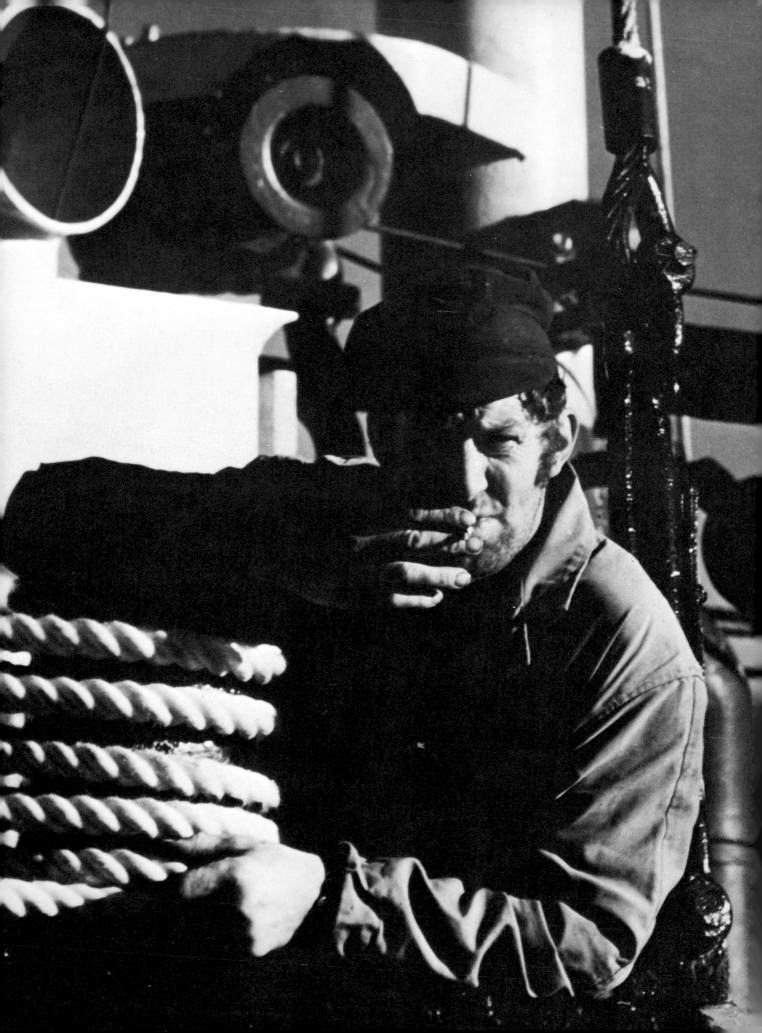

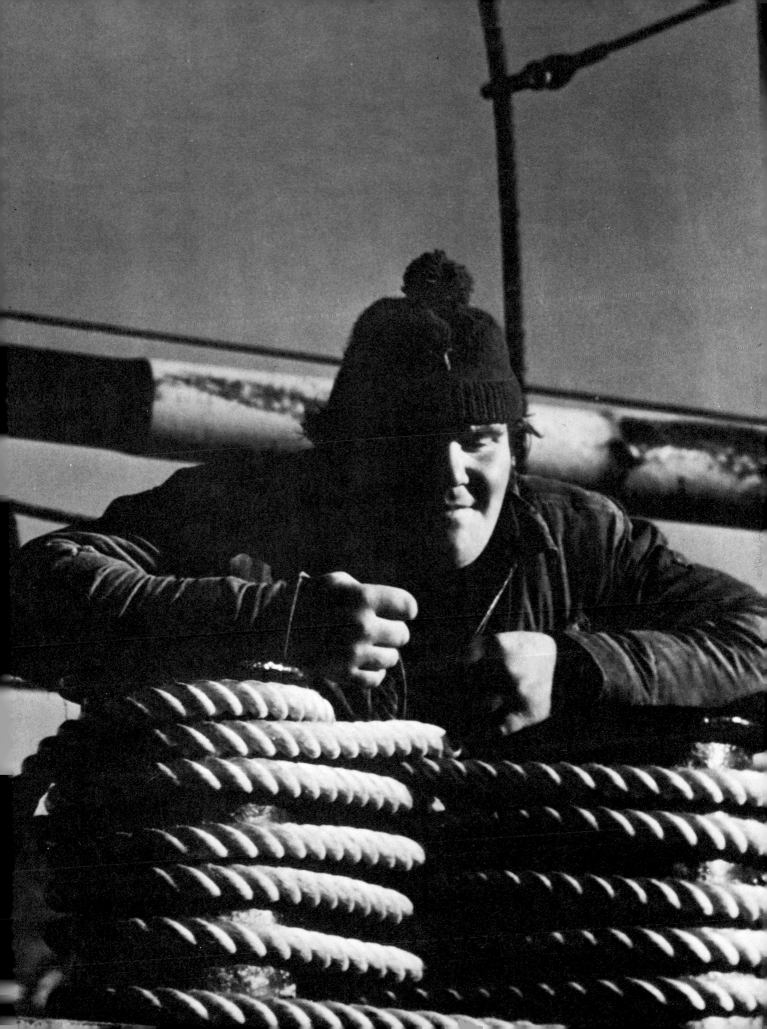

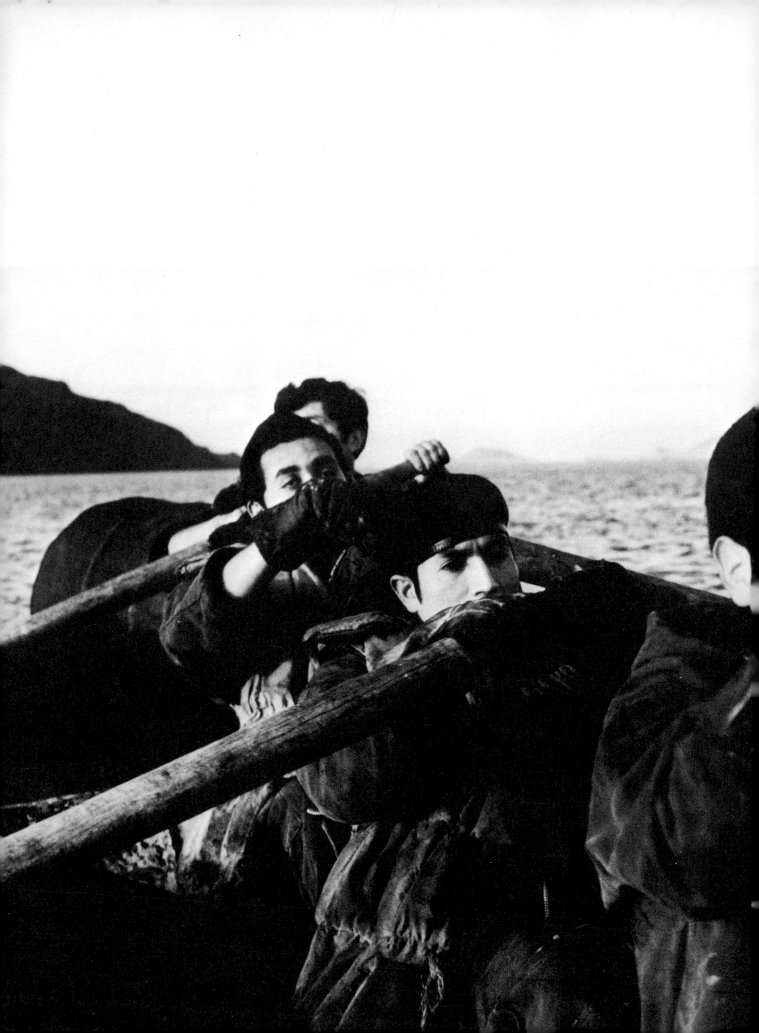

A song I sing of my sea-adventure,
The strain of peril, the stress of toil,
Which oft I endured in anguish of spirit
Through weary hours of aching woe.
My bark was swept by the breaking seas;
Bitter the watch from the bow by night
As my ship drove on within sound
 of the rocks.
My feet were numb with the nipping cold,
Hunger sapped a sea-weary spirit,
And care weighed heavy upon my heart.
Little the land-lubber, safe on shore,
Knows what I've suffered in icy seas
Wretched and worn by the winter storms,
Hung with icicles, stung by hail,
Lonely and friendless and far from home.
In my ears no sound but the roar of the sea,
The icy combers, the cry of the swan;
In place of the mead-hall and laughter
 of men
My only singing the sea-mew's call,
The scream of the gannet, the shriek
 of the gull;
Through the wail of the wild gale beating
 the bluffs
The piercing cry of the ice-coated petrel,
The storm-drenched eagle's echoing scream.
In all my wretchedness, weary and lone,
I had no comfort of comrade or kin.

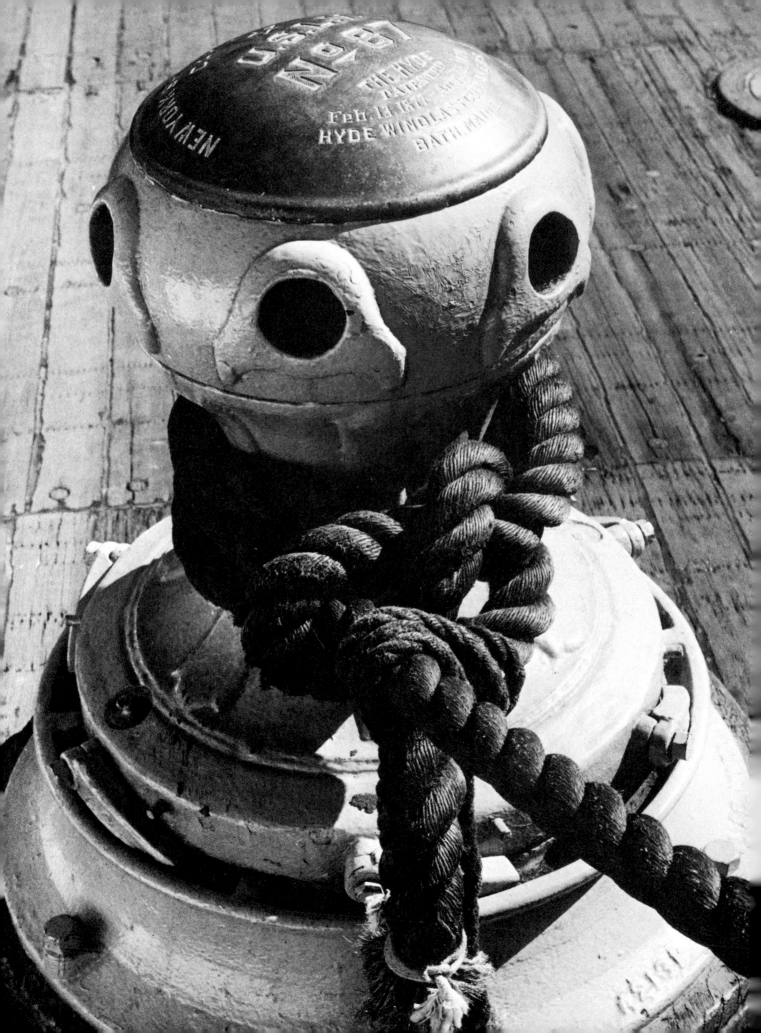

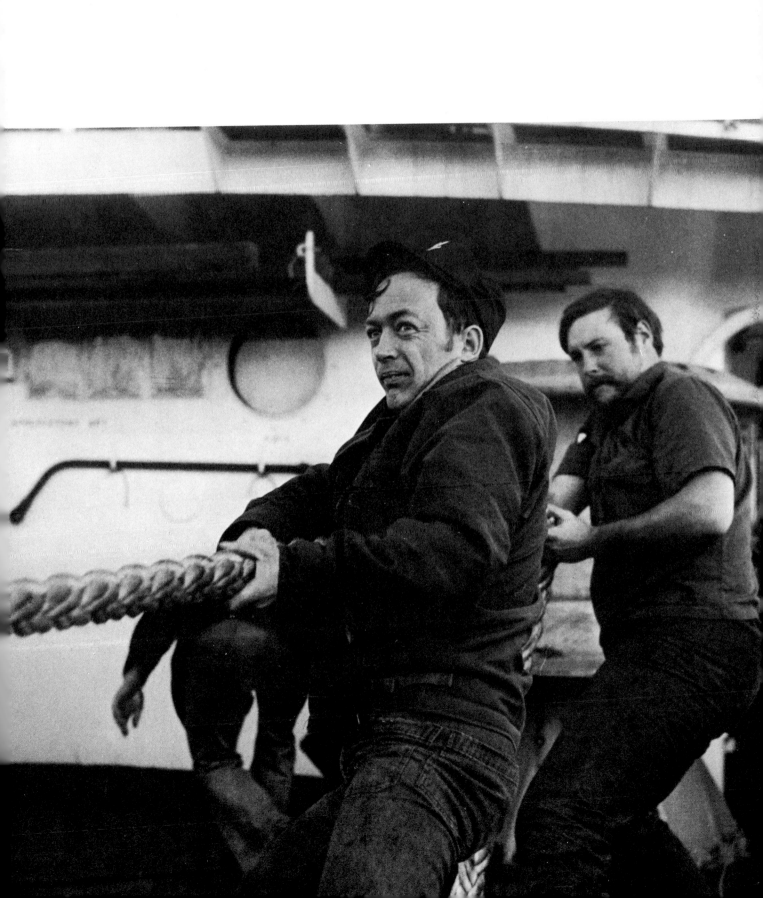

Little indeed can he credit, whose town-life
Pleasantly passes in feasting and joy,
Sheltered from peril, what weary pain
Often I've suffered in foreign seas.
Night shades darkened with driving snow
From the freezing north, and the bonds
 of frost
Firm-locked the land, while falling hail,
Coldest of kernels, encrusted earth.
Yet still, even now, my spirit within me
Drives me seaward to sail the deep,
To ride the long swell of the salt sea-wave.
Never a day but my heart's desire
Would launch me forth on the long sea-path,
Fain of far harbors and foreign shores.
Yet lives no man so lordly of mood,
So eager in giving, so ardent in youth,
So bold in his deeds, or so dear to his lord,
Who is free from dread in his far sea-travel,
Or fear of God's purpose and plan for
 his fate.
The beat of the harp, and bestowal
 of treasure,
The love of woman, and worldly hope,
Nor other interest can hold his heart
Save only the sweep of the surging billows;
His heart is haunted by love of the sea.
Trees are budding and towns are fair,
Meadows kindle and all life quickens,
All things hasten the eager-hearted,
Who joyeth therein, to journey afar,
Turning seaward to distant shores.
The cuckoo stirs him with plaintive call,
The herald of summer, with mournful song,
Foretelling the sorrow that stabs the heart.
Who liveth in luxury, little he knows
What woe men endure in exile's doom.
Yet still, even now, my desire outreaches,
My spirit soars over tracts of sea,
O'er the home of the whale, and the
 world's expanse.
Eager, desirous, the lone sprite returneth;
It cries in my ears and it calls to my heart
To launch where the whales plough their
 paths through the deep.
 —*Author Unknown*

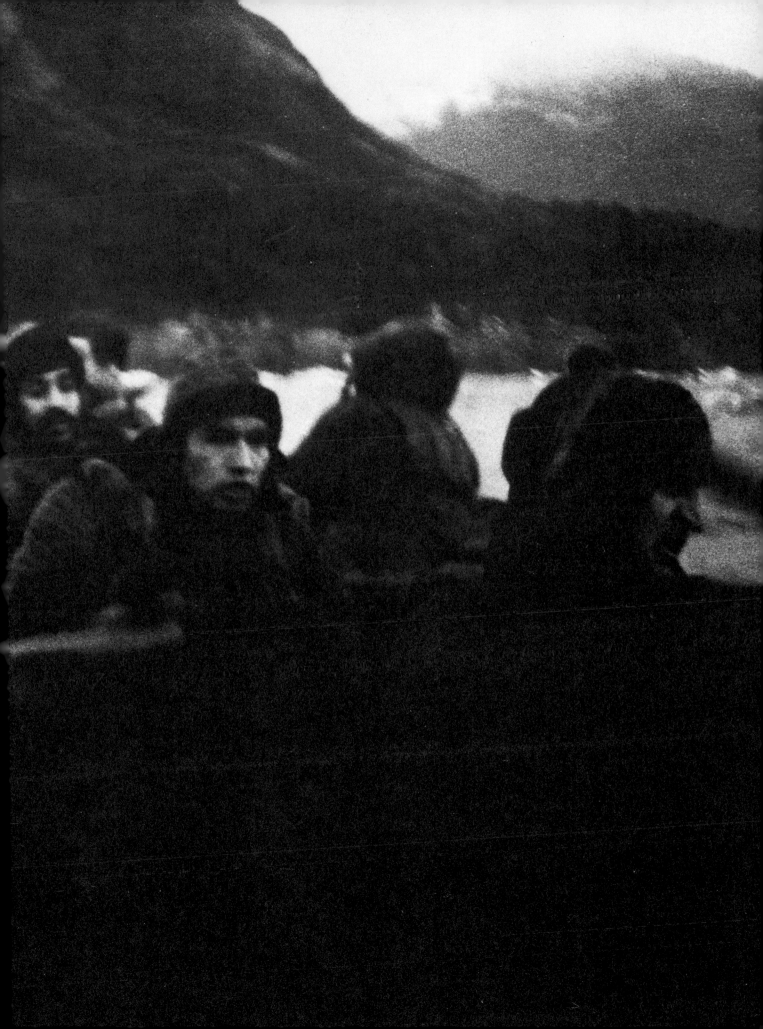

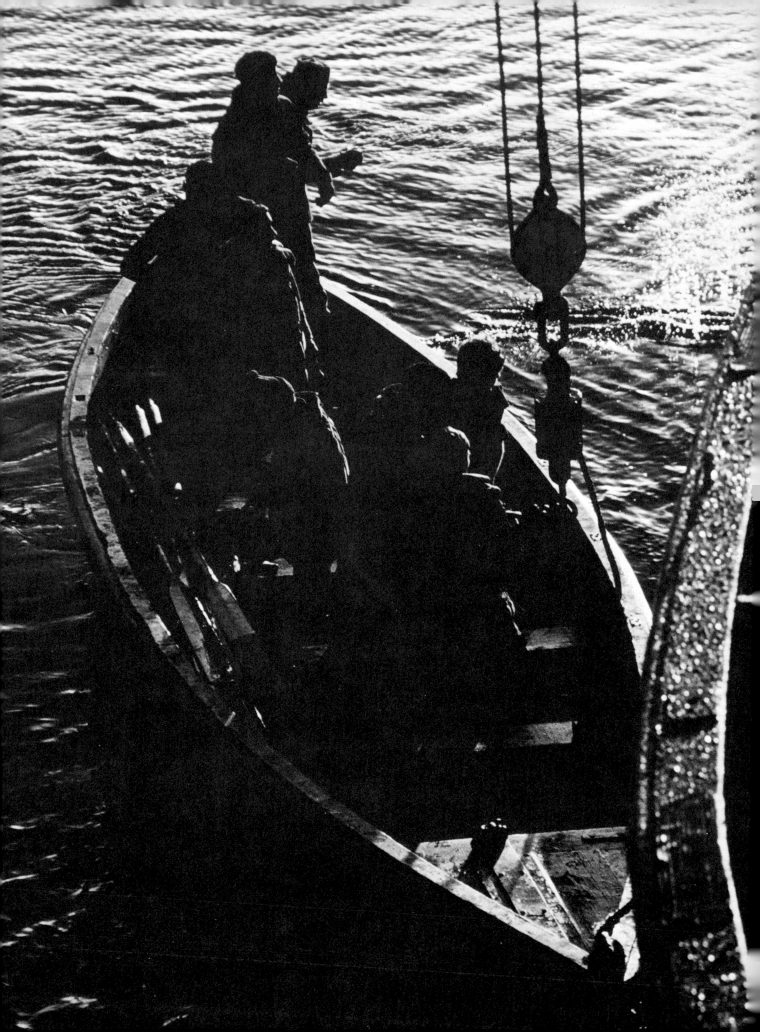

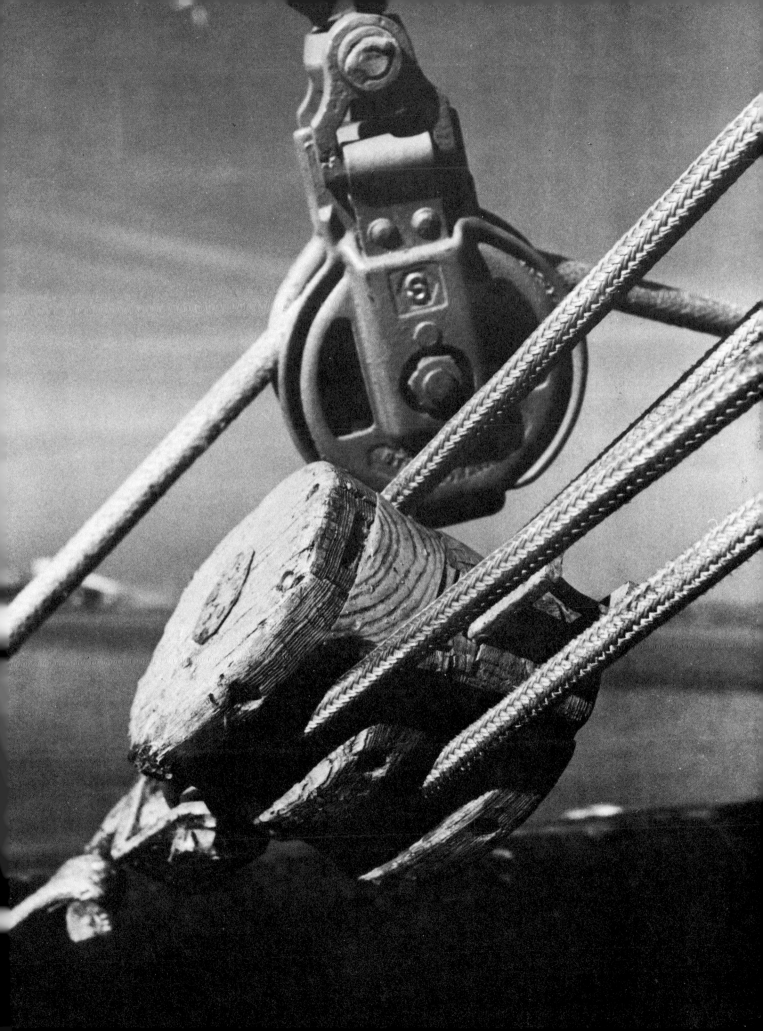

They who possess the sea within their blood
have blood that courses with an endless
 motion,
deep is its surging, like a tide at flood from
 out of the ocean.
They hold the blue spray-water in
 their veins
that hints no crimson torn from leaf or berry,
neither the flame of sumach nor the stain of
 the wild cherry.
 —*Marguerite Janurin Adams*

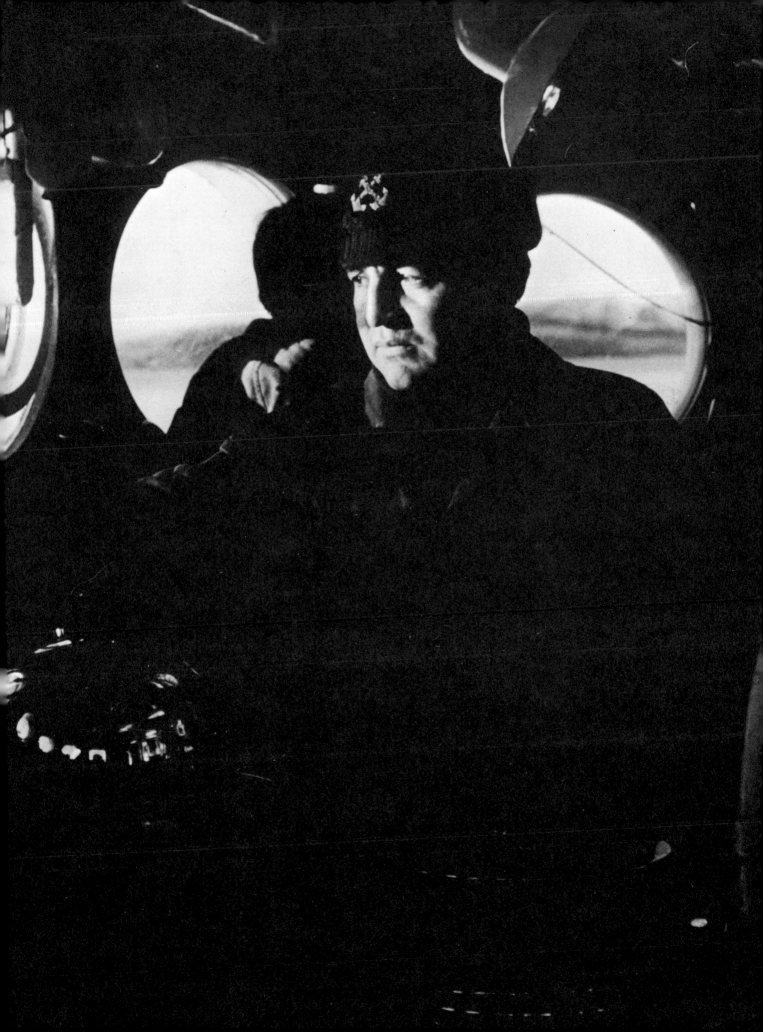

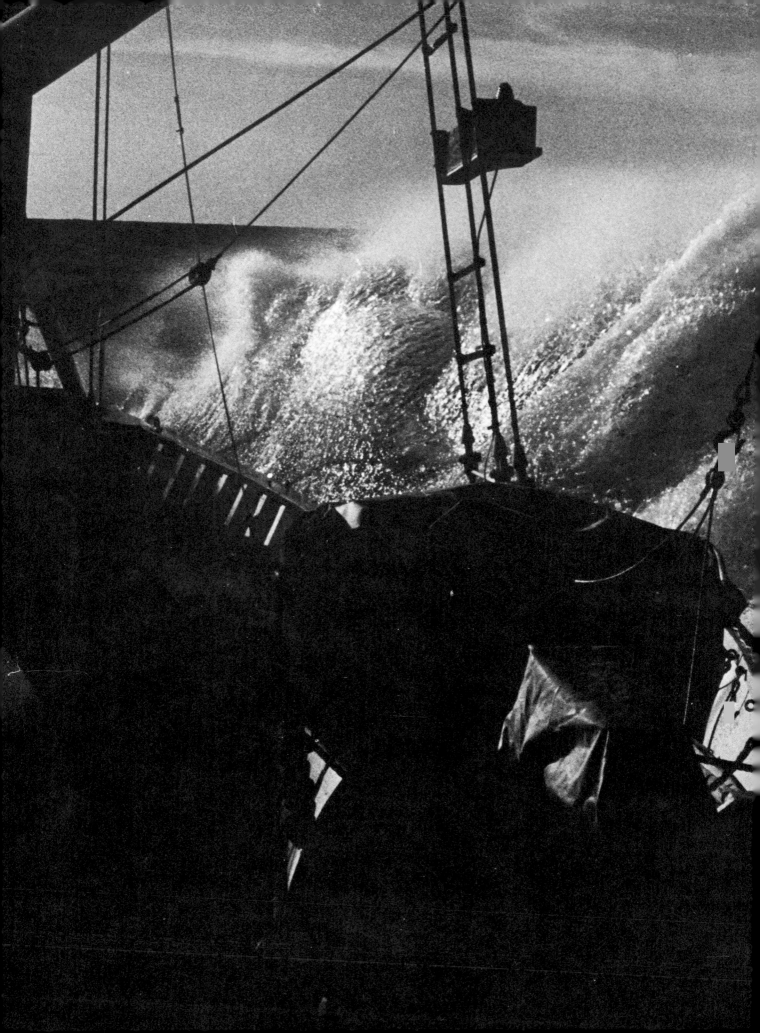

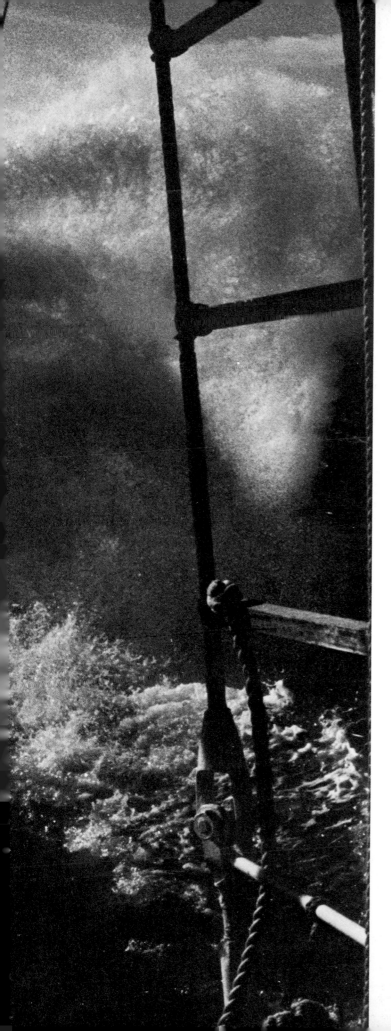

I lay on the bowsprit, facing astern, with
the water foaming into spume under me, the
masts with every sail white in the moonlight,
towering high above me. I became drunk
with the beauty and the singing rhythm of
it, and for a moment I lost myself—actually
lost my life. I was set free! I dissolved in the
sea, became white sails and flying spray,
became beauty and rhythm, became moon-
light and the ship and the high dim-starred
sky! I belonged, without past or future,
within place and unity and a wild joy, within
something greater than my own life, or the
life of man, to Life itself! To God, if you
want to put it that way.

—*Eugene O'Neill*

97

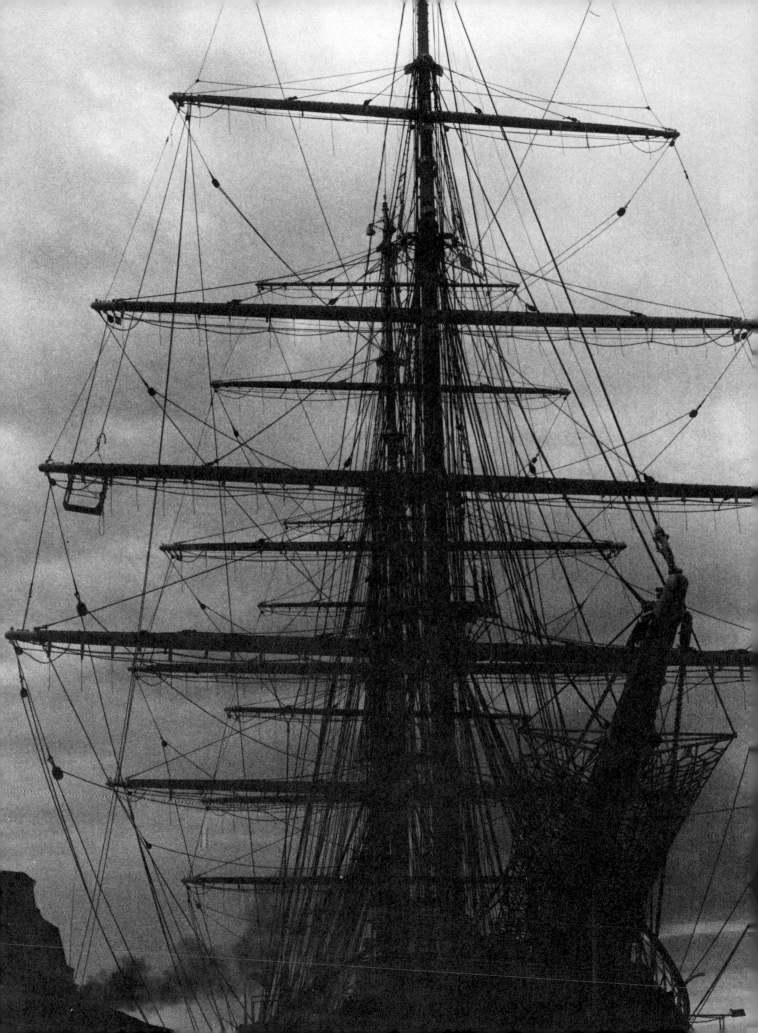

There is a memory stays upon old ships,
A weightless cargo in the musty hold,—
Of bright lagoons and prow caressing lips,
Of stormy midnights,—and a tale untold.
They have remembered islands in the dawn,
And windy capes that tried their slender
 spars,
And tortuous channels where their keels
 have gone,
And calm blue nights of stillness and the
 stars.

Ah, never think that ships forget a shore,
Or bitter seas, or winds that made them
 wise;
There is a dream upon them, evermore;
And there be some who say that sunk ships
 rise
To seek familiar harbors in the night,
Blowing in mists, their spectral sails like
 light.

—David Morton

Here speaks the man of the masts and sails, to whom the sea is not a navigable element, but an intimate companion. The length of passages, the growing sense of solitude, the close dependence upon the very forces that, friendly today, without changing their nature, by the mere putting forth of their might, become dangerous tomorrow, make for that sense of fellowship which modern seamen, good men as they are, cannot hope to know. And, besides, your modern ship which is a steamship makes her passages on other principles than yielding to the weather and humouring the sea. She receives smashing blows, but she advances; it is a slogging fight, and not a scientific campaign. The machinery, the steel, the fire, the steam have stepped in between the man and the sea. A modern fleet of ships does not so much make use of the sea as exploit a highway. The modern ship is not the sport of the waves. Let us say that each of her voyages is a triumphant progress; and yet it is a question whether it is not a more subtle and more human triumph to be the sport of the waves and yet survive, achieving your end.

—*Joseph Conrad*

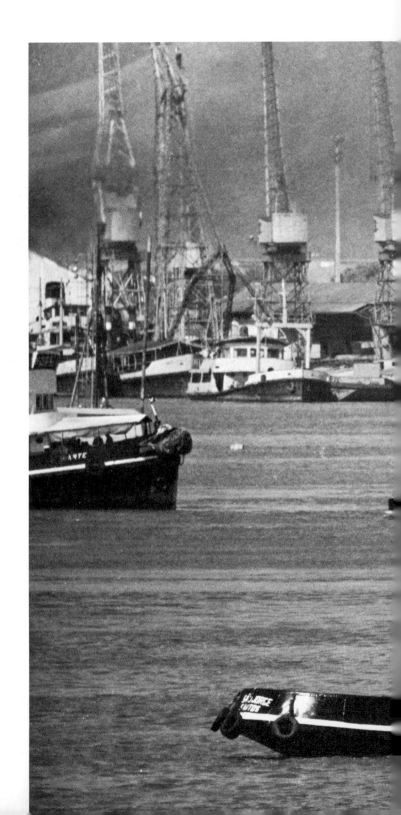

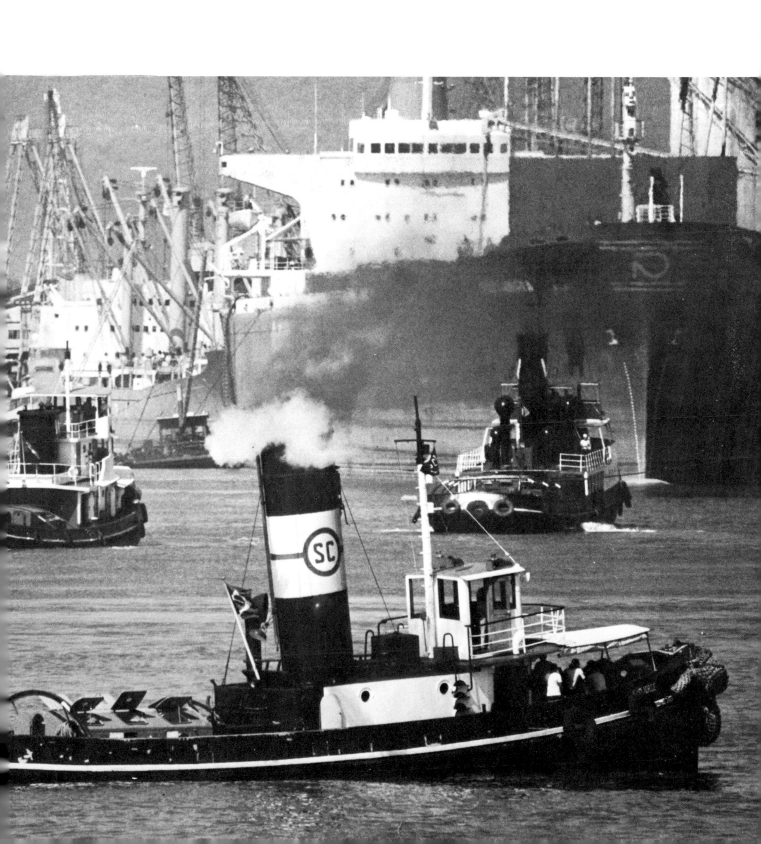

Today a rude brief recitative,
Of ships sailing the seas, each with its
 special flag or ship-signal;
Of unnamed heroes in the ships—Of waves
 spreading and spreading, far as the eye
 can reach,
Of dashing spray, and the winds piping and
 blowing;
And out of these a chant, for the sailors of
 all nations,
Fitful, like a surge.

Of sea-captains young or old, and the mates
 —and of all intrepid sailors,
Of the few, very choice, taciturn, whom fate
 can never surprise, nor death dismay,
Pick'd sparingly, without noise, by thee, old
 Ocean—chosen by thee,
Thou Sea that pickest and cullest the race,
 in time, and unitest nations,
Suckled by thee, old husky Nurse—
 embodying thee!
Indomitable, untamed as thee.

(Ever the heroes, on water or on land, by
 ones or twos appearing,
Ever the stock preserv'd and never lost,
 though rare—enough for seed preserv'd.)

Flaunt out, O Sea, your separate flags of
 nations!
Flaunt out, visible as ever, the various
 ship-signals!
But do you reserve especially for yourself,
 and for the soul of man, one flag above
 all the rest,
A spiritual woven signal for all nations,
 emblem of man elate above death,
Token of all brave captains, and all intrepid
 sailors and mates,
And all that went down doing their duty;
Reminiscent of them—twined from all
 intrepid captains, young or old;
A pennant universal, subtly waving, all time,
 o'er all brave sailors,
All seas, all ships.

 —Walt Whitman

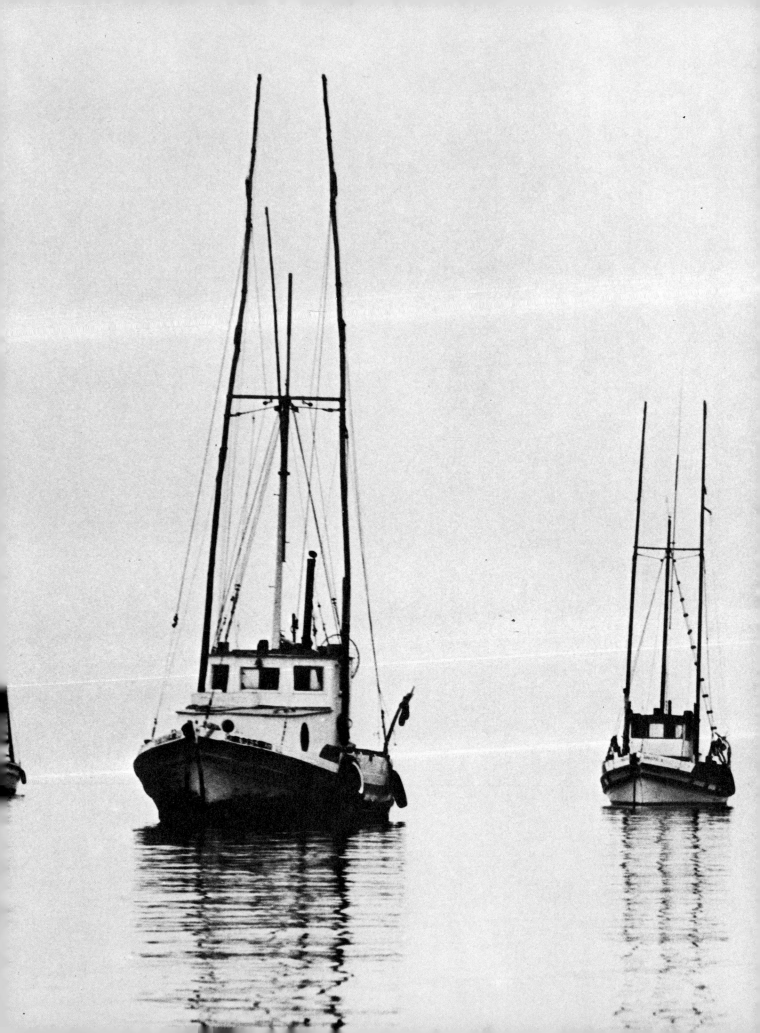

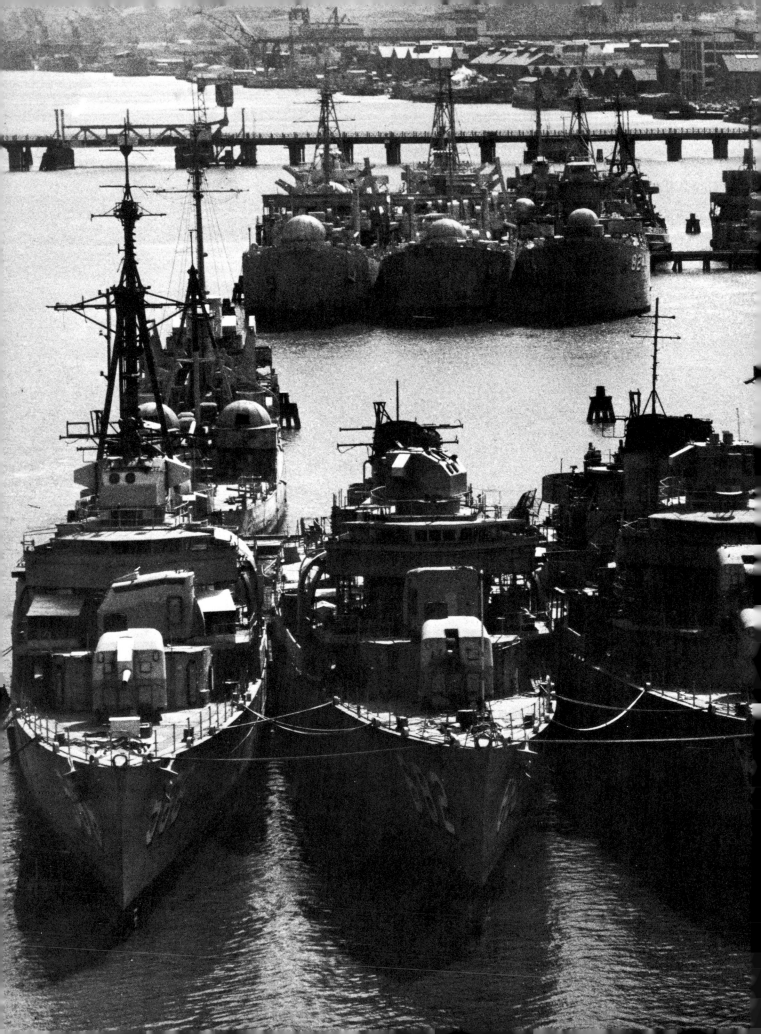

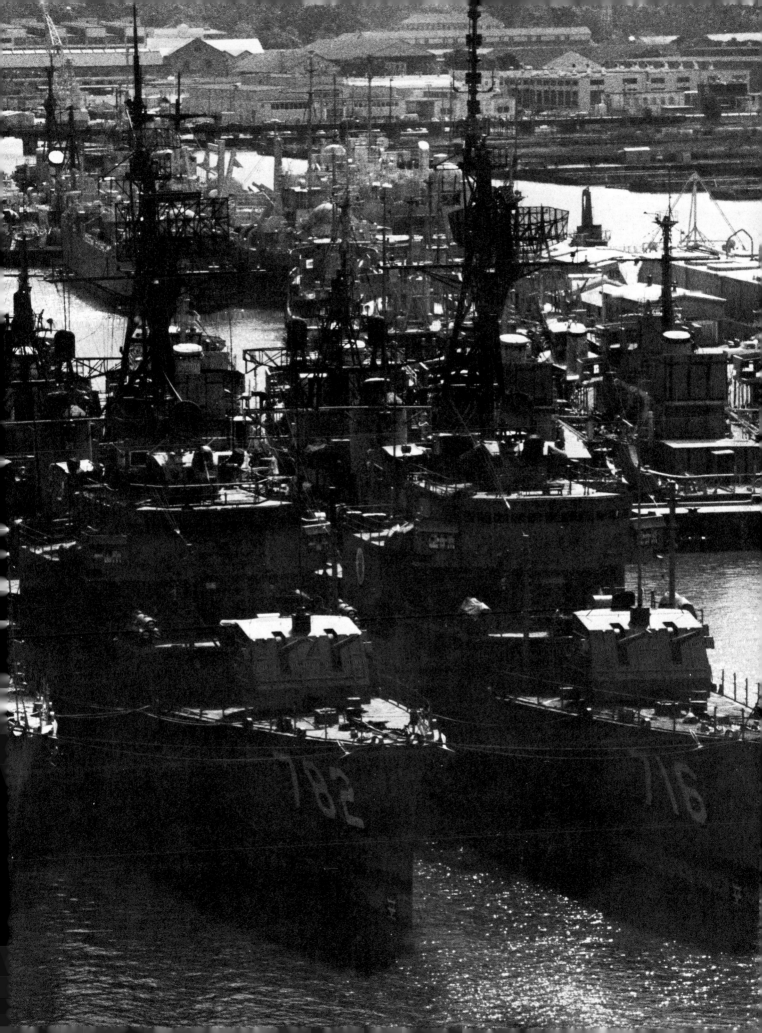

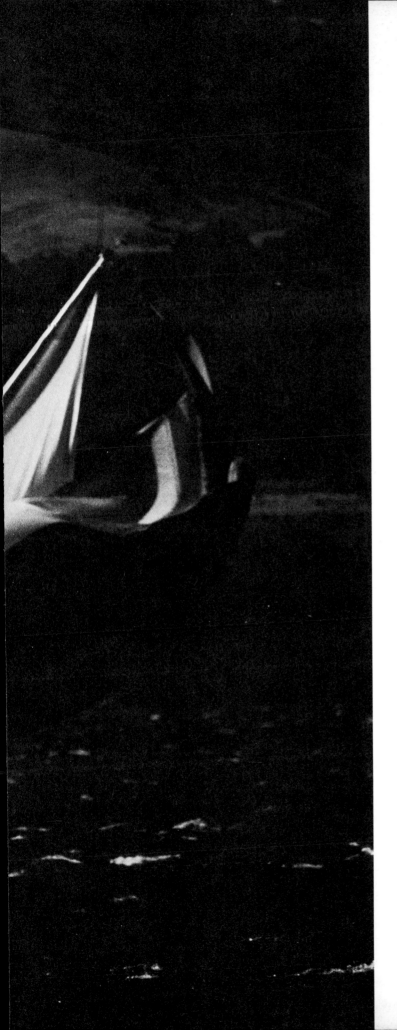

We bore down on the ship at the sea's edge
and launched her on the salt immortal sea,
stepping our mast and spar in the black
ship; embarked the ram and ewe and went
aboard in tears, with bitter and sore dread
upon us. But now a breeze came up for us
astern—a canvas-bellying landbreeze, hale
shipmate sent by the singing nymph with
sun-bright hair; so we made fast the braces,
took our thwarts, and let the wind and
steersman work the ship with full sail spread
all day above our coursing, till the sun
dipped, and all the ways grew dark upon the
fathomless unresting sea.

—Homer

I find immense pleasure in the gurgle and splash of a boat propelled by a direct force of nature, the snapping of canvas and the humming of rigging in a fresh breeze, the rattle of ropes running through blocks, the crying of gulls, the lift and heave of a buoyant hull, the pressure of wind against my body, the sting of flying spray, the sight of billowing sails and the swirling foam of the wake. To me, nothing made by man is more beautiful than a sailboat under way in fine weather, and to be *on* that sailboat is to be as close to heaven as I expect to get. It is unalloyed happiness.

—*Robert Manry*

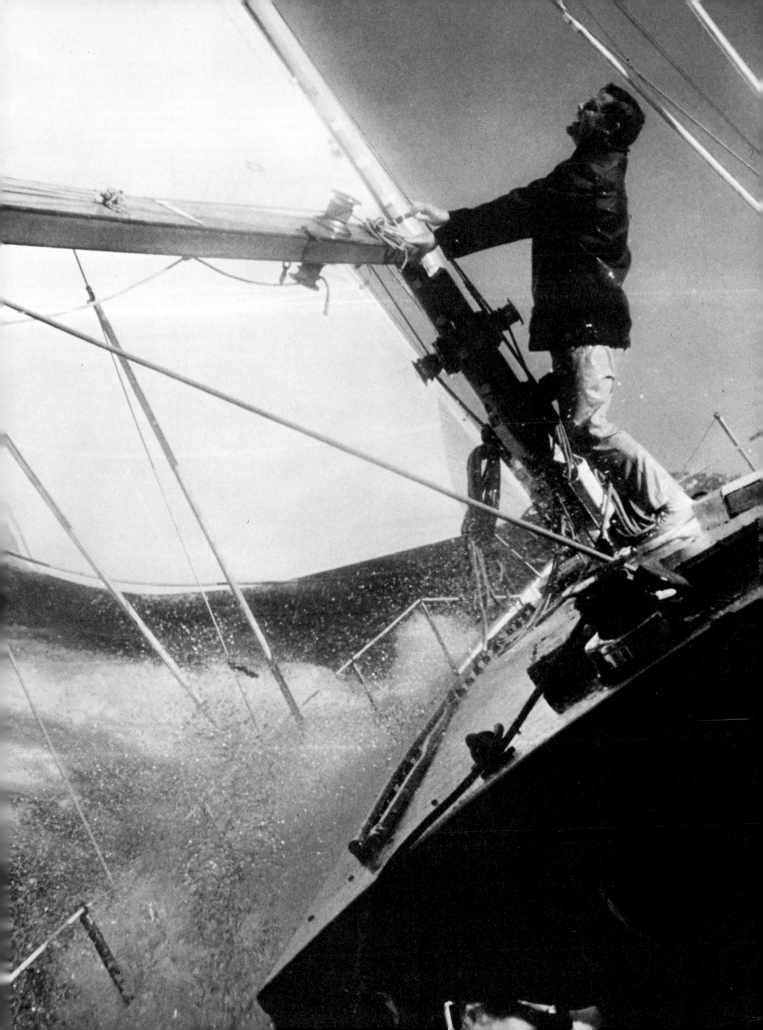

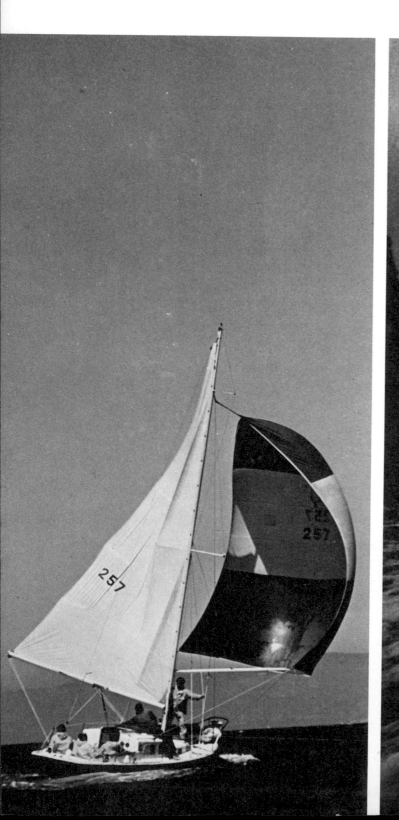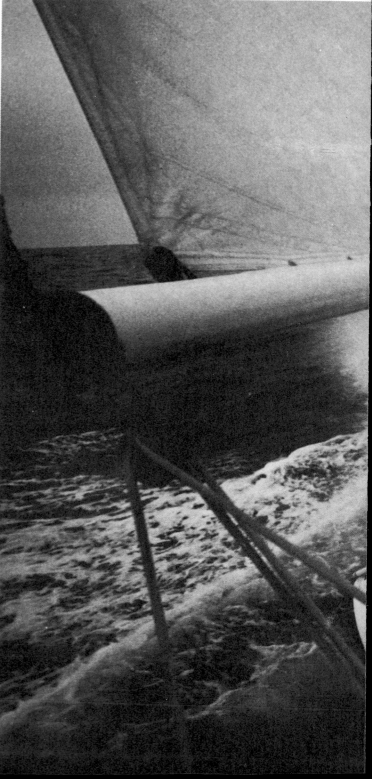

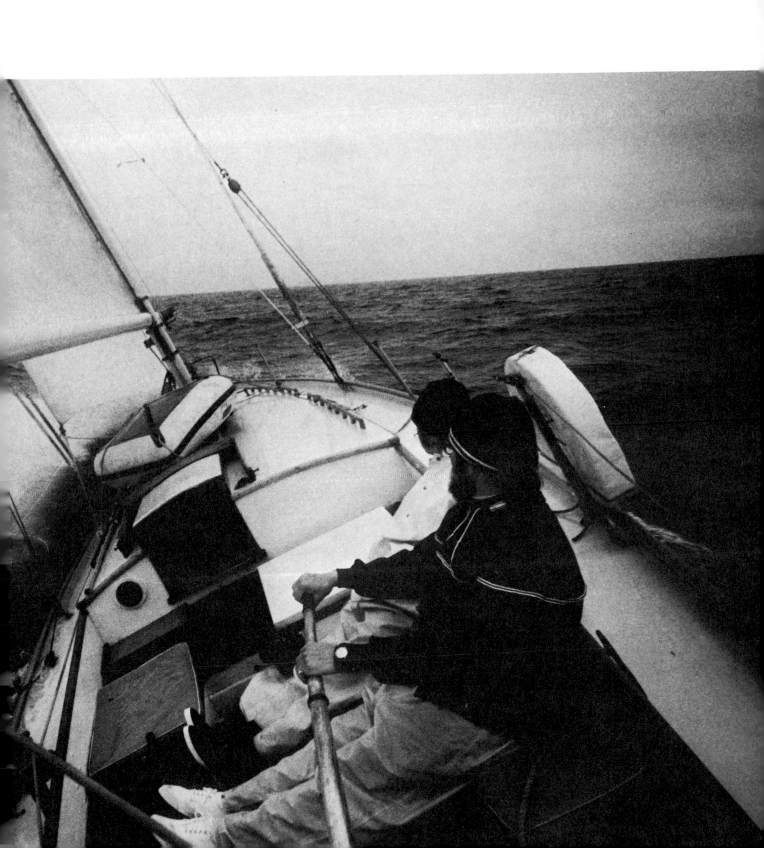

The clouds raced with her mastheads; they rose astern enormous and white, soared to the zenith, flew past, and, falling down the wide curve of the sky, seemed to dash headlong into the sea—the clouds swifter than the ship, more free, but without a home.

—*Joseph Conrad*

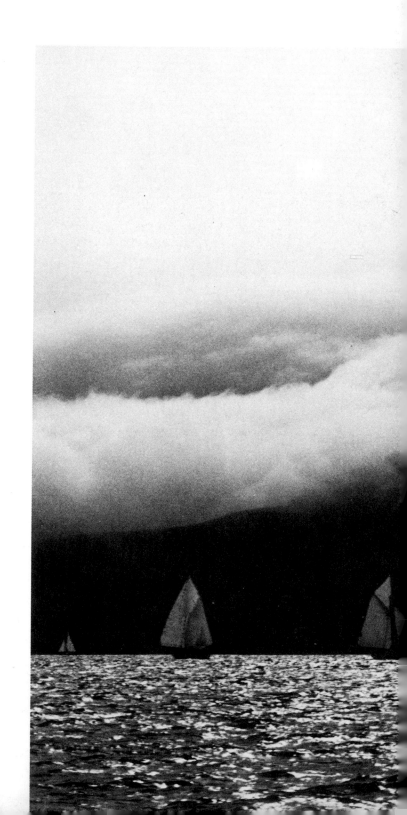

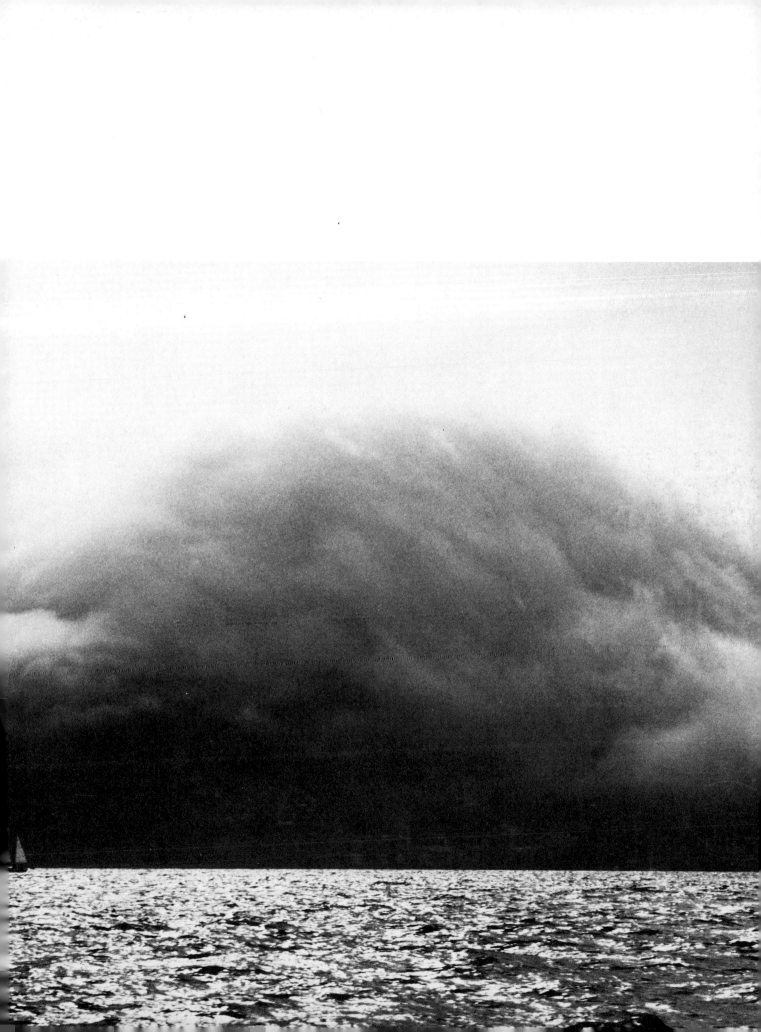

The tall masts are the pillars supporting the balanced planes that, motionless and silent, catch from the air the ship's motive-power, as it were a gift from Heaven vouchsafed to the audacity of man; and it is the ship's tall spars, stripped and shorn of their white glory, that incline themselves before the anger of the clouded heaven.

When they yield to a squall in a gaunt and naked submission, their tallness is brought best home even to the mind of a seaman. The man who has looked upon his ship going over too far is made aware of the preposterous tallness of a ship's spars. It seems impossible but that those gilt trucks which one had to tilt one's head back to see, now falling into the lower plane of vision, must perforce hit the very edge of the horizon. Such an experience gives you a better impression of the loftiness of your spars than any amount of running aloft could do. And yet in my time the royal yards of an average profitable ship were a good way up above her decks.

No doubt a fair amount of climbing up iron ladders can be achieved by an active man in a ship's engine-room, but I remember moments when even to my supple limbs and pride of nimbleness the sailing-ship's machinery seemed to reach up to the very stars.

For machinery it is, doing its work in perfect silence and with a motionless grace, that seems to hide a capricious and not always governable power, taking nothing away from the material stores of the earth. Not for it the unerring precision of steel moved by white steam and living by red fire and fed with black coal. The other seems to draw its strength from the very soul of the world, its formidable ally, held to obedience by the frailest bonds, like a fierce ghost captured in a snare of something even finer than spun silk. For what is the array of the strongest ropes, the tallest spars, and the stoutest canvas against the mighty breath of the infinite, but thistle stalks, cobwebs, and gossamer?

—*Joseph Conrad*

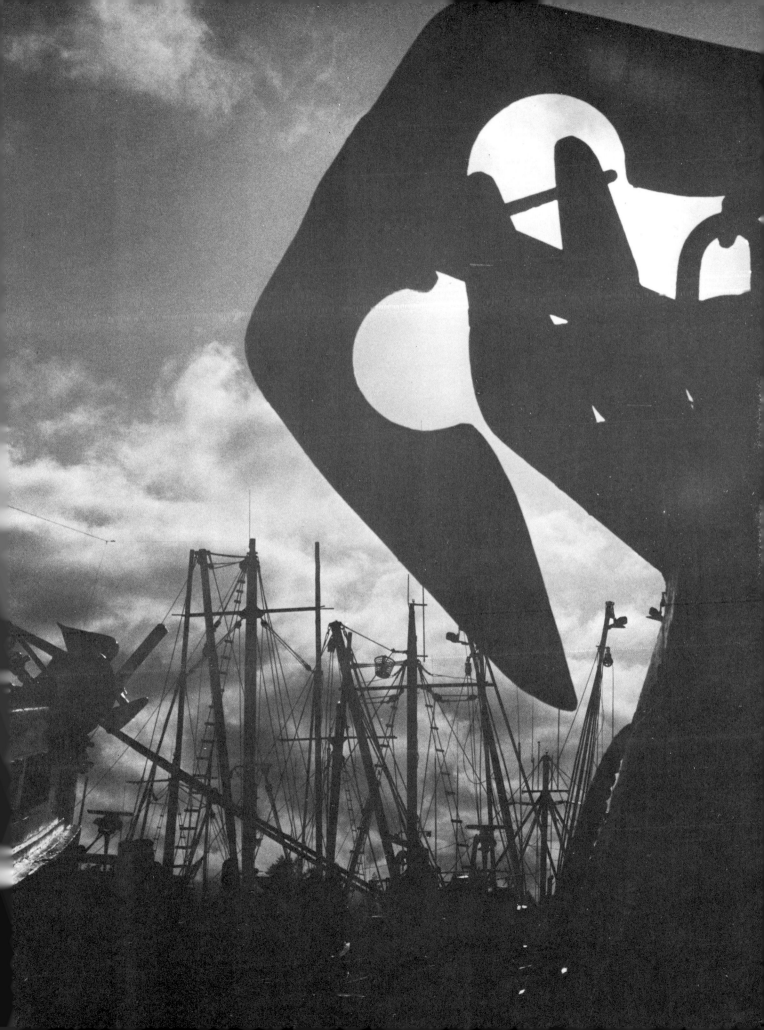

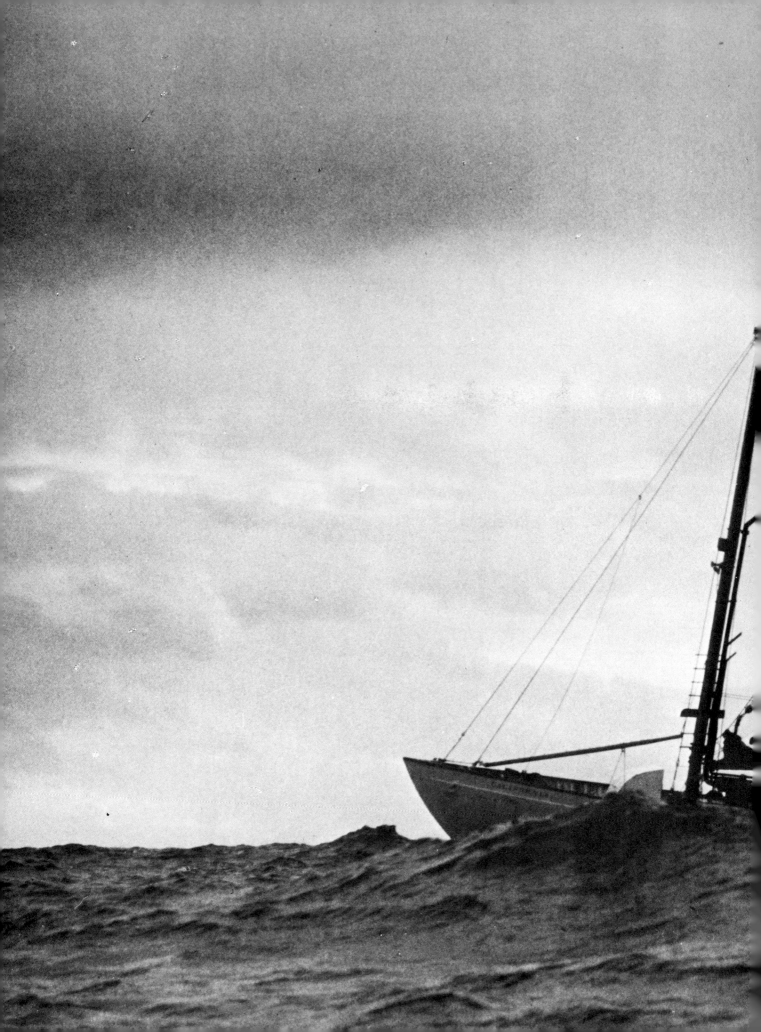

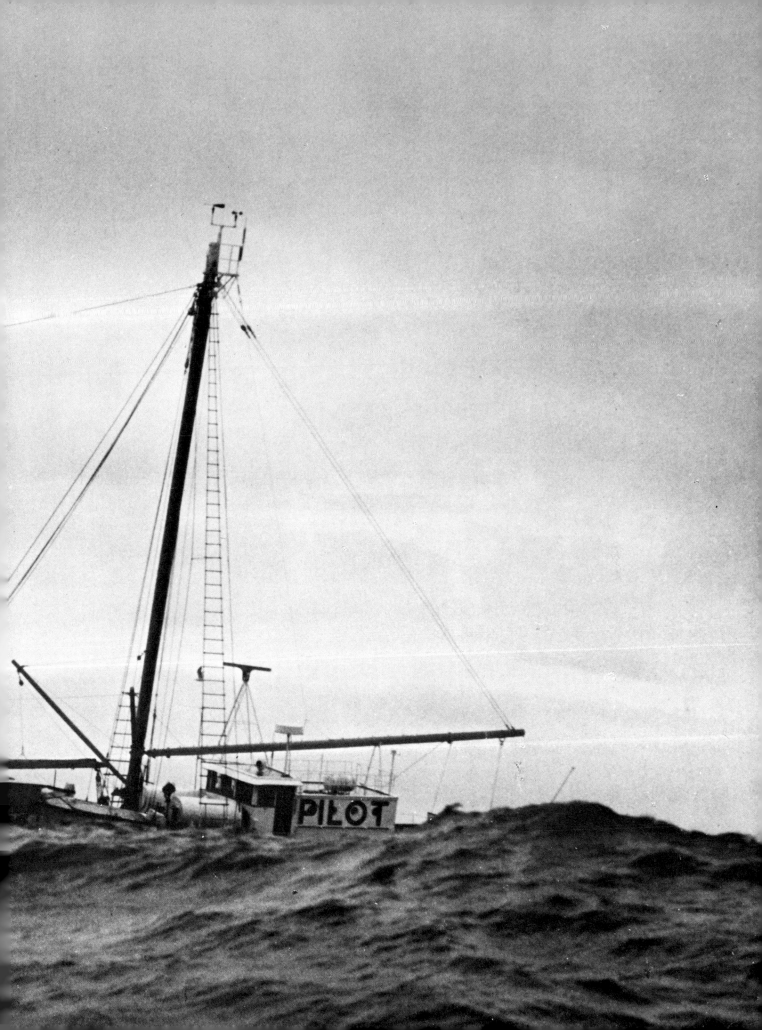

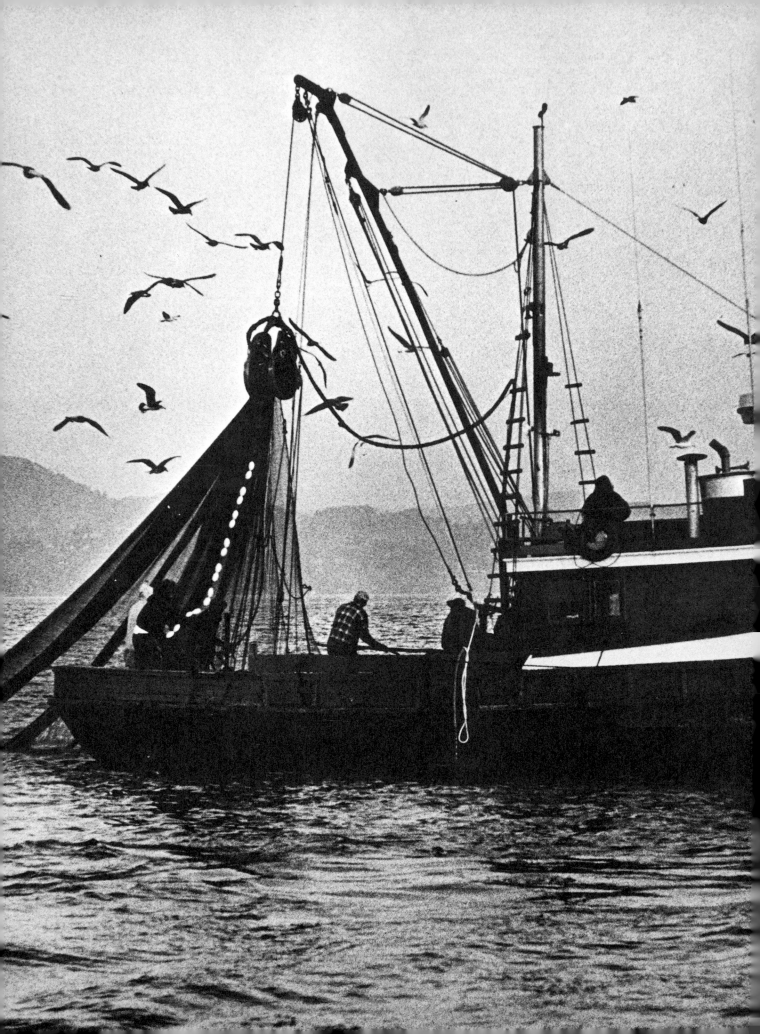

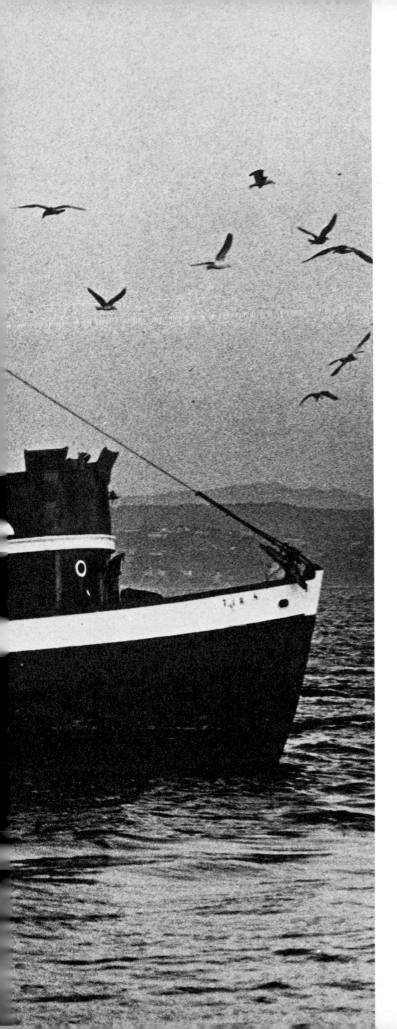

The osprey sails about the sound,
The geese are gone, the gulls are flying;
The herring shoals swarm thick around,
The nets are launched, the boats are plying;
Yo ho, my hearts! let's seek the deep.
Raise high the song, and cheerily wish her,
Still as the bending net we sweep.
"God bless the fish-hawk and the fisher!"

She brings us fish—she brings us spring,
Good times, fair weather, warmth, and
 plenty,
Fine stores of shad, trout, herring, ling,
Sheepshead and drum, and old-wives dainty.
Yo ho, my hearts! let's seek the deep,
Ply every oar, and cheerily wish her,
Still as the bending net we sweep,
"God bless the fish-hawk and the fisher!"

She rears her young on yonder tree,
She leaves her faithful mate to mind 'em;
Like us, for fish, she sails to sea,
And, plunging, shows us where to find 'em.
Yo ho, my hearts! let's seek the deep,
Ply every oar, and cheerily wish her,
While the slow bending net we sweep,
"God bless the fish-hawk and the fisher!"

—Alexander Wilson

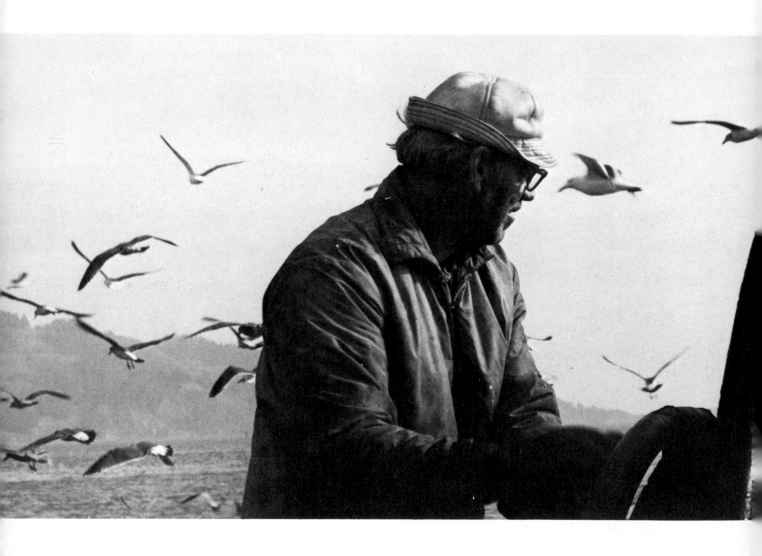

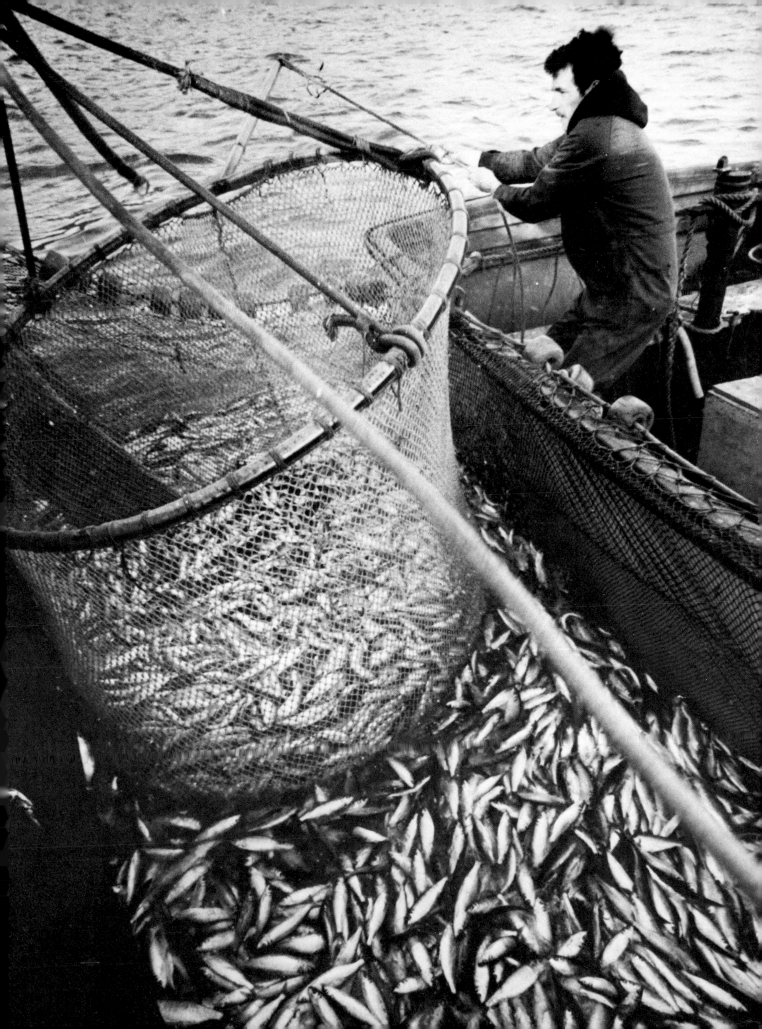

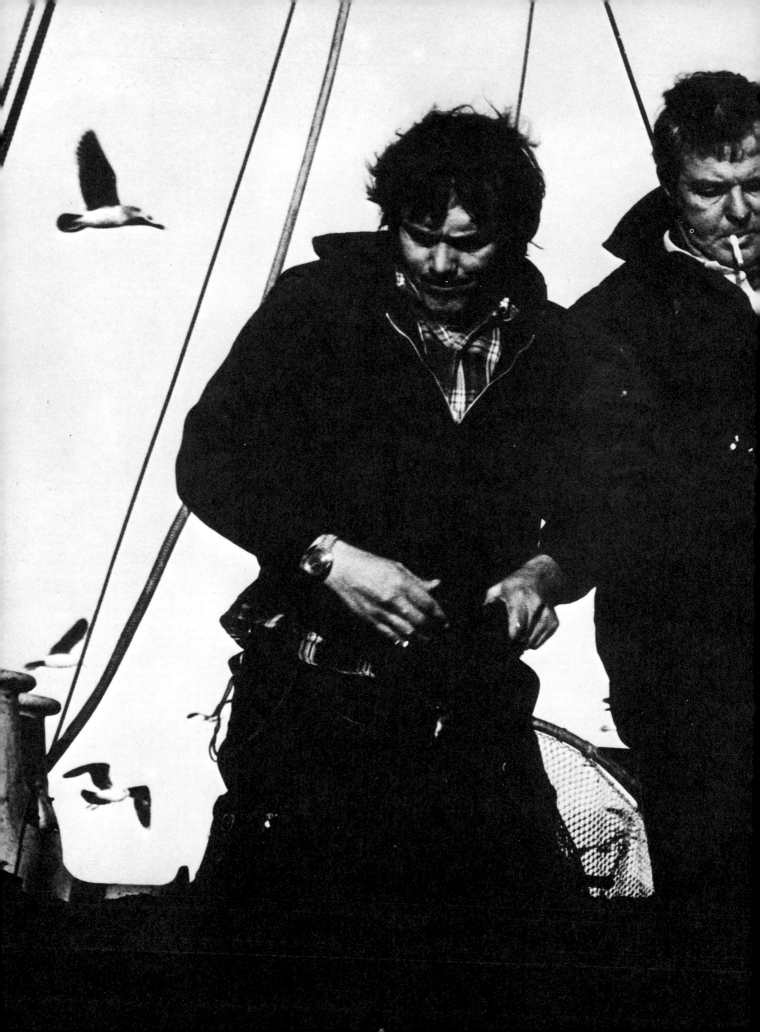

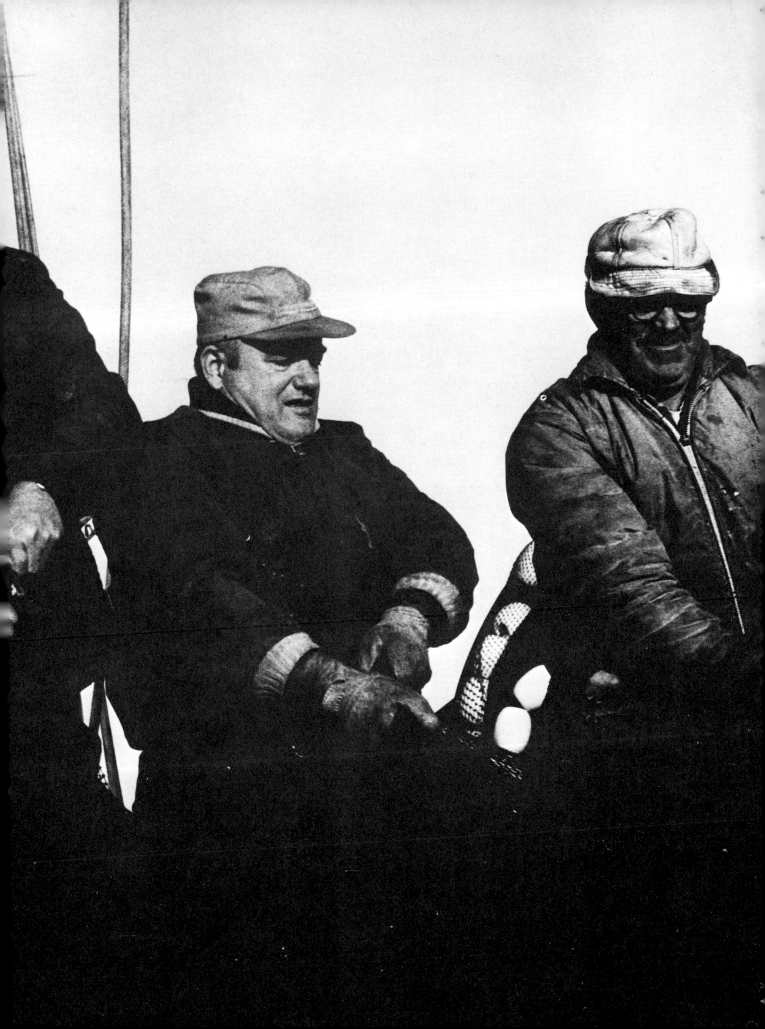

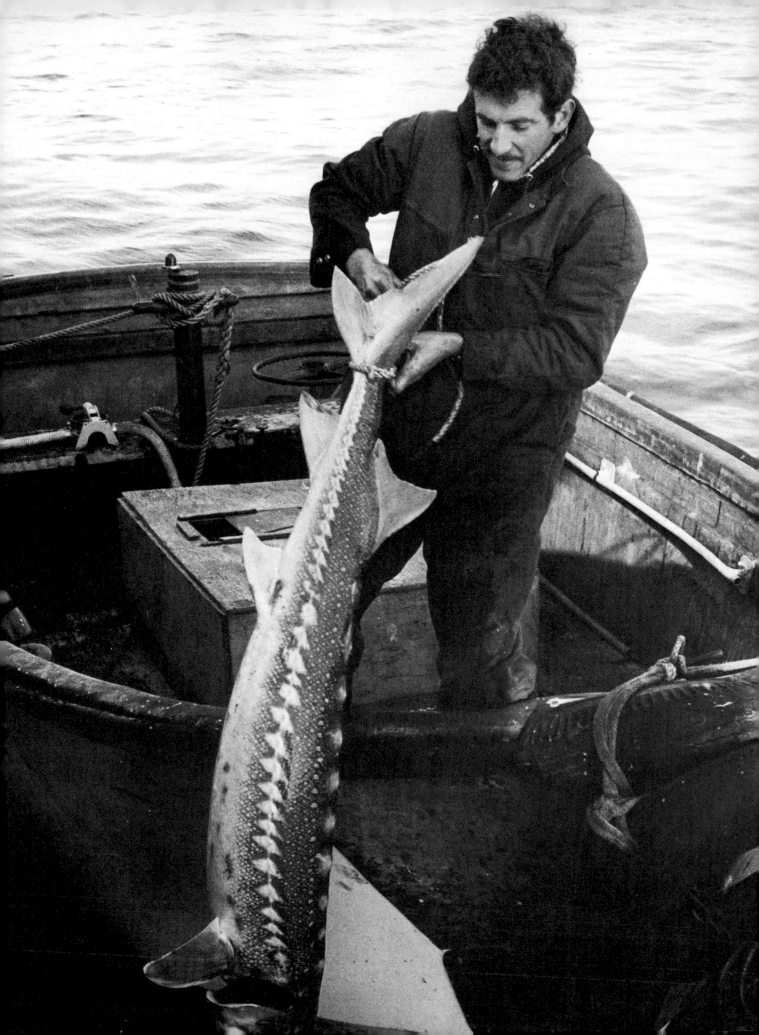

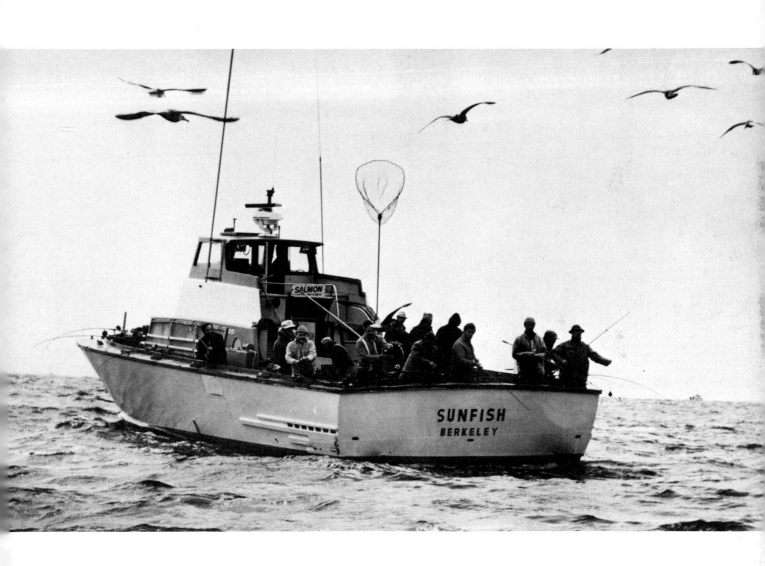

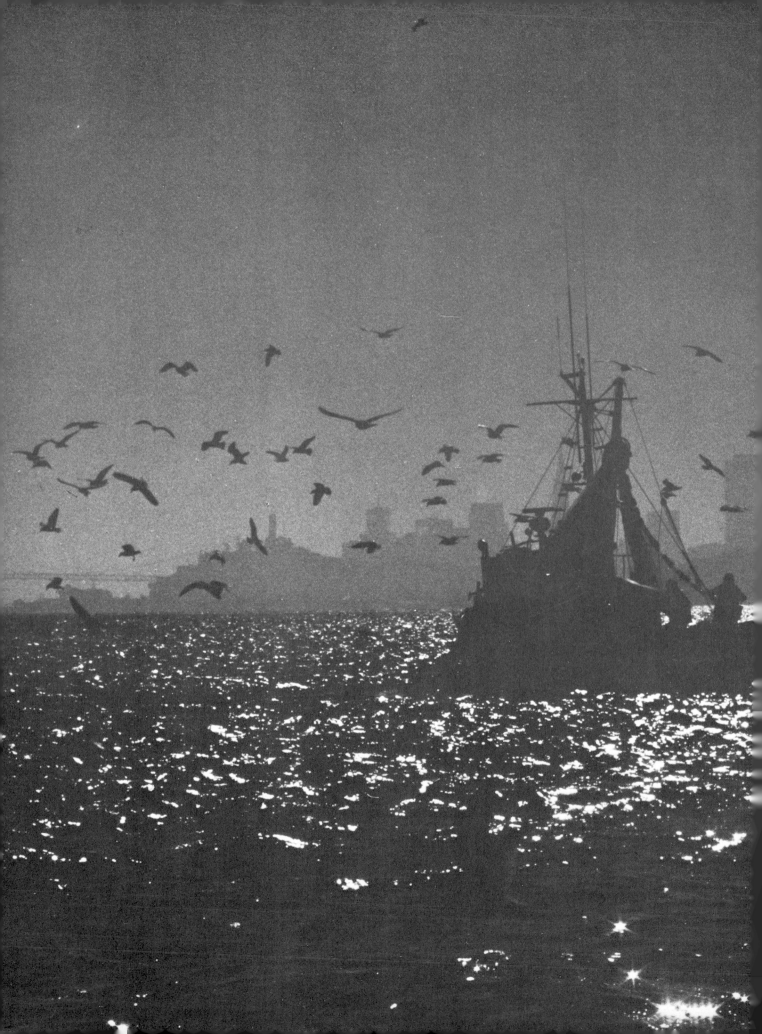

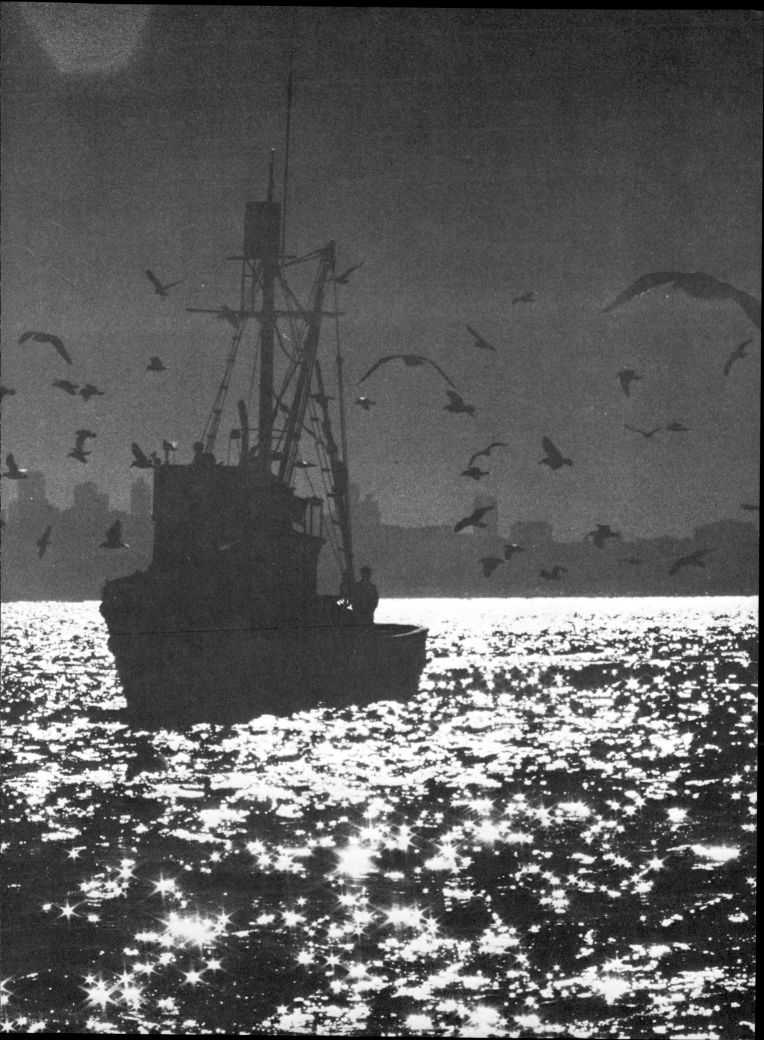

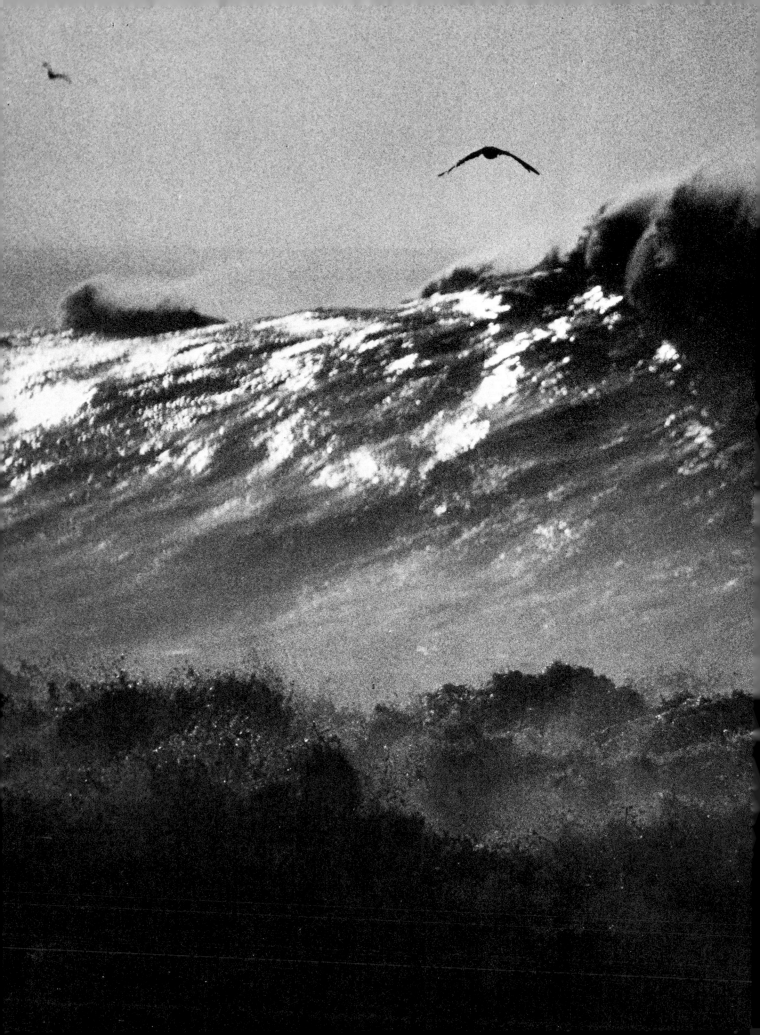

The birds have a harder life than we do except for the robber birds and the heavy strong ones. Why did they make birds so delicate and fine as those sea swallows when the ocean can be so cruel? She is kind and very beautiful. But she can be so cruel and it comes so suddenly and such birds that fly, dipping and hunting, with their small sad voices are made too delicately for the sea.

—*Ernest Hemingway*

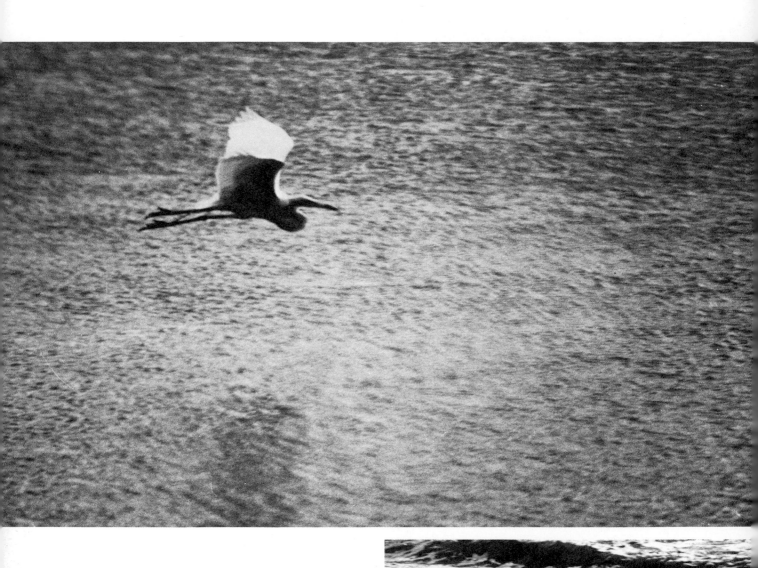

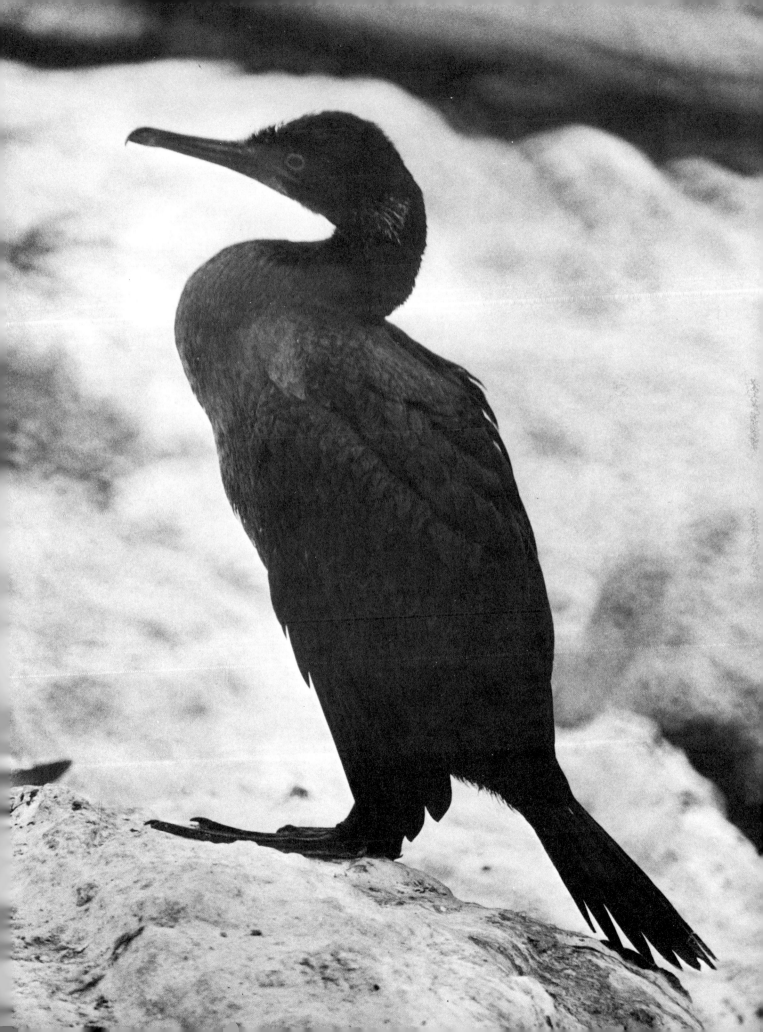

This day we saw the last of the albatrosses, which had been our companions a great part of the time off the Cape. I had been interested in the bird from descriptions which I had read of it, and was not all disappointed. We caught one or two with a baited hook which we floated astern upon a shingle. Their long, flapping wings, long legs, and large, staring eyes, give them a very peculiar appearance. They look well on the wing: but one of the finest sights that I have ever seen, was an albatross asleep upon the water, during a calm, off Cape Horn, when a heavy sea was running.

There being no breeze, the surface of the water was unbroken, but a long, heavy swell was rolling, and we saw the fellow, all white, directly ahead of us, asleep upon the waves, with his head under his wing; now rising on the top of a huge billow, and then falling slowly until he was lost in the hollow between. He was undisturbed for some time, until the noise of our bows, gradually approaching, roused him, when, lifting his head, he stared upon us for a moment, and then spread his wide wings and took his flight.

—*Richard Henry Dana*

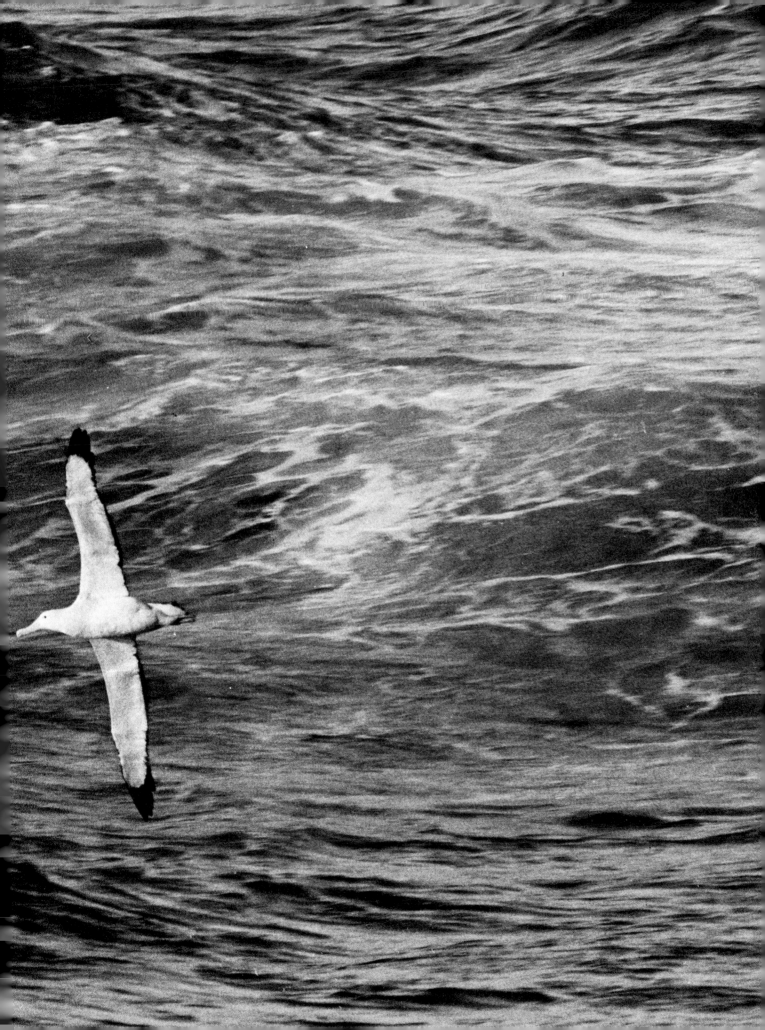

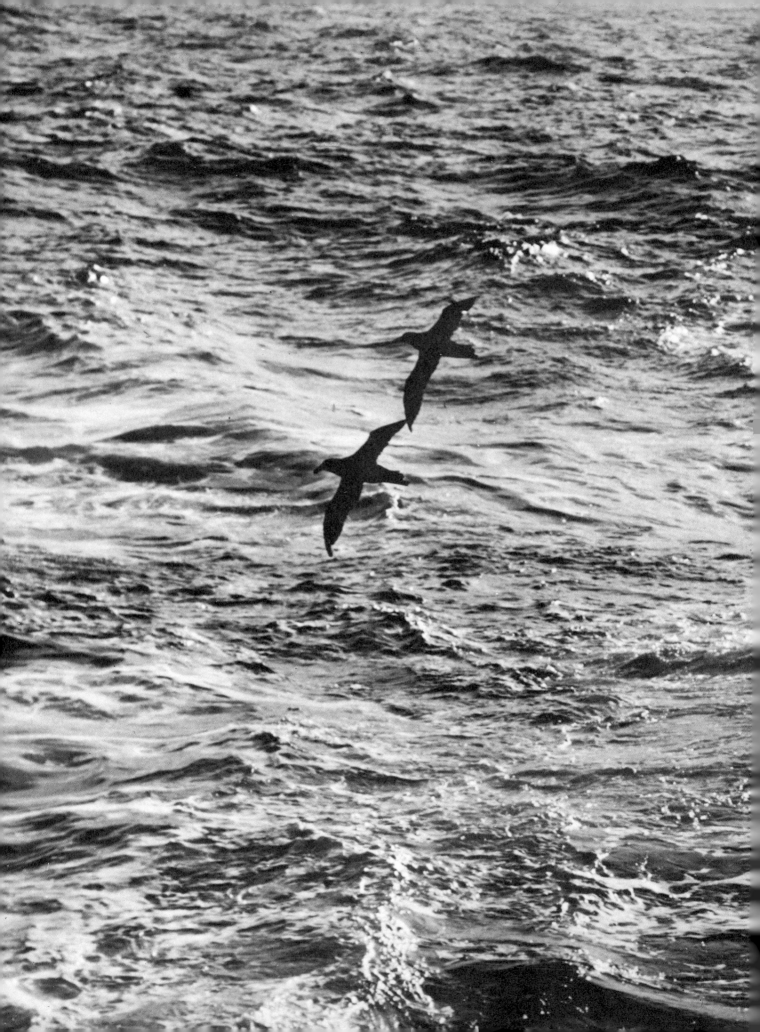

I have done my bit of carving,
Figureheads of quaint design,
For the Olives and the Ruddocks,
And the famous Black Ball Line.
Brigantines and barques and clippers,
Brigs and schooners, lithe and tall,
But the bounding *Marco Polo*
Was the proudest of them all.

I can see that white-winged clipper
Reeling under scudding clouds,
Tramping down a hazy sky-line,
With a Norther in her shrouds.
I can feel her lines of beauty,
See her flecked with spume and brine,
As she drives her scuppers under,
And that figurehead of mine.

'Twas of seasoned pine I made it,
Clear from outer bark to core,
And the finest piece of timber
From the mast-pond on Straight Shore.
Every bite of axe or chisel,
Every ringing mallet welt,
Brought from out that block of timber
All the spirit that I felt.

I had read of Marco Polo
Till his daring deeds were mine,
And I saw them all aglowing
In that balsam-scented pine;
Saw his eyes alight with purpose,
Facing every vagrant breeze;
Saw him lilting, free and careless,
Over all the Seven Seas.

That was how I did my carving;
Beat of heart and stroke of hand
Blended into life and action
All the purpose that I planned;
Flowing robes and wind-tossed tresses,
Forms of beauty, strength, design—
Saw them all, and strove to carve them
In those figureheads of mine.

I am old, my hands are feeble,
And my outward eyes are dim,
But I see again those clippers
Lifting o'er the ocean's rim;
Great white fleet of reeling rovers,
Wind above, the surf beneath,
And the *Marco Polo* leading
With my carving in her teeth.

—H. A. Cody

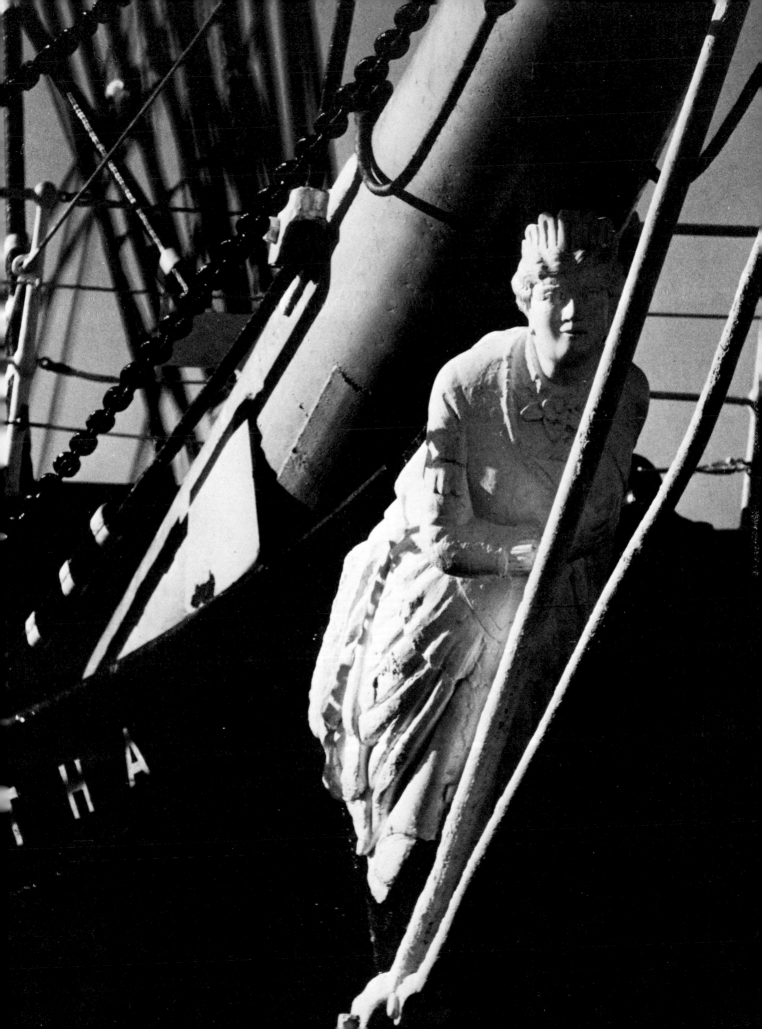

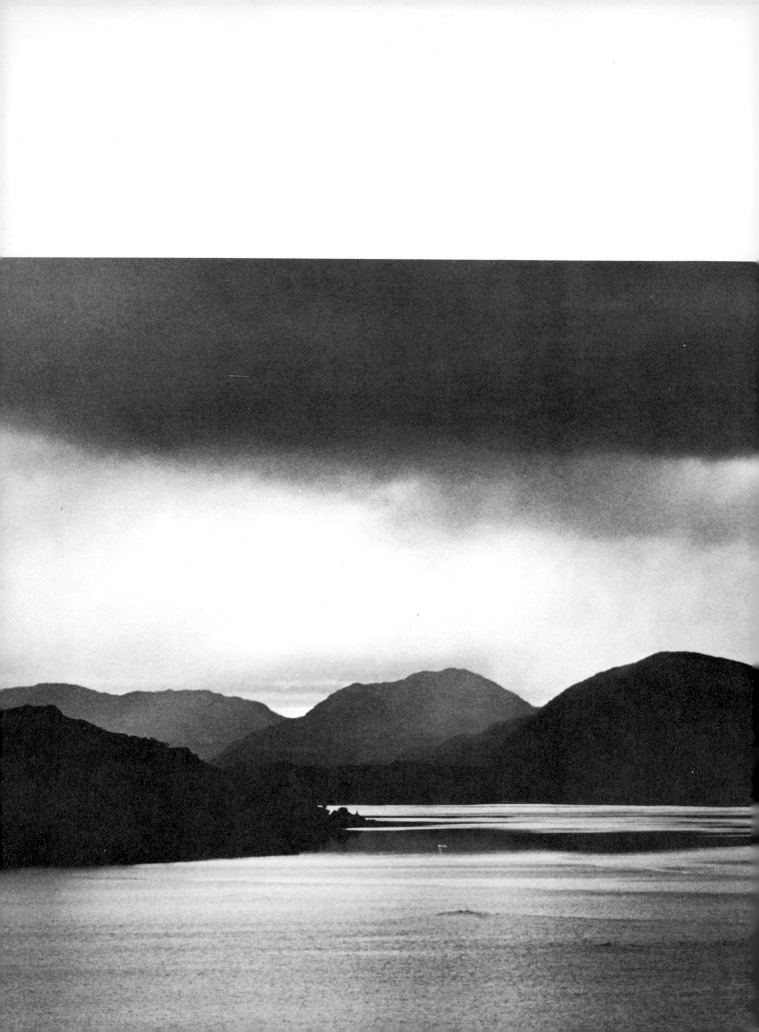

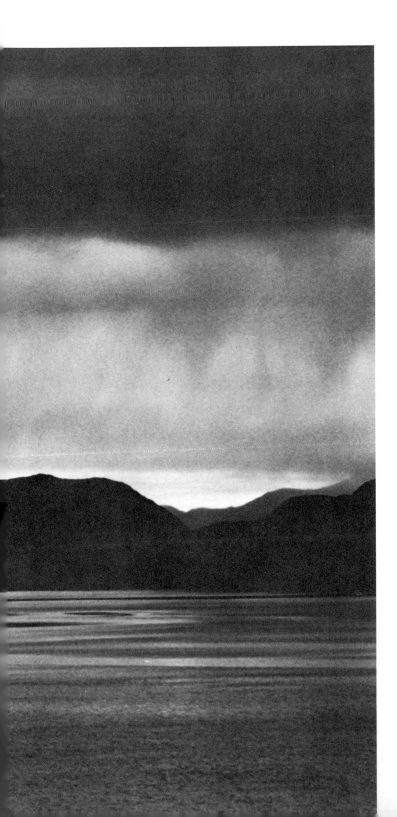

When it wishes to be, the sea is gay. No other joy has the radiance of the sea. The ocean is brightness itself. Nothing can cast a shadow upon it save the cloud, and it chases the shadow away with a puff. If you do not look beneath the surface, the ocean is liberty—and equality also. At this level every gleam radiates contentedly. The all-encompassing merriment of the clear sky sprawls everywhere. The tranquil sea is a holiday. No siren's call is sweeter or more seductive. Not a sailor but would be tempted to set out. There is nothing to equal this serenity; the whole immensity is but a caress. The waters sigh and the reef sings, the algae kiss the rock, the gulls and the pintails fly, and the soft meadows of the sea undulate from billow to billow; under the halcyons' nests the water seems like a nurse, the wave like a cradle, while the sun covers over those formidable hypocrisies of the deep with a blinding layer of light.

—*Victor Hugo*

The three great elemental sounds in nature are the sound of rain, the sound of wind in a primeval wood, and the sound of outer ocean on a beach. I have heard them all, and of the three elemental voices, that of ocean is the most awesome, beautiful, and varied. For it is a mistake to talk of the monotone of ocean or of the monotonous nature of its sound. The sea has many voices. Listen to the surf, really lend it your ears, and you will hear in it a world of sounds: hollow boomings and heavy roarings, great watery tumblings and tramplings, long hissing seethes, sharp, rifle-shot reports, splashes, whispers, the grinding undertone of stones, and sometimes vocal sounds that might be the half-heard talk of people in the sea. And not only is the great sound varied in the manner of its making, it is also constantly changing its tempo, its pitch, its accent, and its rhythm, being now loud and thundering, now almost placid, now furious, now grave and solemn-slow, now a simple measure, now a rhythm monstrous with a sense of purpose and elemental will.

Every mood of the wind, every change in the day's weather, every phase of the tide—all these have subtle sea musics all their own. Surf of the ebb, for instance, is one music, surf of the flood another, the change in the two musics being most clearly marked during the first hour of a rising tide. With the renewal of the tidal energy, the sound of the surf grows louder, the fury of battle returns to it as it turns again on the land, and beat and sound change with the renewal of the war.

—*Henry Beston*

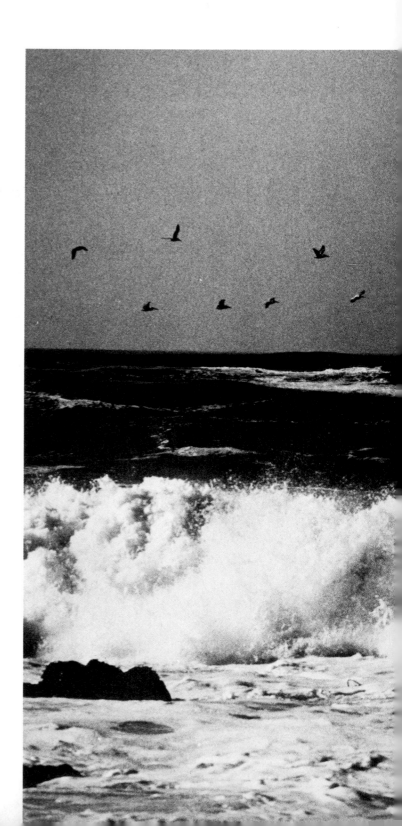

140

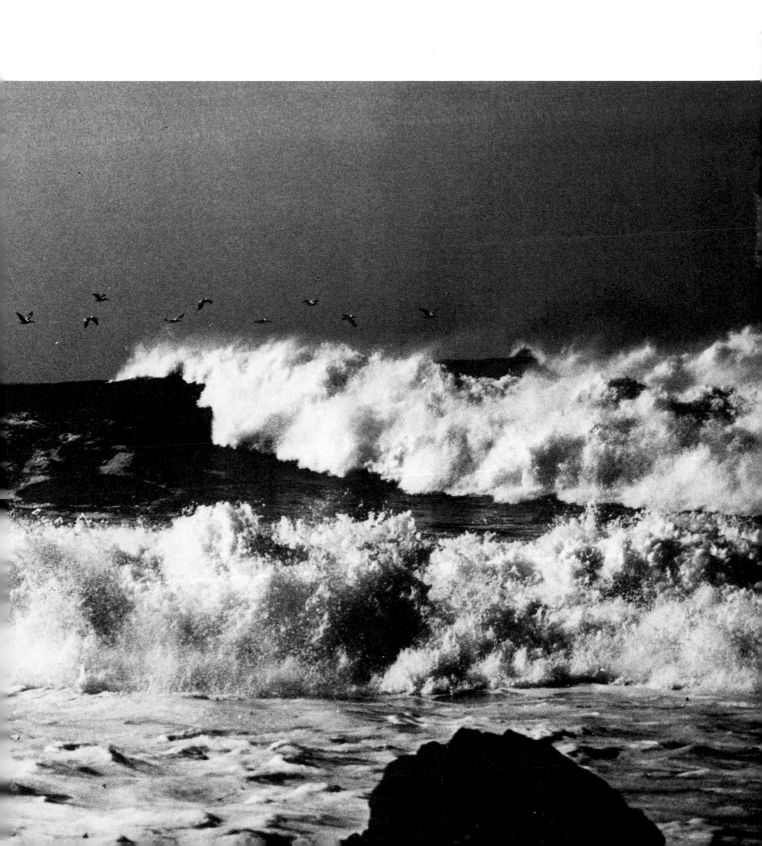

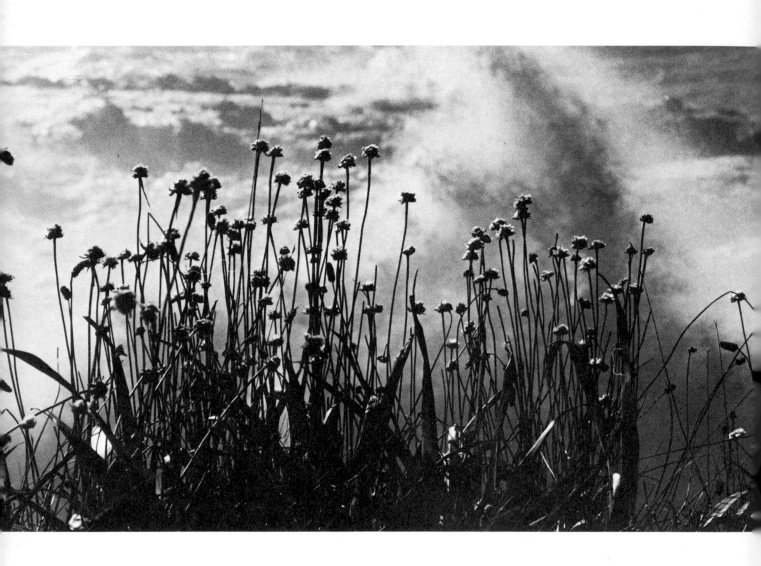

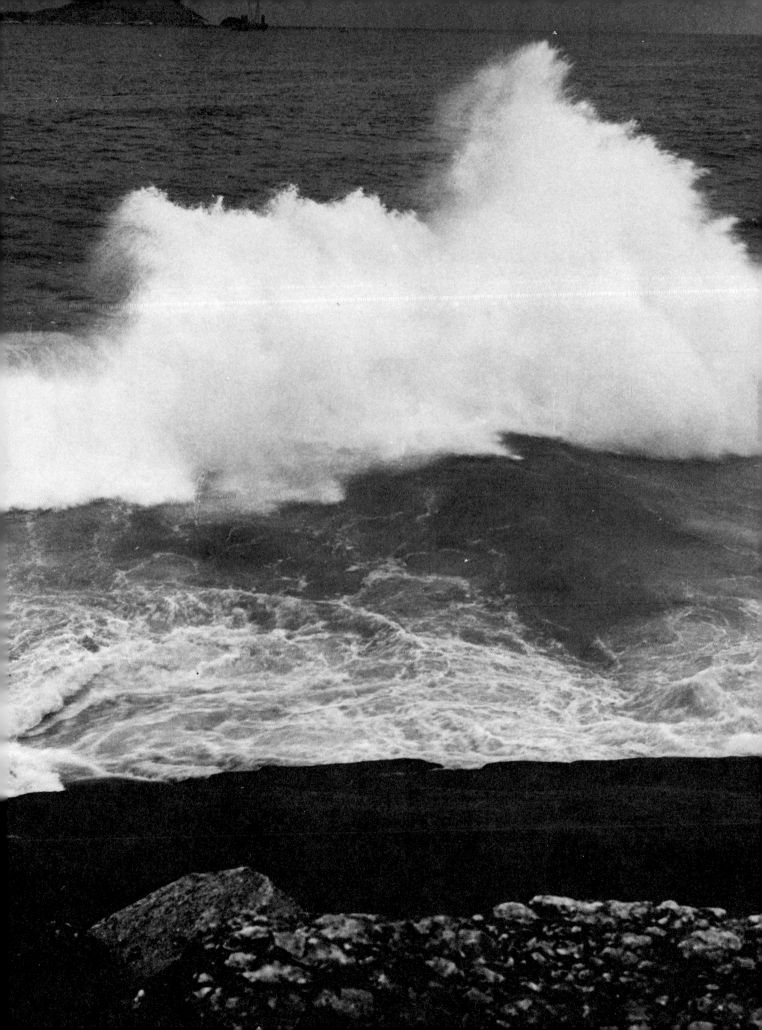

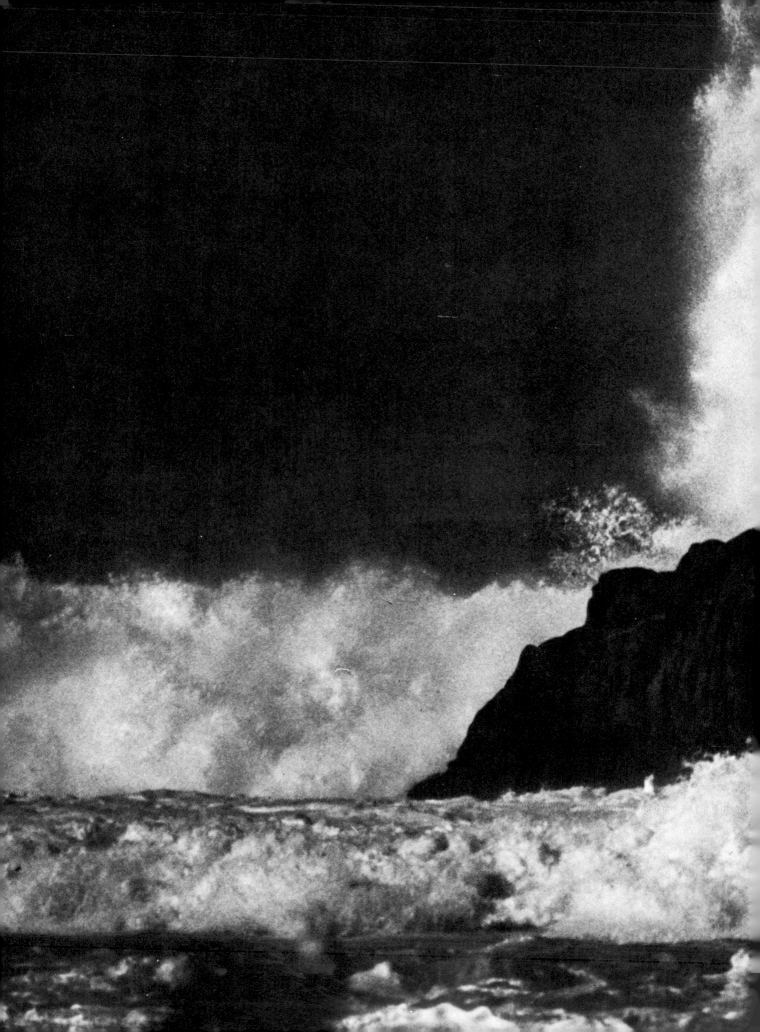

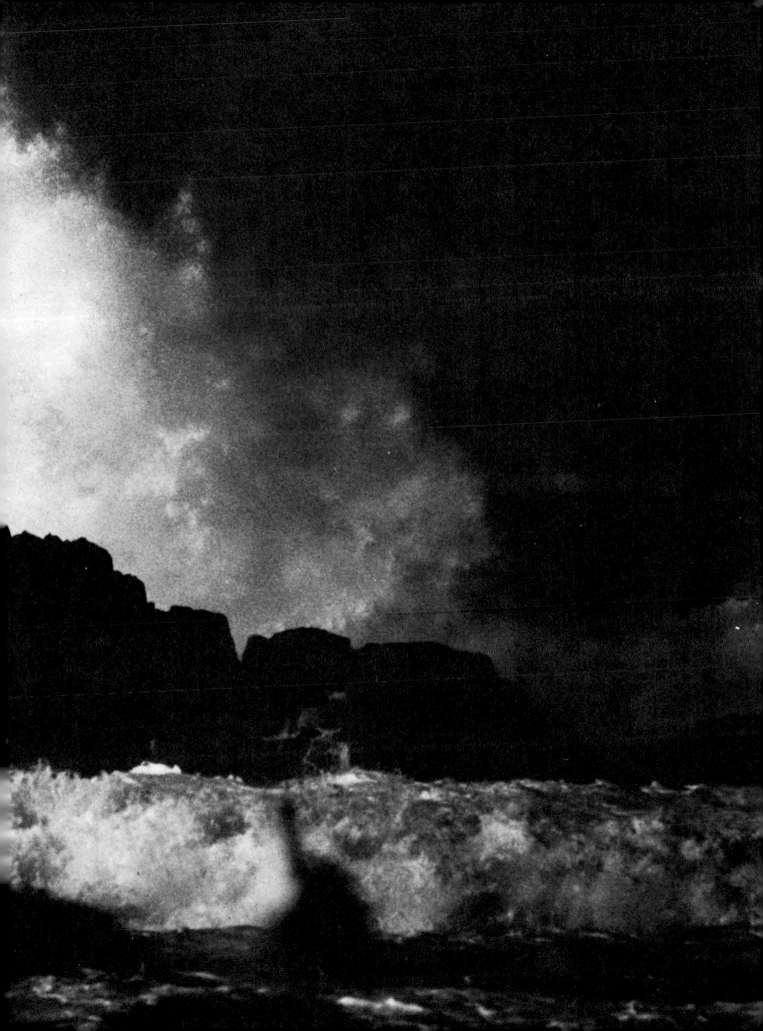

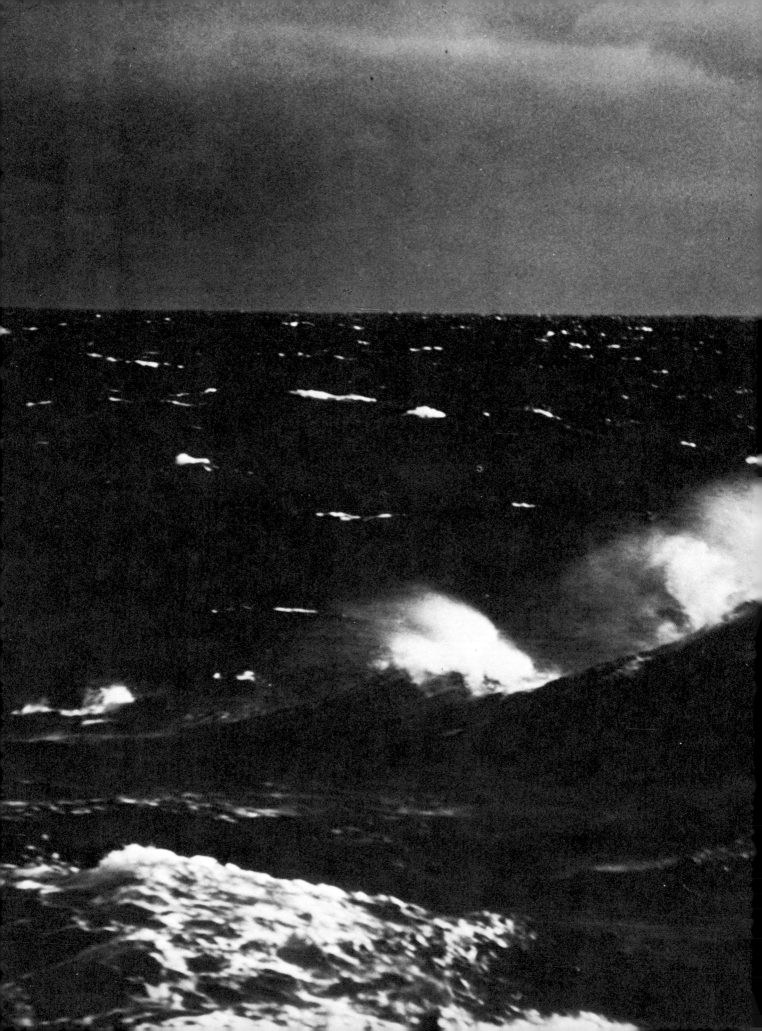

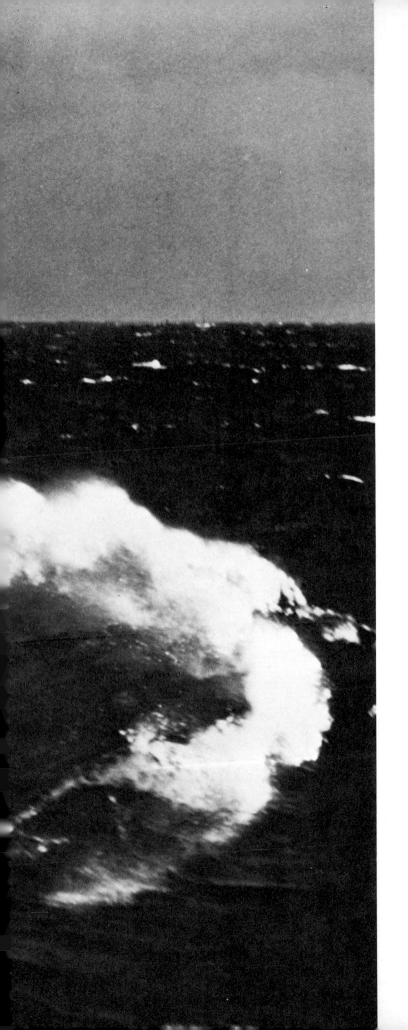

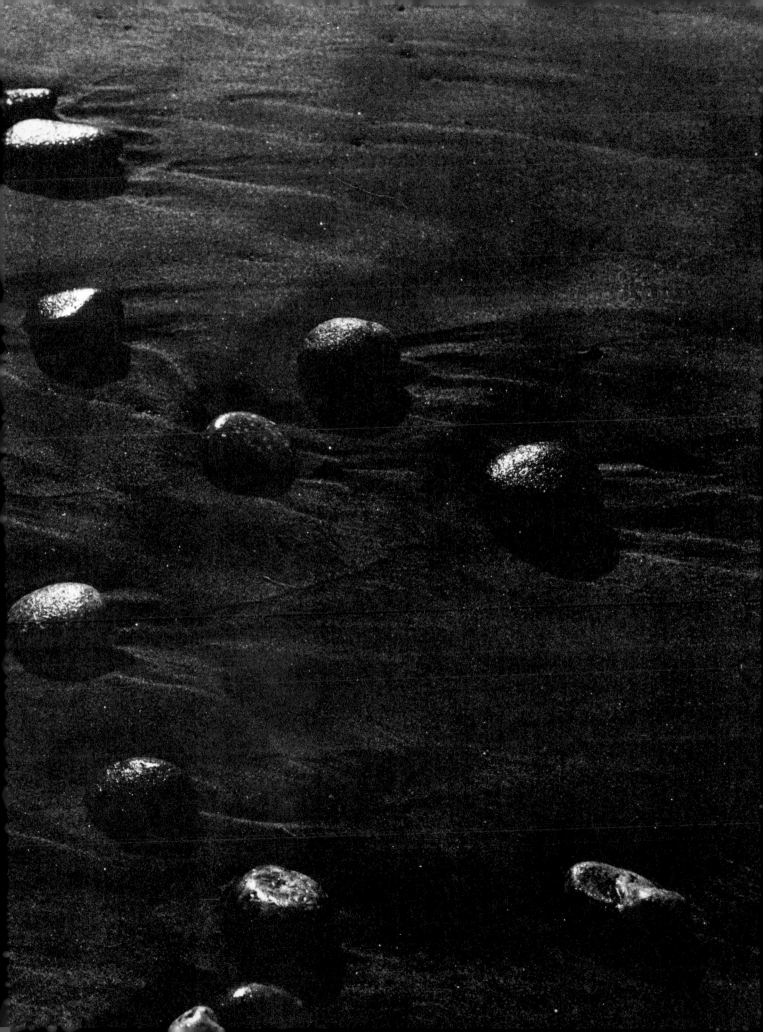

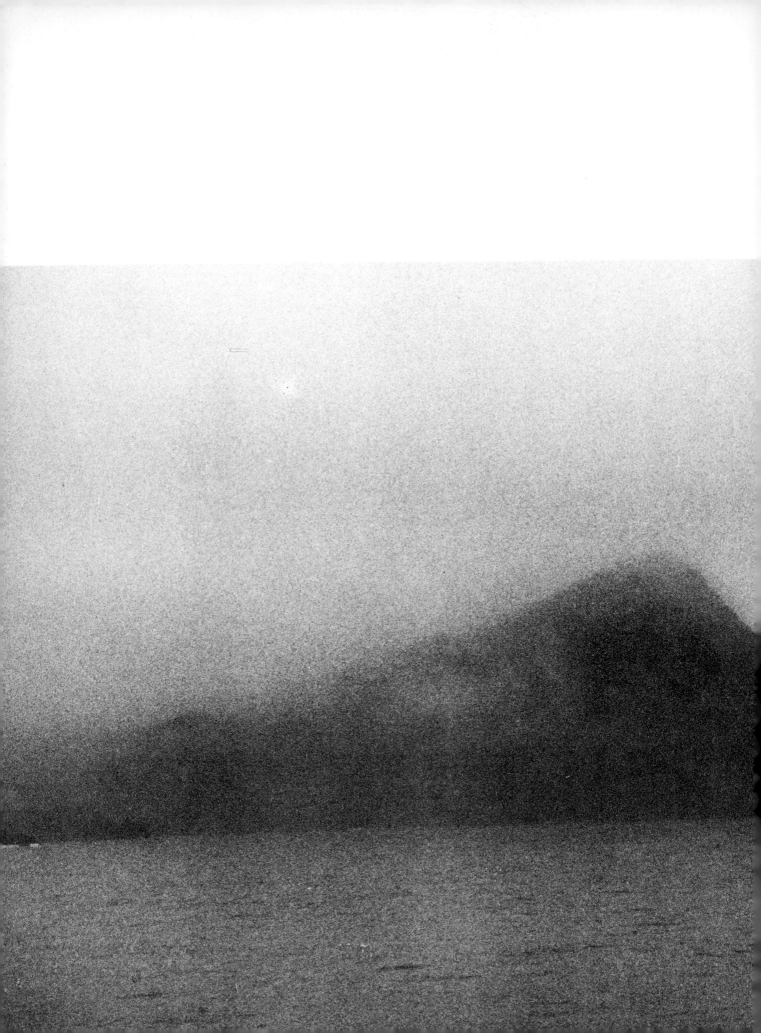

About midnight the fog shut down again denser than ever before. One could almost "stand on it." It continued so for a number of days, the wind increasing to a gale. The waves rose high, but I had a good ship. Still, in the dismal fog I felt myself drifting into loneliness, an insect on a straw in the midst of the elements.

—*Capt. Joshua Slocum*

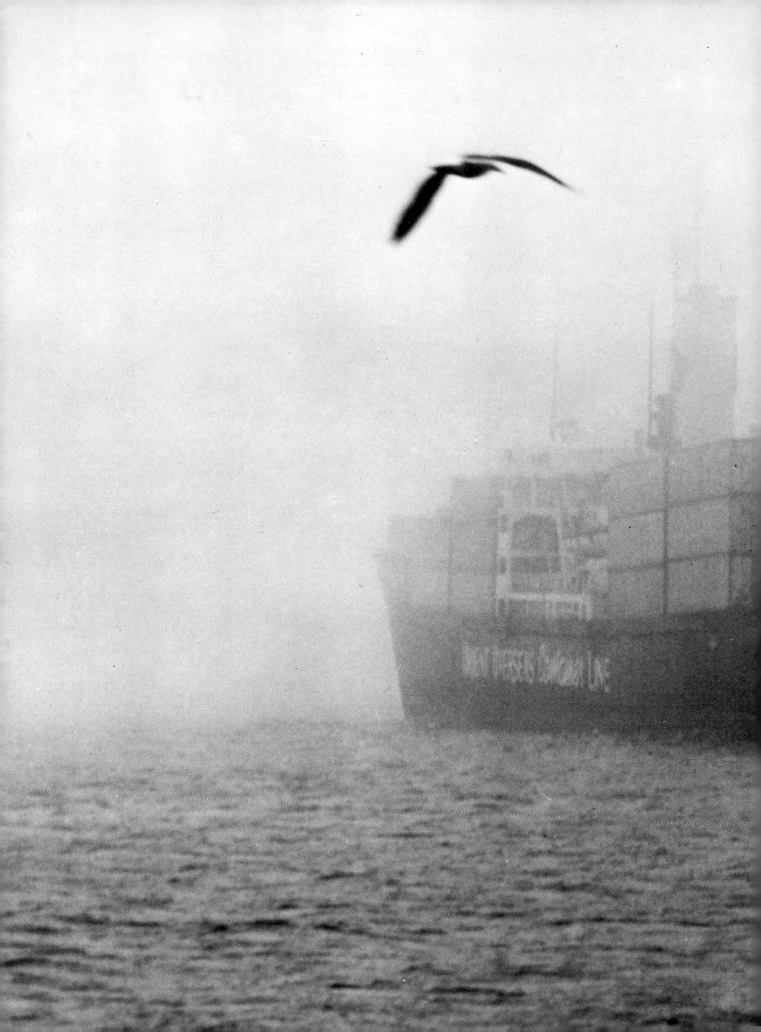

The sky was covered with a white veil, which darkened towards its lower border near the horizon, and gradually passed into dull grey leaden tints; over this the still waters threw a pale light, which fatigued the eyes and chilled the gazer through and through. All at once, liquid designs played over the surface, such light evanescent rings as one forms by breathing on a mirror. The sheen of the waters seemed covered with a net of faint patterns, which intermingled and reformed, rapidly disappearing. Everlasting night, or everlasting day, one could scarcely say what it was; the sun, which pointed to no special hour of the day, remained fixed, as if presiding over the fading glory of dead things; it appeared but as a mere ring, being almost without substance, and magnified enormously by a shifting halo.

—*Pierre Loti*

154

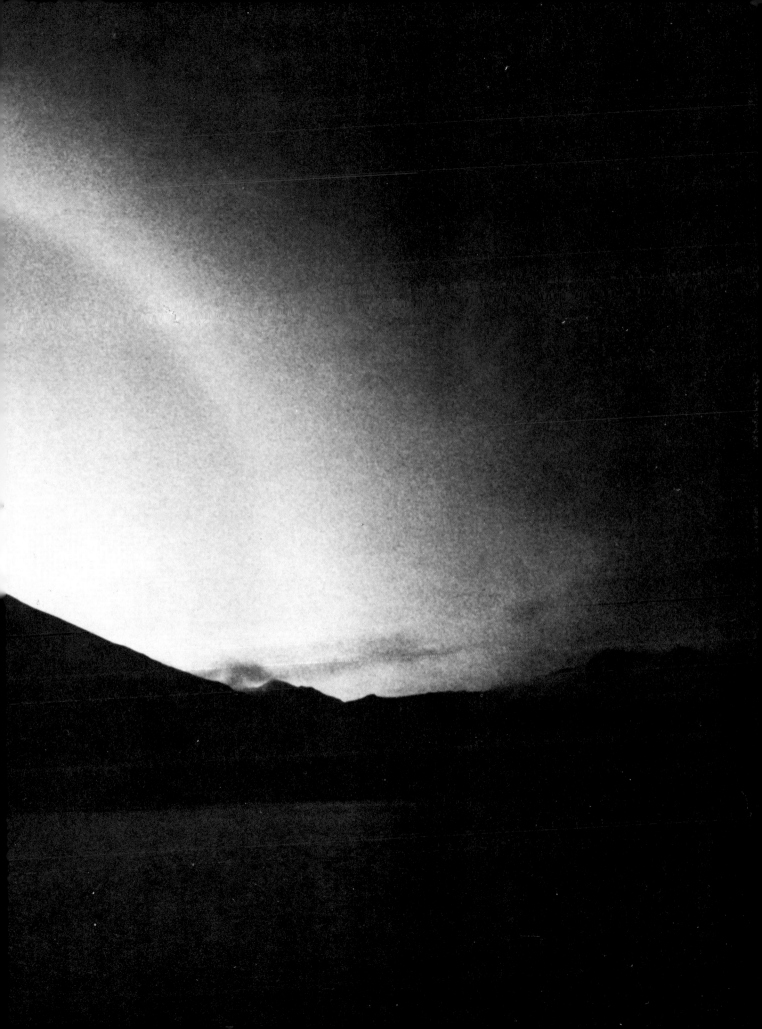

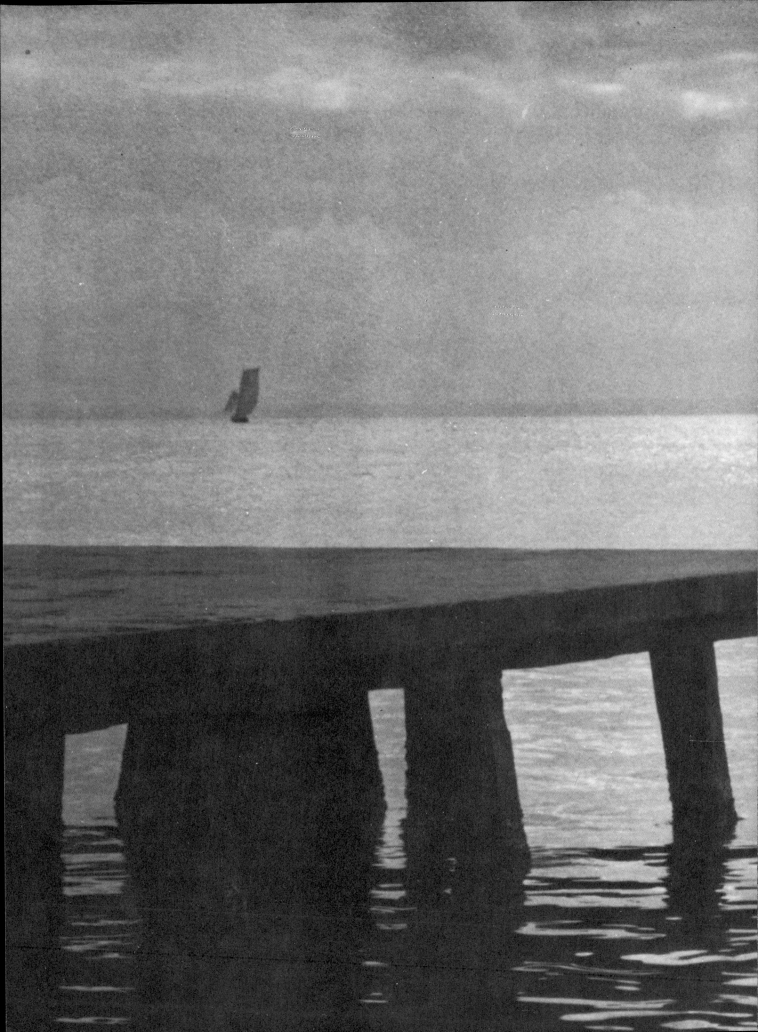

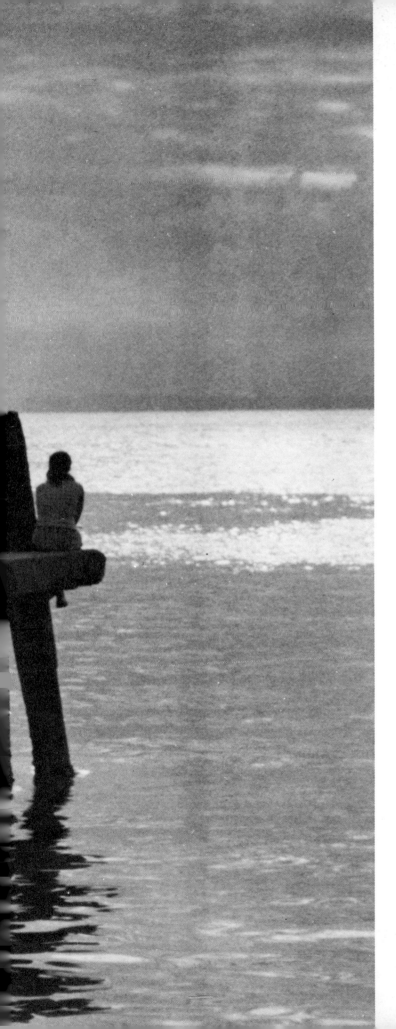

The seashore is a sort of neutral ground, a most advantageous point from which to contemplate this world. It is even a trivial place. The waves forever rolling to the land are too far-traveled and untamable to be familiar. Creeping along the endless beach amid the sun-squawl and the foam, it occurs to us that we, too, are the product of sea-slime.

It is a wild, rank place, and there is no flattery in it. Strewn with crabs, horse-shoes, and razor-clams, and whatever the sea casts up—a vast *morgue*, where famished dogs may range in packs, and crows come daily to glean the pittance which the tide leaves them. The carcasses of men and beasts together lie stately up upon its shelf, rotting and bleaching in the sun and waves, and each tide turns them in their beds, and tucks fresh sand under them. There is naked Nature—inhumanly sincere, wasting no thought on man, nibbling at the cliffy shore where gulls wheel amid the spray.

—*Henry David Thoreau*

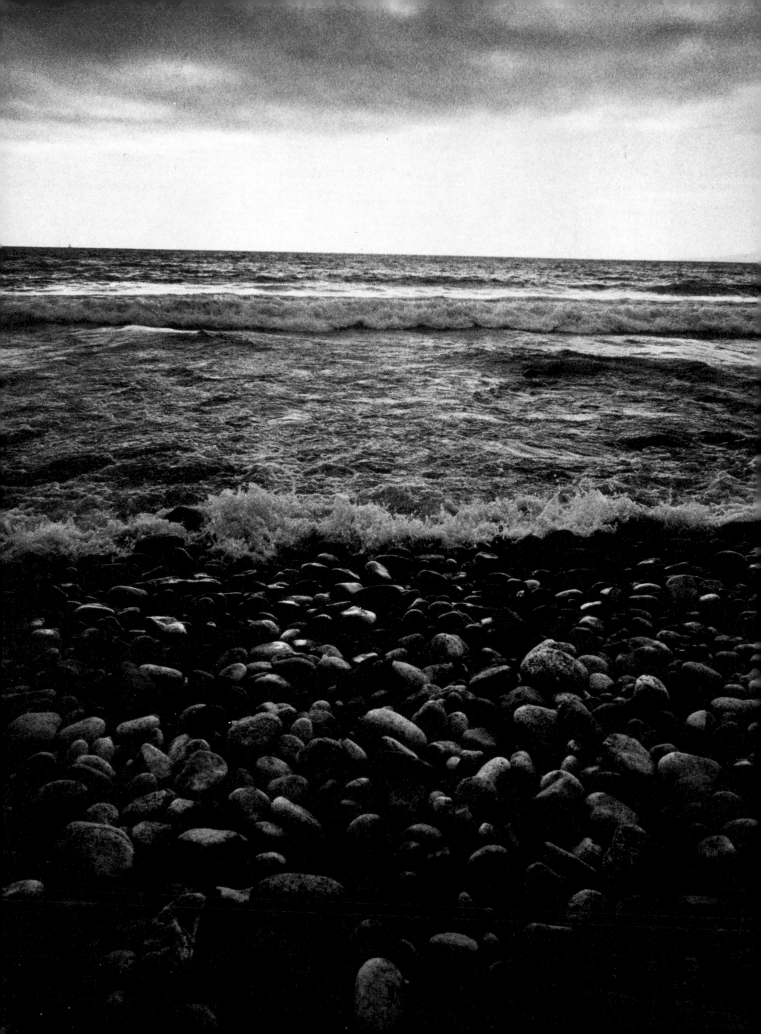

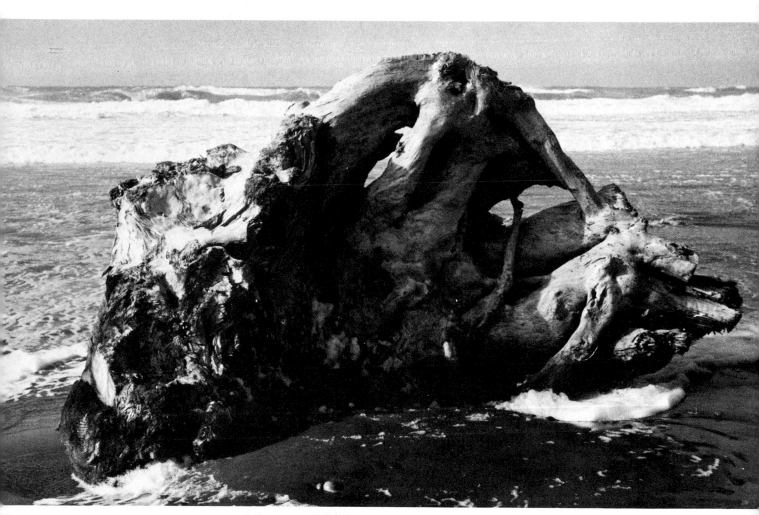

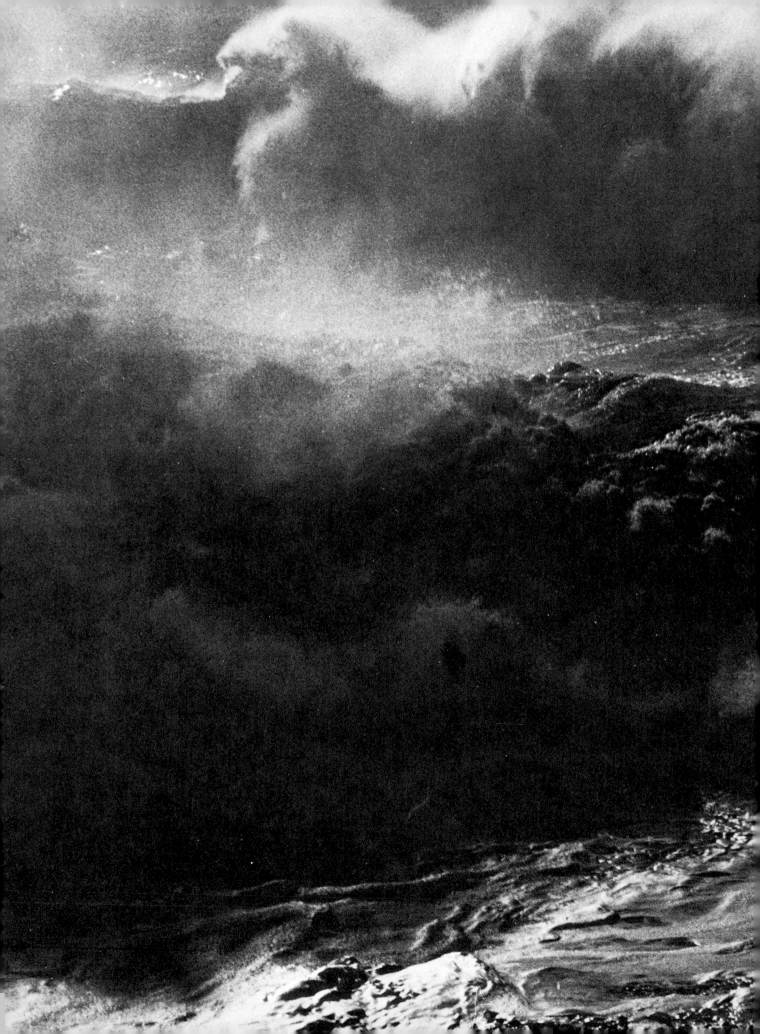

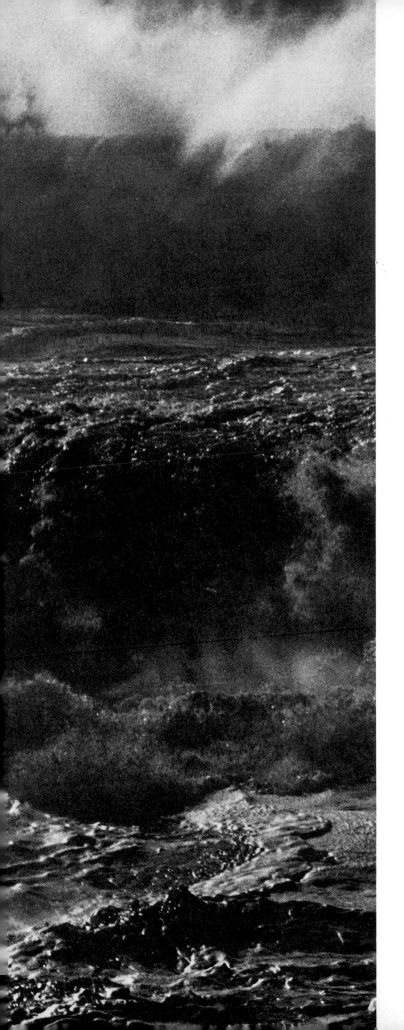

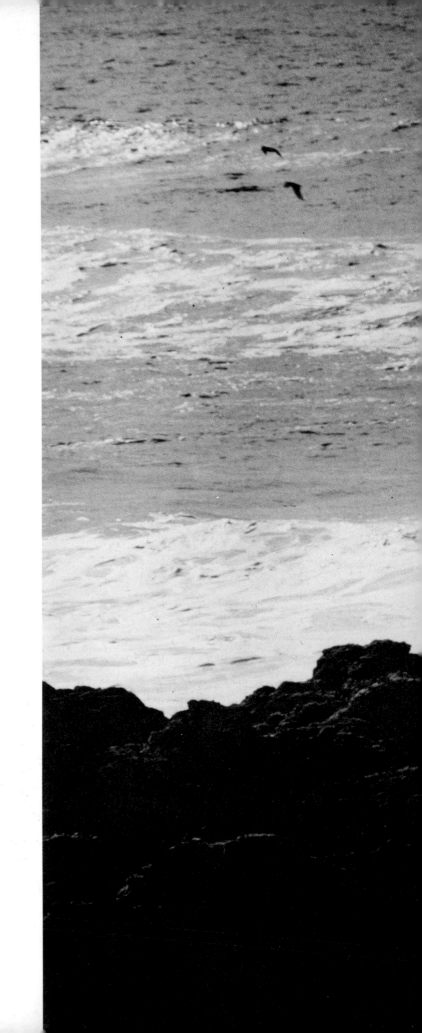

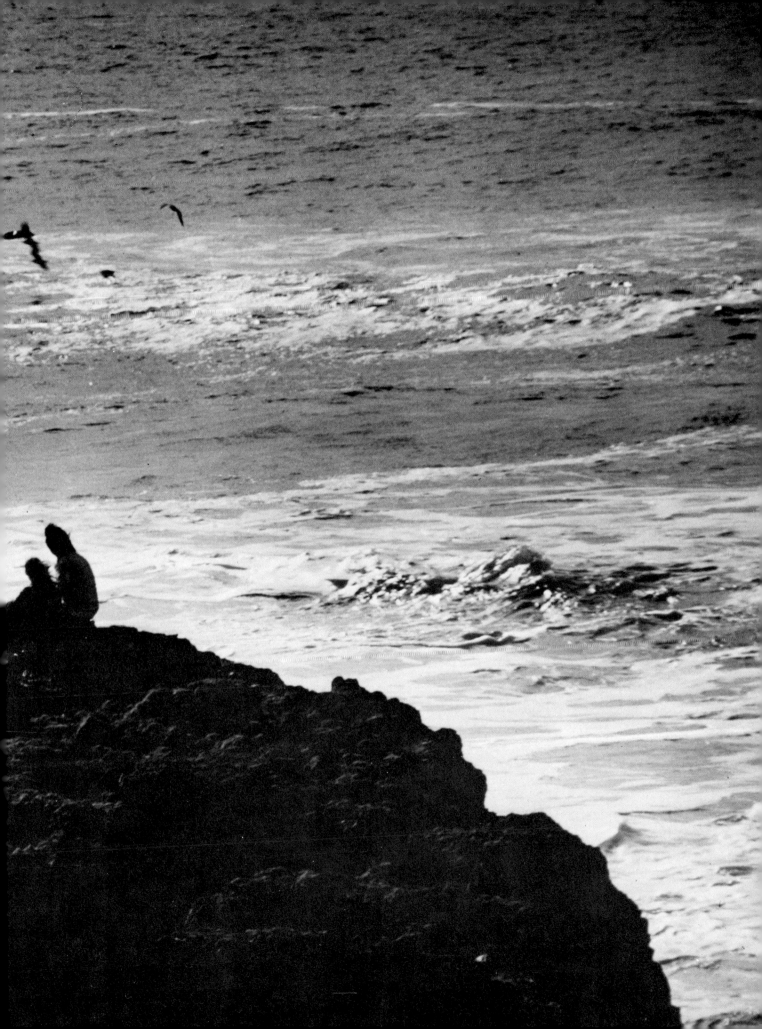

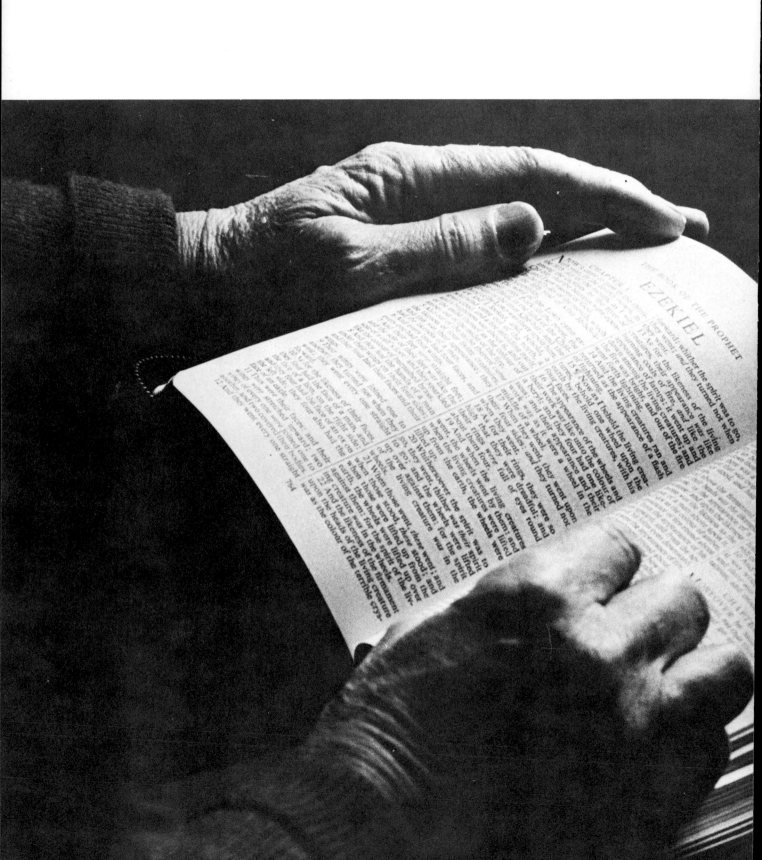

The Bible is to the sailor a sacred book. It may lie in the bottom of his chest voyage after voyage; but he never treats it with positive disrespect. I never knew but one sailor who doubted its being the inspired word of God; and he was one who had received an uncommonly good education, except that he had been brought up without any early religious influence. The most abandoned man of our crew, one Sunday morning, asked one of the boys to lend him his Bible. The boy said he would, but was afraid he would make sport of it. "No!" said the man, "I don't make sport of God Almighty."

—*Richard Henry Dana*

167

Death is at all times solemn, but never so much so as at sea. A man dies on shore; his body remains with his friends, and "the mourners go about the streets"; but when a man falls overboard at sea and is lost, there is a suddenness in the event, and a difficulty in realizing it, which give to it an air of awful mystery.

A man dies on shore—you follow his body to the grave, and a stone marks the spot. You are often prepared for the event. There is always something which helps you to realize it when it happens, and to recall it when it has passed.

A man is shot down by your side in battle, and the mangled body remains an *object*, and a *real evidence*; but at sea, the man is near you—at your side—you hear his voice, and in an instant he is gone, and nothing but a *vacancy* shows his loss.

Then, too, at sea—to use a homely but expressive phrase—you *miss* a man so much.

A dozen men are shut up together in a little bark, upon the wide, wide sea, and for months and months see no forms and hear no voices but their own, and one is taken suddenly from among them, and they miss him at every turn. It is like losing a limb.

—*Richard Henry Dana*

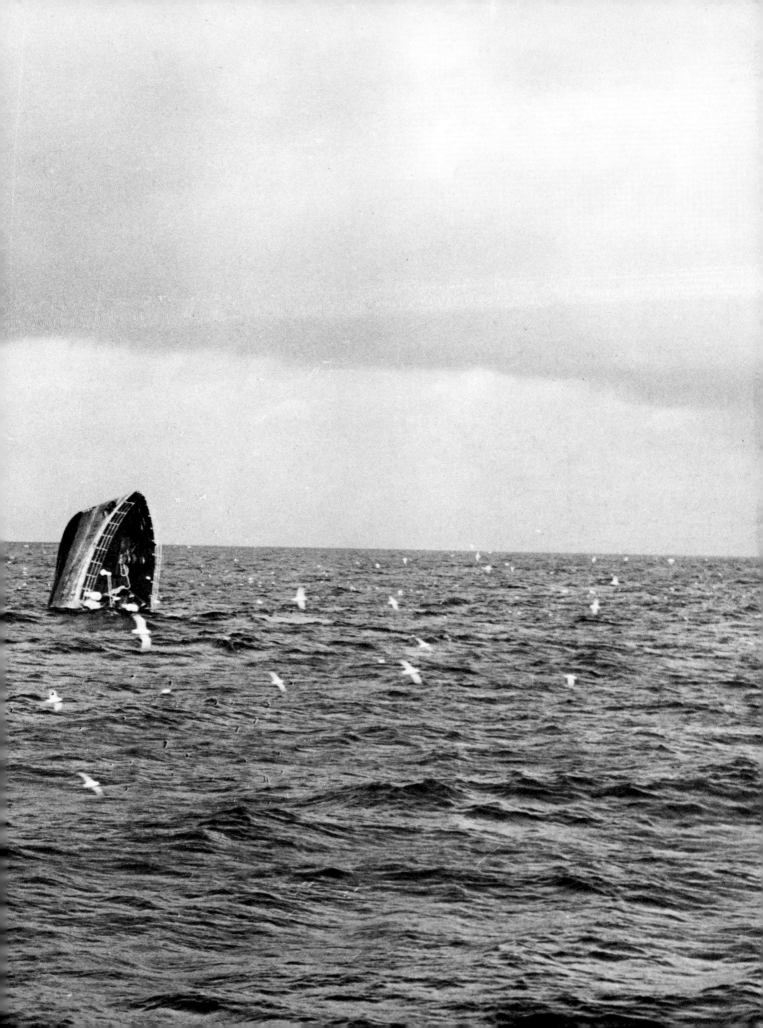

It might seem that he was looking at the sea for the first time in his life. The lens of the lantern cast into the darkness an enormous triangle of light, beyond which the eye of the old man was lost in the black distance completely, in the distance mysterious and awful. But that distance seemed to run toward the light. The long waves following one another rolled out from the darkness, and went bellowing toward the base of the island; and then their foaming backs were visible, shining rose-coloured in the light of the lantern. The incoming tide swelled more and more, and covered the sandy bars. The mysterious speech of the ocean came with a fullness more powerful and louder, at one time like the thunder of cannon, at another like the roar of great forests, at another like the distant dull sound of the voices of people. At moments it was quiet; then to the ears of the old man came some great sigh, then a kind of sobbing, and again threatening outbursts. At last the wind bore away the haze, but brought black, broken clouds, which hid the moon. From the west it began to blow more and more; the waves sprang with rage against the rock of the lighthouse, licking with foam the foundation walls. In the distance a storm was beginning to bellow. On the dark, disturbed expanse certain green lanterns gleamed from the masts of ships. These green points rose high and then sank; now they swayed to the right, and now to the left. Skavinski descended to his room. The storm began to howl. Outside, people on those ships were struggling with night, with darkness, with waves; but inside the tower it was calm and still. Even the sounds of the storm hardly came through the thick walls, and only the measured tick-tack of the clock lulled the wearied old man to his slumber.

Hours, days, and weeks began to pass. Sailors assert that sometimes when the sea is greatly roused, something from out the midst of night and darkness calls them by name. If the infinity of the sea may call out thus, perhaps when a man is growing old, calls come to him, too, from another infinity still darker and more deeply mysterious; and the more he is wearied by life the dearer are those calls to him. But to hear them quiet is needed. Besides old age loves to put itself aside, as if with a foreboding of the grave. The lighthouse had become for Skavinski such a half grave. Nothing is more monotonous than life on a beacon-tower. If young people consent to take up this service they leave it after a time. Lighthouse keepers are generally men not young, gloomy, and confined to themselves. If by chance one of them leaves his lighthouse and goes among men, he walks in the midst of them like a person roused from deep slumber. On the tower there is a lack of minute impressions which in ordinary life teach men to adapt themselves to everything. All that a lighthouse keeper comes in contact with is gigantic and devoid of definitely outlined forms. The sky is one whole, the water another; and between those two infinities the soul of man is in loneliness. That is a life in which thought is continual meditation, and out of that meditation nothing rouses the keeper, not even his work. Day is like day as two beads in a rosary, unless changes of weather form the only variety.

—Henryk Sienkiewicz

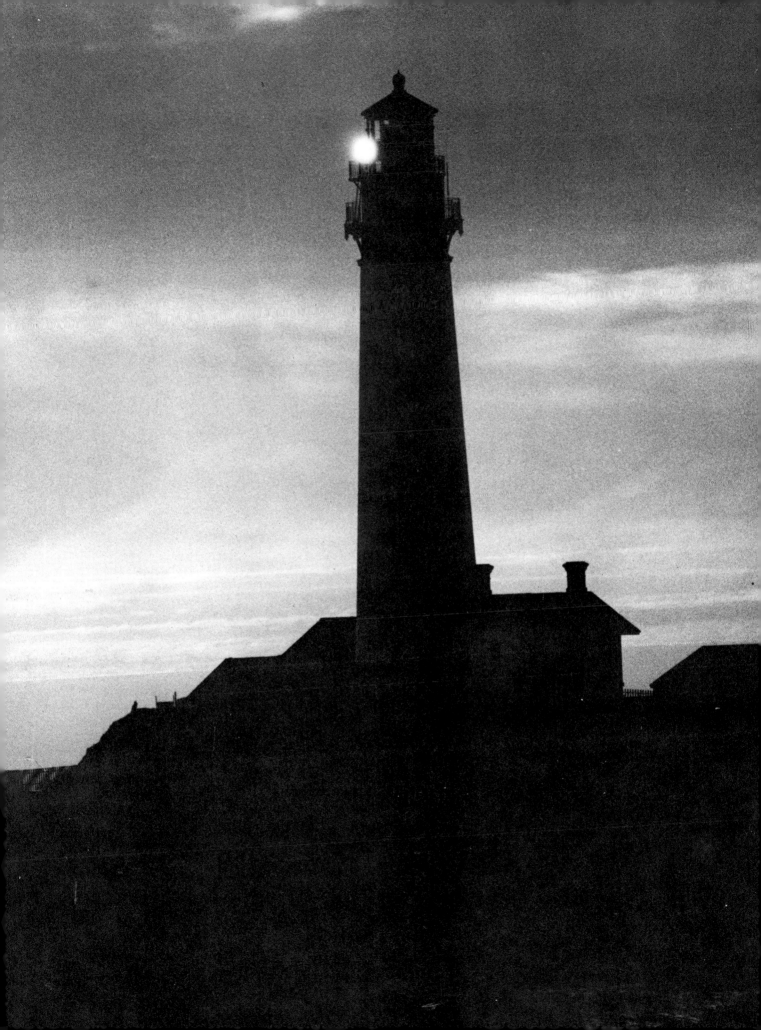

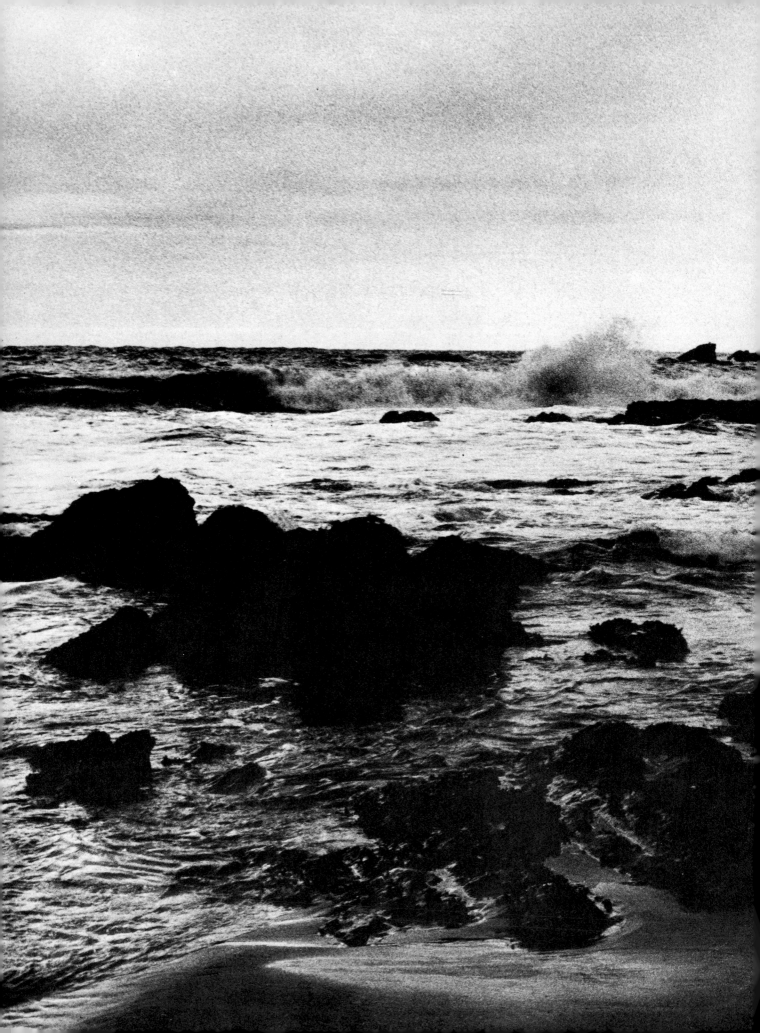

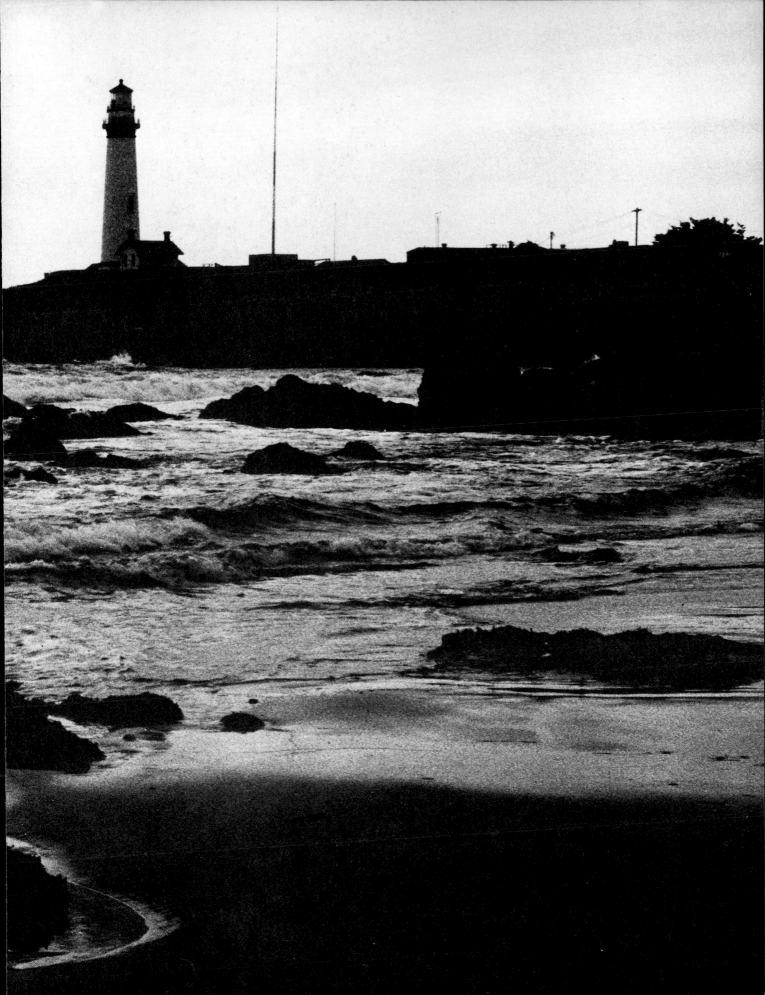

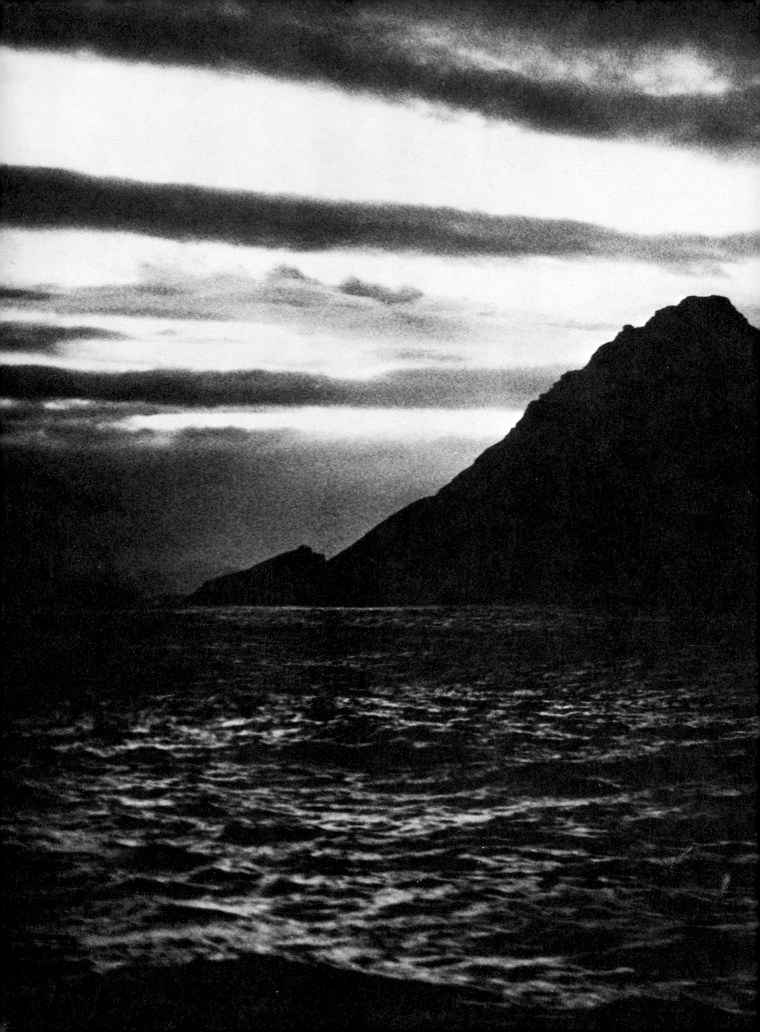

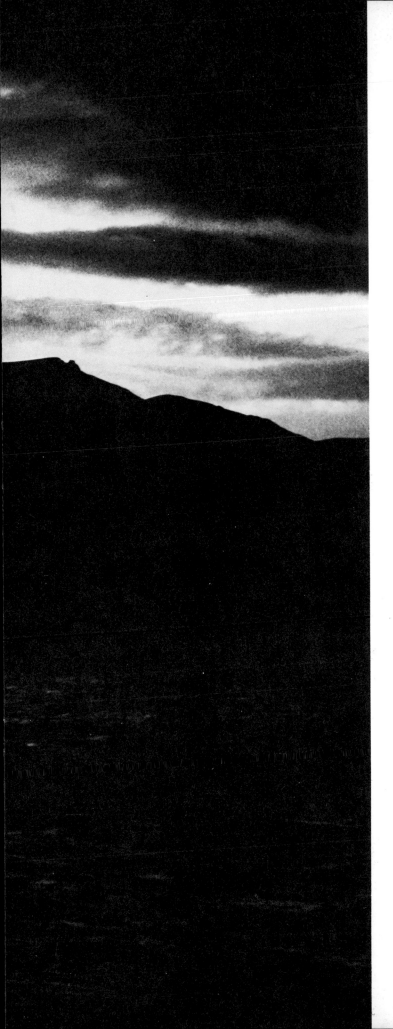

Land! An island! We devoured it greedily
with our eyes and woke the others, who
tumbled out drowsily and stared in all direc-
tions as if they thought our bow was about
to run on to a beach. Screaming sea birds
formed a bridge across the sky in the direc-
tion of the distant island, which stood out
sharper against the horizon as the red back-
ground widened and turned gold with the
approach of the sun and the full daylight.

—*Thor Heyerdahl*

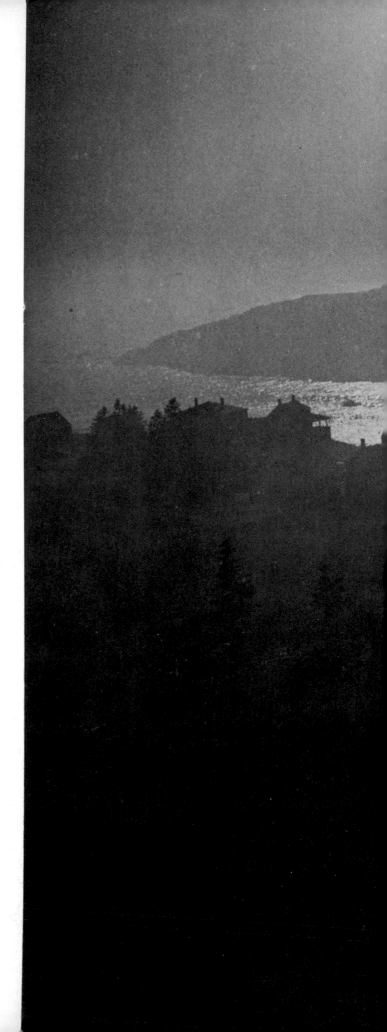

This is a salt steep-cobbled town
where every morning the men go down
to breathe the sun-wet sea;

where maples shadow the sloping street
and the dawn-cool reek of fog is sweet
in the dooryard chestnut tree.

This is the place where fishermen
stride down to the silver wharves again,
to the creak of the waiting hulls

where a lifting leeward wind comes through
and a shaking sail with a patch or two
is followed by flashing gulls.

This is a small brine-weathered town
where the houses lean to winds gone down
the other side of the world,

where chimney-smoke floats blue to gray,
piling that creaks with ended day
while the snagging ropes are hurled.

This is the place where fishermen
stride up the cobbled hill again
and scan the faint-starred skies,

where doors stand open to lilac-shine
and supper-drift blows warm and fine
and windows have seaward eyes.

—*Frances Frost*

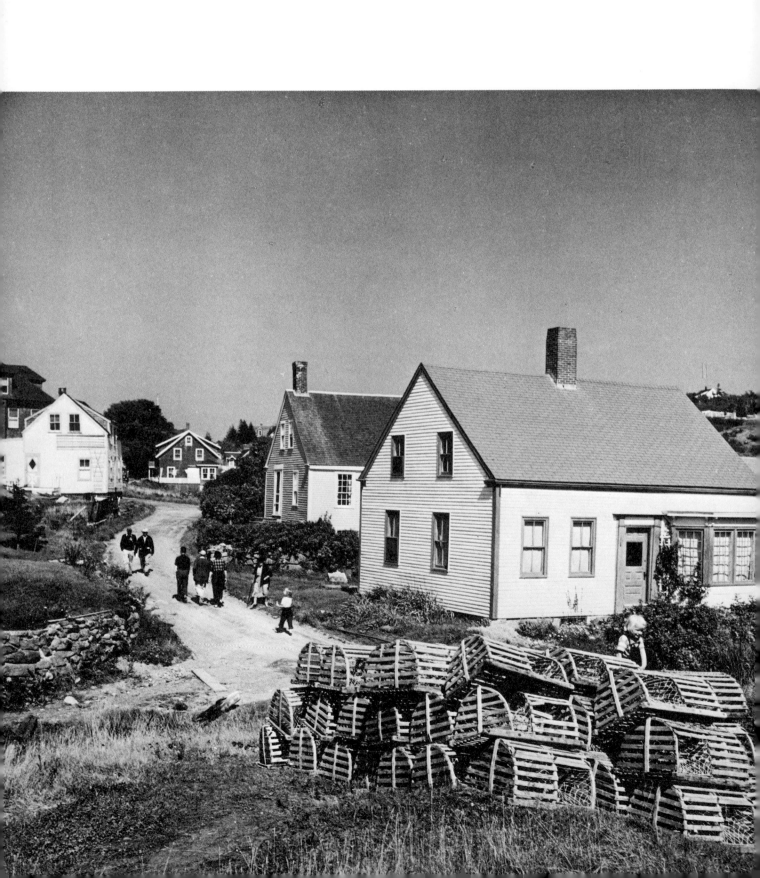

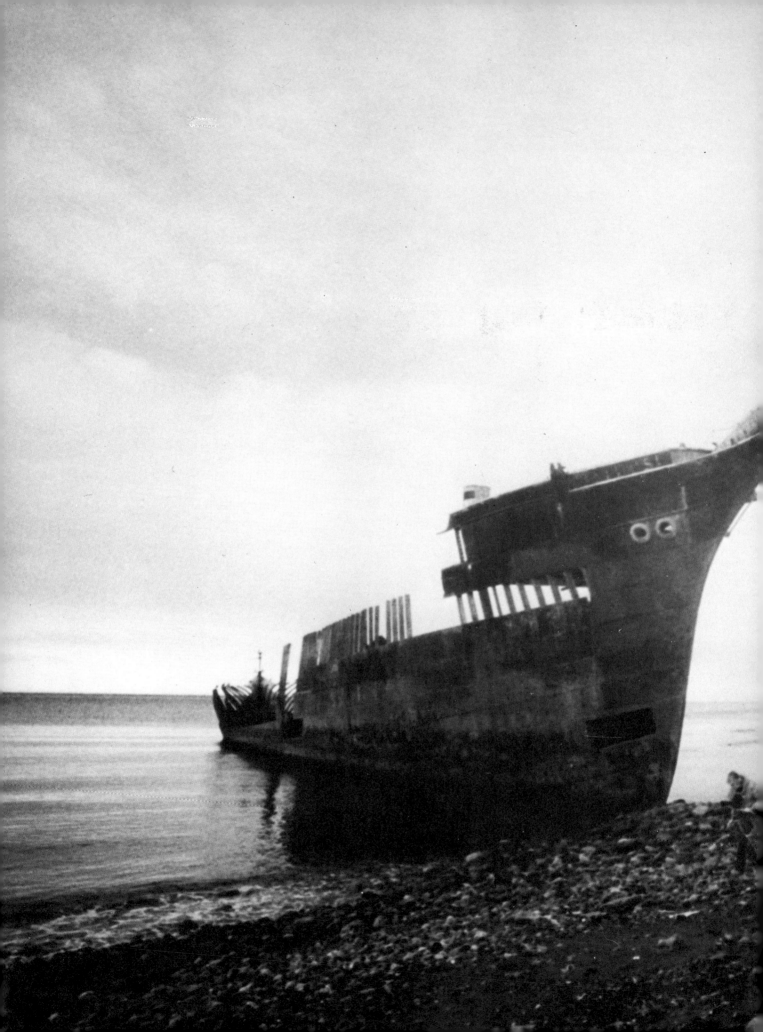

The sea—this truth must be confessed—has no generosity. No display of manly qualities —courage, hardihood, endurance, faithfulness—has ever been known to touch its irresponsible consciousness of power. The ocean has the conscienceless temper of a savage autocrat spoiled by much adulation. He cannot brook the slightest appearance of defiance, and has remained the irreconcilable enemy of ships and men ever since ships and men had the unheard-of audacity to go afloat together in the face of his frown. From that day he has gone on swallowing up fleets and men without his resentment being glutted by the number of victims—by so many wrecked ships and wrecked lives. To-day, as ever, he is ready to beguile and betray, to smash and to drown the incorrigible optimism of men who, backed by the fidelity of ships, are trying to wrest from him the fortune of their house, the dominion of their world, or only a dole of food for their hunger. If not always in the hot mood to smash, he is always stealthily ready for a drowning. The most amazing wonder of the deep is its unfathomable cruelty.

—Joseph Conrad

Unfathomable Sea! whose waves are years,
Ocean of Time, whose waters of deep woe
Are brackish with the salt of human tears!
Thou shoreless flood, which in thy ebb and
 flow
Claspest the limits of mortality,
And sick of prey, yet howling on for more,
Vomitest thy wrecks on its inhospitable
 shore;
Treacherous in calm, and terrible in storm,
Who shall put forth on thee,
Unfathomable Sea?

 —*Percy Bysshe Shelley*

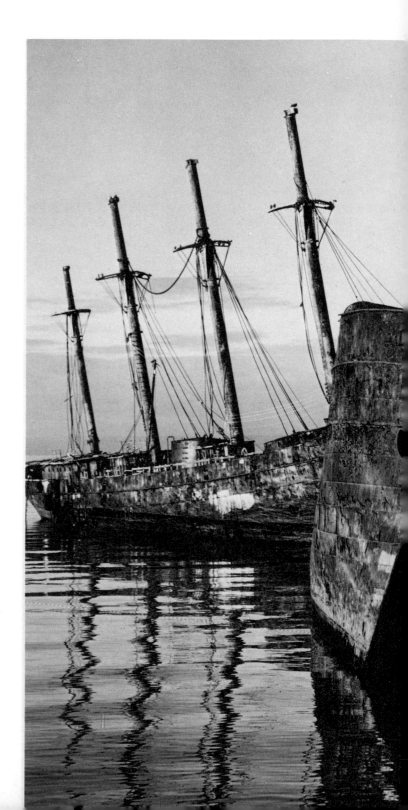

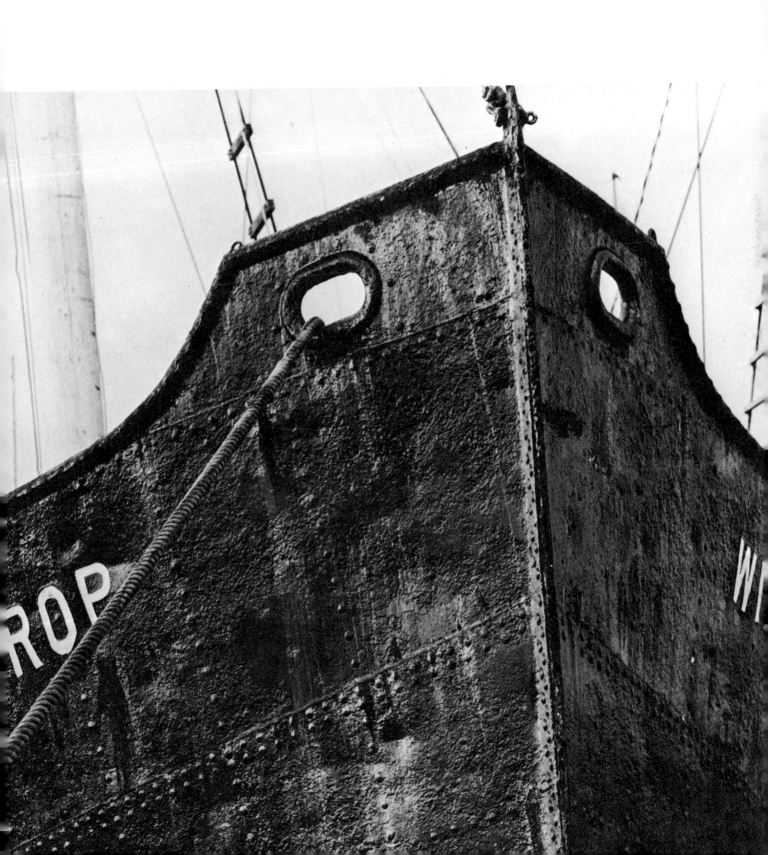

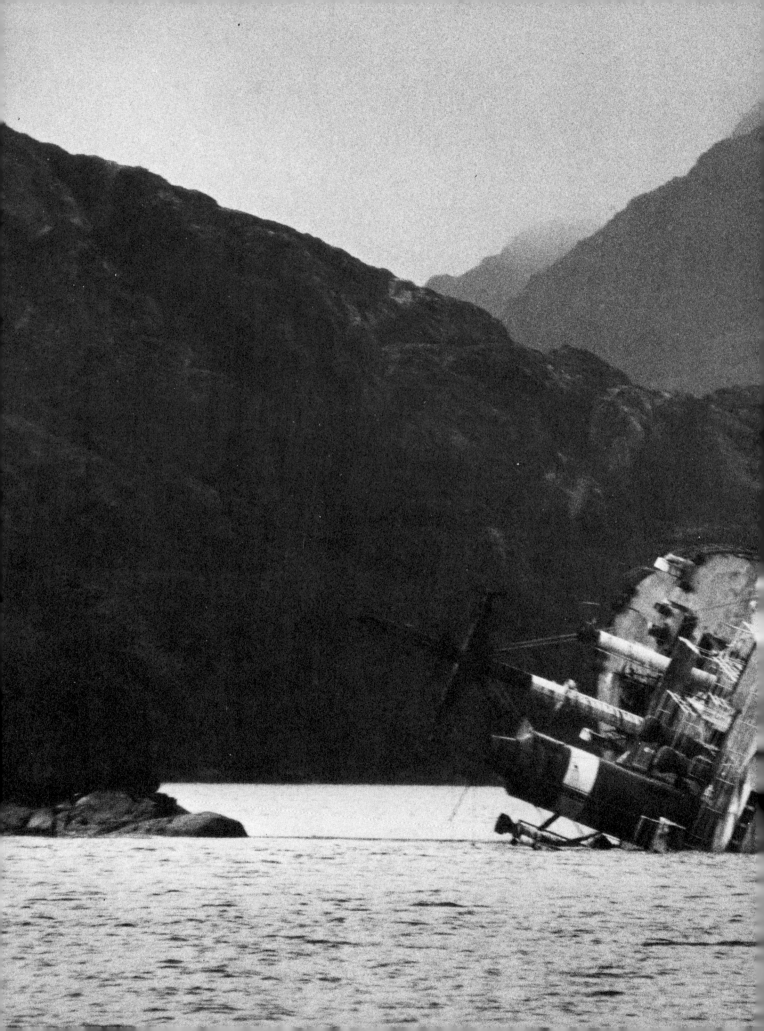

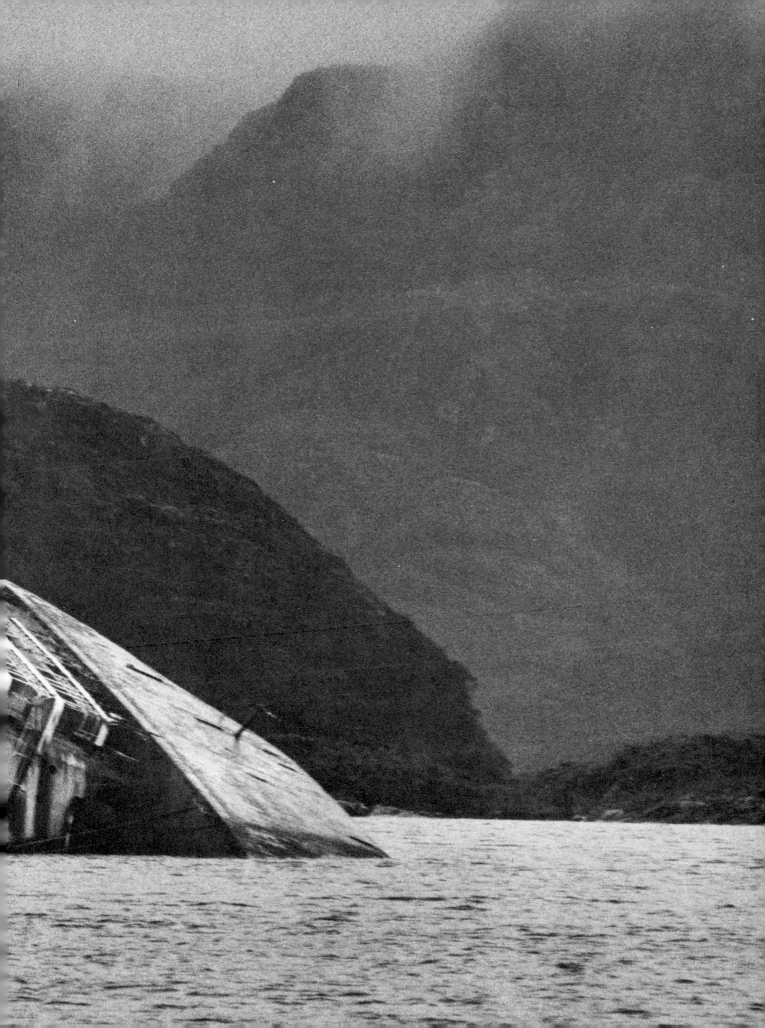

Yes, I did love the sea! At times I saw her spreading from the headland far away and mingling with the blue firmament, like a sapphire floor, smooth, calm, and silent with a secret that I longed to know. At times I saw her in a fury, spattering the shore angrily with white foam, toppling over the reefs, scaling the caves of the great rocks with a restless thundering roar, as if she sought to penetrate the earth's fiery womb and to extinguish the flames that burned there. This intoxicated me, and I ran to play with her, to make her angry and provoke her, so that she might rush against me and chase me, and lash my body with her spray —tease her as we like to tease wild beasts bound with chains. Then, when I saw a ship lifting anchor and sailing out of the harbour into the open sea, and heard the cheering chanties of the sailors labouring at the capstan sheets and the farewells of the women, my soul would fly like a lonely bird after it. The sails of dark grey, swelling with the wind, the stays stretching like delicate lines against the horizon, the golden trucks leaving behind them a trail of light in the blue sky, called out to me to go with them, promising new lands, new men, riches, joys, strange kisses that, though I knew it not, were stored in my heart as the inherited pleasures of my fathers. So, day and night, my soul longed for nothing else but the day of sailing away. Even when the news of a shipwreck reached the island, and the death of the drowned men lay heavy on everybody's heart, and silent grief spread from the frowning faces to the inanimate pebbles of the beach; even when I met the orphans of the dead in the streets, like gilded pieces of wood among the ruins of a once prosperous home, and saw the women clothed in black, and the bereaved sweethearts left disconsolate, and heard the survivors of the shipwreck tell of their misfortune—even then I was sorry and jealous that I had not been with them to see my own sweetheart in her wild majesty and to wrestle with her, wrestle unto death.

—*Antrea Karkavitsas*

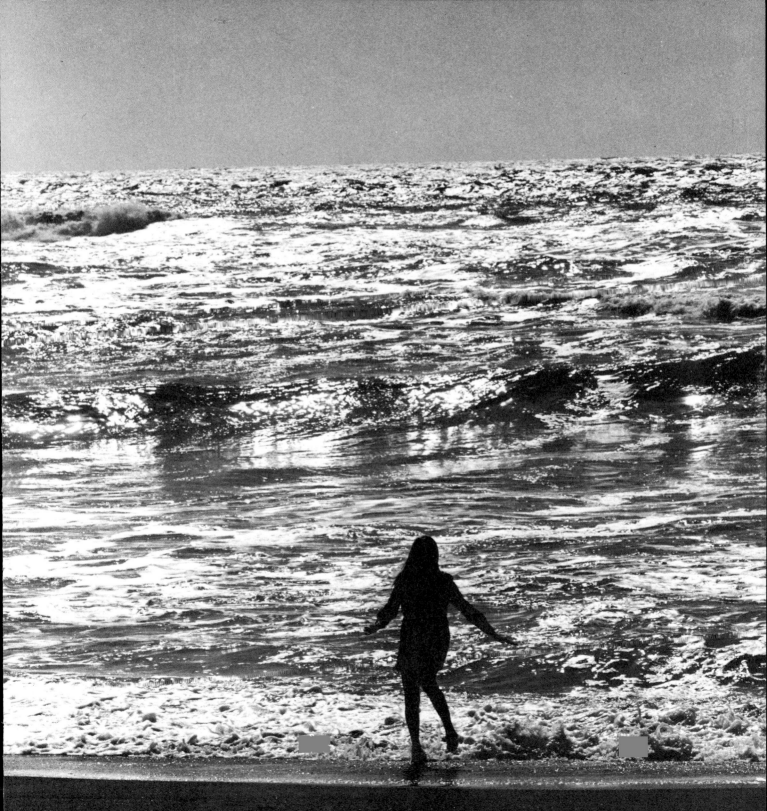

afterimages

*All the rivers run into the sea; yet the sea
is not full; unto the place from whence the
rivers come, thither they return again.*
<div align="right">(<i>Ecclesiastes 1:7</i>)</div>

**And thus it is with the literature of the sea.
Writers and photographers still unborn will
continue the flow of sea imagery in words
and pictures. The preceding pages at best
reflect but a small sampling of the sea litera-
ture of the past. These "afterimages" are
designed to give recognition to passages
without which this volume would
not be complete.**

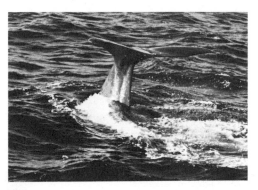

They say the sea is cold, but the sea contains
the hottest blood of all, and the wildest, the
 most urgent.

All the whales in the wider deeps, hot are
 they, as they urge
on and on, and dive beneath the icebergs.
The right whales, the sperm-whales, the
 hammer-heads, the killers
there they blow, there they blow, hot wild
 white breath out of the sea!

And they rock, and they rock, through the
 sensual ageless ages
on the depths of the seven seas,
and through the salt they reel with drunk
 delight
and in the tropics tremble they with love
and roll with massive, strong desire, like
 gods.

Then the great bull lies up against his bride
in the blue deep of the sea.
as mountain pressing on mountain, in the
 zest of life:
and out of the inward roaring of the inner
 red ocean of whale blood
the long tip reaches strong, intense, like the
 maelstrom-tip, and comes to rest
in the clasp and the soft, wild clutch of a
 she-whale's fathomless body.

And over the bridge of the whale's strong
 phallus, linking the wonder of whales
the burning archangels under the sea keep
 passing, back and forth,
keep passing archangels of bliss
from him to her, from her to him, great
 Cherubim

that wait on whales in mid-ocean,
 suspended in the waves of the sea
great heaven of whales in the waters, old
 hierarchies.
And enormous mother whales lie dreaming
 suckling their whale-tender young
and dreaming with strange whale eyes wide
 open in the waters of the beginning and
 the end.

And bull-whales gather their women and
 whale-calves in a ring
when danger threatens, on the surface of the
 ceaseless flood
and range themselves like great fierce
 Seraphim facing the threat
encircling their huddled monsters of love.
and all this happiness in the sea, in the salt
where God is also love, but without words:
and Aphrodite is the wife of whales
most happy, happy she!
and Venus among the fishes skips and is a
 she-dolphin
she is the gay, delighted porpoise sporting
 with love and the sea
she is the female tunny-fish, round and
 happy among the males
and dense with happy blood, dark rainbow
 bliss in the sea.

 —*D. H. Lawrence*

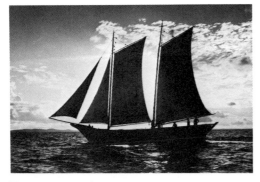

Dear God!
My boat is so very small—
and Thy sea so very wide.
Have mercy!

 —*Author Unknown*

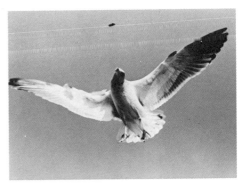

"**A**t length did cross an Albatross,
Thorough the fog it came;
As if it had been a Christian soul,
We hailed it in God's name.

"It ate the food it ne'er had eat,
And round and round it flew.
The ice did split with a thunder-fit;
The helmsman steered us through!

"And a good south wind sprung up behind;
The Albatross did follow,
And every day, for food or play,
Came to the mariners' hollo!

"In mist or cloud, on mast or shroud,
It perched for vespers nine;
Whiles all the night, through fog-smoke
 white,
Glimmered the white moon-shine."

"God save thee, ancient Mariner!
From the fiends, that plague thee thus!—
Why look'st thou so?"—"With my
 cross-bow
I shot the Albatross!"

 —*Samuel Taylor Coleridge*

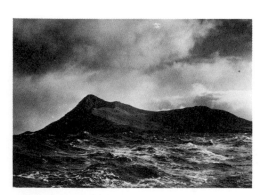

It seems to me that no man born and truthful to himself could declare that he ever saw the sea looking young as the earth looks young in spring. But some of us, regarding the ocean with understanding and affection, have seen it looking old, as if the immemorial ages had been stirred up from the undisturbed bottom of ooze. For it is a gale of wind that makes the sea look old.

From a distance of years, looking at the remembered aspects of the storms lived through, it is that impression which disengages itself clearly from the great body of impressions left by many years of intimate contact.

If you would know the age of the earth, look upon the sea in a storm. The greyness of the whole immense surface, the wind furrows upon the faces of the waves, the great masses of foam, tossed about and waving, like matted white locks, give to the sea in a gale an appearance of hoary age, lustreless, dull, without gleams, as though it had been created before light itself.

—*Joseph Conrad*

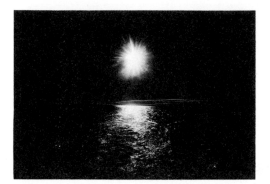

The sun, sinking low, seemed incapable of ever rising again over all things, though glowing through this phantom island so tangibly that it seemed placed in front of it. Incomprehensible sight! no longer was it surrounded by a halo, but its disc had become firmly spread, rather like some faded yellow planet slowly decaying and suddenly checked there in the heart of chaos. . . .

—*Pierre Loti*

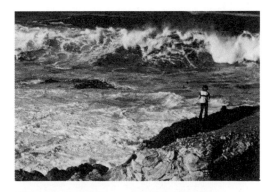

One gazed at the sea, one listened to the wind, or yielded to the drowsiness of ecstasy. When the eyes are filled with an excess of beauty and light, it is luxury to close them.

—*Victor Hugo*

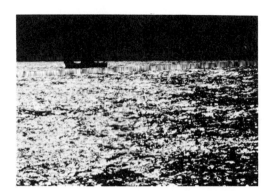

When I saw her first there was a smoke of mist about her as high as her foreyard. Her topsails and flying kites had a faint glow upon them where the dawn caught them. Then the mist rolled away from her, so that we could see her hull and the glimmer of the red sidelight as it was hoisted inboard. She was rolling slightly, tracing an arc against the heaven, and as I watched her the glow upon her deepened, till every sail she wore burned rosily like an opal turned to the sun, like a fiery jewel. She was radiant, she was of an immortal beauty, that swaying, delicate clipper. Coming as she came, out of the mist into the dawn, she was like a spirit, like an intellectual presence. Her hull glowed, her rails glowed; there was colour upon the boats and tackling. She was a lofty ship (with skysails and royal staysails), and it was wonderful to watch her, blushing in the sun, swaying and curveting. She was alive with a more than mortal life. One thought that she would speak in some strange language or break out into a music which would express the sea and that great flower in the sky. She came trembling down to us, rising up high and plunging; showing the red lead below her water-line; then diving down till the smother bubbled over her hawseholes. She bowed and curveted; the light caught the skylights on the poop; she gleamed and sparkled; she shook the sea from her as she rose. There was no man aboard of us but was filled with the beauty of that ship. I think they would have cheered her had she been a little nearer to us; as it

was, we ran up our flags in answer to her, adding our position and comparing our chronometers, then dipping our ensigns and standing away. For some minutes I watched her, as I made up the flags before putting them back in their cupboard. The old mate limped up to me, and spat and swore. 'That's one of the beautiful sights of the world,' he said. 'That, and a cornfield, and a woman with her child. It's beauty and strength. How would you like to have one of them skysails round your neck? I gave him some answer and continued to watch her, till the beautiful, precise hull, with all its lovely detail, had become blurred to leeward, where the sun was now marching in triumph, the helm of a golden warrior plumed in cirrus.

—*John Masefield*

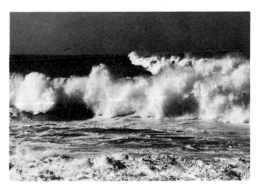

What is a Woman that you forsake her,
And the hearth-fire and the home-acre,
To go with the old grey Widow-maker?

She has no house to lay a guest in—
But one chill bed for all to rest in,
That the pale suns and the stray bergs nest
 in.

She has no strong white arms to fold you,
But the ten-times-fingering weed to hold
 you—
Out on the rocks where the tide has rolled
 you.

—*Rudyard Kipling*

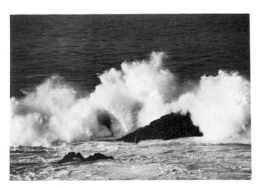

The sea is calm tonight,
The tide is full, the moon lies fair
Upon the straits;—on the French coast the
 light
Gleams and is gone; the cliffs of England
 stand,
Glimmering and vast, out in the tranquil
 bay.
Come to the window, sweet is the night-air!

Only, from the long line of spray
Where the sea meets the moon-blanched
 land,
Listen! you hear the grating roar
Of pebbles which the waves draw back, and
 fling,
At their return, up the high strand,
Begin, and cease, and then again begin,
With tremulous cadence slow, and bring
The eternal note of sadness in.

Sophocles long ago
Heard it on the Aegean, and it brought
Into his mind the turbid ebb and flow
Of human misery; we
Find also in the sound a thought,
Hearing it by this distant northern sea.

 —Matthew Arnold

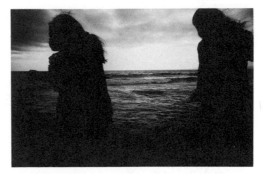

The world is too much with us; late and
 soon,
Getting and spending, we lay waste our
 powers:
Little we see in Nature that is ours;
We have given our hearts away, a sordid
 boon!
The sea that bares her bosom to the moon;
The winds that will be howling at all hours,
And are up-gathered now like sleeping
 flowers;
For this, for everything, we are out of tune;
It moves us not.—Great God! I'd rather be
A pagan suckled in a creed outworn;
So might I, standing on this pleasant lea,
Have glimpses that would make me less
 forlorn;
Have sight of Proteus rising from the sea;
Or hear old Triton blow his wreathed horn.

 —William Wordsworth

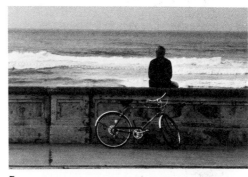

In certain places, at certain hours, gazing at
the sea is dangerous. It is what looking at a
woman sometimes is.

 —Victor Hugo